TRAVEL PHOTOGRAPHY

A GUIDE TO TAKING BETTER PICTURES

RICHARD I'ANSON

Travel Photography: A Guide to Taking Better Pictures

1st edition – October 2000

Published by
Lonely Planet Publications Pty Ltd A.B.N. 36 005 607 983
192 Burwood Rd, Hawthorn, Victoria 3122, Australia

Lonely Planet Offices
Australia PO Box 617, Hawthorn, Victoria 3122
USA 150 Linden Street, Oakland, CA 94607
UK 10a Spring Place, London NW5 3BH
France 1 rue du Dahomey, 75011, Paris

Printed by The Bookmaker International Ltd
Printed in China

Photographs
The images in this guide are by Richard I'Anson and are available for licensing
from Lonely Planet Images.
email: lpi@lonelyplanet.com.au

ISBN 1 86450 207 X

text © Lonely Planet 2000
all photos © Richard I'Anson 2000

CONTENTS

1

THE AUTHOR

Richard I'Anson is a Melbourne-based landscape, travel, editorial and stock photographer. He travels regularly in Australia and overseas photographing people and places for clients and his stock collection.

Richard received his first camera as a gift from his parents when he was 16, and hasn't stopped taking photographs since. After studying photography, film and television for two years at Rusden State College, he worked in a camera store and minilab before going freelance in 1982. His work has been widely published in books, magazines, brochures and calendars, and has been exhibited in both solo and group exhibitions. He also produces limited edition prints for corporate and domestic use. In 1998 he published his first book, *Chasing Rickshaws*, a collaboration with Lonely Planet founder Tony Wheeler.

To establish himself in this niche area of photography, Richard travelled for almost three years in Asia and has travelled frequently in Australia over the last 20 years.

He has won several Australian Institute of Professional Photography awards and in 1996 achieved the level of Master of Photography.

Lonely Planet has been using Richard's photographs for 10 years and his work has been featured in over 150 editions of LP titles. He has also helped to establish Lonely Planet Images.

His latest project is another collaboration with Tony Wheeler, *Rice Trails*, a pictorial book to be published in 2001.

FROM THE AUTHOR

I feel extremely privileged to see the world through the eyes of a photographer. I love taking photographs and I love travelling. I can talk about both for hours, but to put down on paper what I've been doing instinctively over the last 20 years was indeed a daunting proposition. The pain in the neck from hours at the keyboard was even greater than the pain in the shoulders I'm accustomed to from lugging camera gear around. By the end of it I was well and truly ready to focus on infinity again.

Many people have helped me along the way. Thanks especially to my clients who put their faith in me to disappear for weeks at a time and come back with the images they need. Eddie, Neil and Sharon at Schreiber Photographics for keeping me in touch with developments in camera equipment, technology and prices. Eddie Tromp, Wade Hatton and Bob Pattie at Gunz Photographics for years of support and service for my Olympus cameras and lenses. Kodak Professional in Australia for support and encouragement over the years.

At Lonely Planet, Sue Galley, Richard Everist, Martine Lleonart, Peter Cruttenden, Simon Bracken and Tony Wheeler all made significant contributions in making this book possible as I grappled with the transition from photographer to author.

Thanks to the team at Lonely Planet Images for sharing in the experience as the book developed.

To Iris, Alice and Sarah whose support, interest and understanding is so generously given and is greatly appreciated.

THIS BOOK

FROM THE PUBLISHER

This book was produced in Lonely Planet's Melbourne office. Martine Lleonart edited this title, with assistance from Kalya Ryan. Thanks to Paul Burrows of ProPhoto magazine for proofing the technical information.

Simon Bracken was responsible for the design and layout of the book with assistance and advice from Andrew Weatherill. Brett Pascoe arranged prepress production of the photographs for the book.

Peter Cruttenden, Sue Galley, David Kemp and Laurence Billiet contributed to the development of this book.

USING THIS BOOK

Travel Photography aims to increase the percentage of good photographs you take. It's not designed to make you a professional travel photographer, but to give you the information you need to make the most of the picture-taking situations that come your way. It aims to help you create photographic opportunities and to make your time away more photo friendly.

This book covers a range of photographic equipment, from compact point-and-shoot cameras to state of the art SLRs. Whatever equipment you have, the principles and advice given will apply. Also, note that prices are given in US dollars throughout the book.

Although this book is about travel photography, many of the ideas and techniques discussed are applicable to photography in general. It could also be said that all photography (outside the studio) is travel photography. One person's back yard is another's dream destination. Even if you don't have immediate plans to leave your own back yard, you can put into practice much of what's discussed here at home, next time you photograph your family, your pets or go on a day trip. In fact, I highly recommend that you do just that, study the resulting photographs, and then go back out and take some more. You'll learn a lot from your own successes and failures and reap the rewards in better photographs on your next trip.

ABOUT THE AUTHOR

The way I go about taking travel photographs has developed over the years and is in a constant state of review. I aim to capture the reality of a place (as I see it) through strong individual images that build on each other to create a comprehensive coverage of a destination or topic, so that viewers get a sense of what it's like to be there. My own interpretation, my style, is expressed through choice of camera format, lens, film type and speed, exposure, what I choose to photograph, viewpoint, composition, the light I photograph in and finally, the images I choose to show.

The equipment I use has changed little over the past 15 years. It isn't the latest, but it allows me to take the pictures I want. I use prime lenses for their speed because I prefer to use available light (daylight or incandescent) no matter how low. I always use fine grain films.

In Australia (where I live) I photograph landscapes and cityscapes with:

· Pentax 6x7 camera (always mounted on a tripod).

· 45mm, 90mm, 105mm and 200mm lenses.

· Gitzo tripod with 3D-head tripod.

· This outfit travels in a Lowe Pro soft-sided bag.

Overseas my standard outfit consists of:

· Three Olympus OM4Ti SLR camera bodies, two with autowinders.

· Six Olympus Zuiko lenses: 24mm f2, 35mm f2, 50mm f1.4, 100mm f2, 180mm f2.8 and a 300mm f4.

· 350mm f2.8, and 1.4x teleconverter (if wildlife is a significant part of the trip).

· Compact Gitzo tripod with a Fobar Superball head. I photograph landscapes and cityscapes on the tripod; everything else is hand-held.

· Metz 32 Z2 flash unit bounced into a LumiQuest Flash bounce kit with a gold reflector.

· This outfit, except the tripod and 300mm lens, fits into a Domke AF4 soft shoulder bag.

I use polarising filters a lot. I also carry, but hardly ever use, an 81B warming filter, an 82B cooling filter and ND graduated filters. I'm currently using Kodak Ektachrome E100VS as my standard film. For extra speed I switch to Kodak Ektachrome E200, which I rate at 800 ISO. I load two of the cameras with E100VS and the third with E200 at 800 ISO. I use an Olympus U[mju:] ZOOM compact camera loaded with colour print film for capturing pictures of family and friends.

PHOTO CAPTIONS

The photographs and captions in this book are provided to help you learn about taking photos under a variety of circumstances. They include the following information:

· Camera, lens and film are given for every photo.

· Some films given are not available anymore or known by a different name in a different country.

· Shutter speed and aperture is given for every photo where it's known.

· Tripod and filters are noted if used.

Once up a time I took all Lonely Planet's photographs.

But then, once upon a time, another publisher said, 'the images in Lonely Planet books look as if they were taken by the author using an instamatic borrowed from his mother.'

Things have changed. These days the photographic standards of our books are so high I'm really pleased when one of my shots is good enough to make the grade or, as still happens occasionally, make the front cover. However, that certainly doesn't make me one of Lonely Planet's ace photographers – I'm not going to quit my day job – but when the sun's shining the right way, the subject cooperates and I've managed to wind the film on, I can produce results that look pretty good. Luck plays a bigger part in it than it would for one of our Nikon aces but as I said, I'm not quitting my day job.

Travelling with Richard I'Anson to work on *Chasing Rickshaws* and our forthcoming *Rice Trails* book has taught me a lot about travel photography, although I have to admit I find I take far fewer pictures when Richard is around than I would normally. Either I think, 'what I'm doing is redundant, Richard will have taken it anyway,' or I think, 'is this a stupid idea, would Richard think I've got the picture framed wrong, the settings haywire, the light coming the wrong way?'

Sometimes working with Richard is simply solid confirmation that all those standard travel photographer cliches really are true. 'The light is best at dawn,' we're told over and over again. It's obviously not just a throw away platitude because I've had more than my fair share of waking to pre-dawn gloom and yawning in another sunrise when I've travelled with Richard. I've also been pleased to find somebody else who moves as fast as me – Richard always seems to be sprinting from one photo opportunity to another and the fact that he generally lists to one side, heeled over by the weight of camera equipment hanging from one shoulder, never seems to slow him at all.

No matter how good your equipment and how skilled the practitioner, successful travel photography can come down to sheer luck and our visit to Nepal for the *Rice Trails* book was a clear reminder of how important it can be to have lady luck on your side. Day after day our search for rice terraces with snow-capped mountains in the background had been thwarted by non-stop rain in what should have been the

post-monsoon dry season. Finally, the sun broke through just hours before our departure. We diverted our airport bound taxi to the edge of the Kathmandu Valley and sprinted up a hill to find, on the other side, the perfect view – rice fields being harvested, picturesque houses in the foreground, soaring Himalayan peaks as a backdrop. And a river separating us from the picture. We tore off our shoes, rolled up our trousers, waded across the river, got the photographs, interrogated the farmers and still made it to the airport in time for our flight. A little damp, rather muddy, but with the images we needed.

Of course, photography is only one half of 'travel photography' and we've had plenty of standard travel incidents, from the usual car breakdowns in India to the search for Asia's most expensive cappuccino (the Raffles in Singapore, by a head). Along the way we also had a beer in every bar in Dhaka (there are only three of them), ran out of money in Tokyo (the Japanese simply don't trust foreigners enough to allow them to withdraw money from their ATMs) and were firmly put in our assigned places at a hotel in Hanoi ('young man upstairs,' the receptionist commanded Richard, 'old man downstairs,' she told me).

Every picture tells a story, a rock musician once claimed, and it's certainly true of travel photography. Looking back over the photographs Richard took for *Chasing Rickshaws* there's a story behind every one of them. Sometimes it's pure serendipity – standing by the roadside near Tiananmen Square on a cold November morning when what may have been the only female rickshaw rider in Beijing pedalled by, or taking a boat ride down the Buriganga River in Dhaka, the capital of Bangladesh, and chancing upon a little timbermill turning tree trunks into rickshaw bodies. Sometimes it's simply a matter of searching for that perfect view – the rice terraces tripping down a hillside in Bali or the confusion of traffic in a Calcutta traffic jam. But always there's a story behind the picture and it's remarkable how ready people are to tell that story when a camera comes into play.

Tony Wheeler,
founder, Lonely Planet

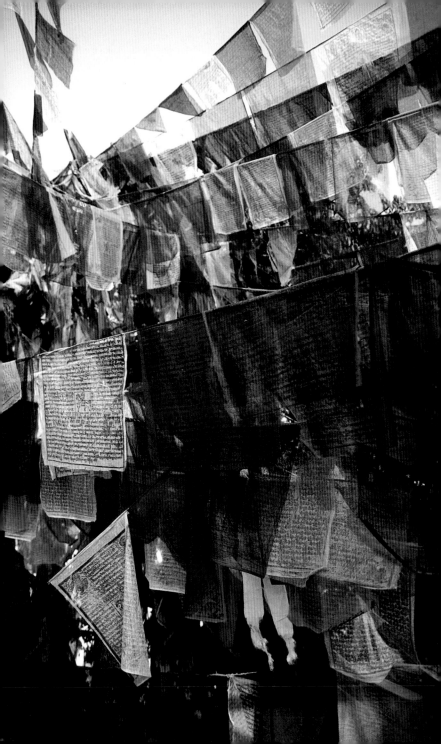

INTRODUCTION

The idea for this book began on a bus in Nepal. I was on my way to Dhunche, the starting point of the Langtang trek. On hearing that I was a photographer, one of the three travellers (squashed into a seat made for two) in front of me asked if I could fix her camera. I could hear the desperation in her voice – she had come a long way to go trekking and now thought she had no way of recording this great event. I'm not a camera technician, but I do know that batteries can be given an extra lease of life with a quick clean. I found myself cleaning many more batteries and answering lots of questions about picture-taking on my travels, so I decided that once home, I would try and pass on some of the experience I've gained.

Most people come back from a holiday with one or two photographs they consider above average, even great, and have no idea how they achieved such heights. Modern automatic cameras have eased the burden of having to understand what's going on when you press the shutter. However, this often means the process and the variable

elements that go into creating a successful image remain a mystery, and cannot be repeated.

Camera manufactures repeatedly make claims along the lines that all you have to do (after buying their camera) is point it at something and stunning, professional images will be yours. Consequently, cameras are blamed when photos don't turn out and credited when they do. Cameras don't take pictures, people do.

Understanding the elements that go into creating good photographs means that you can learn to repeat them, and take control of the picture-taking process. Every decision you make, including choice of camera, lens and film; the combination of film speed, shutter speed and aperture; whether you use a tripod or not; the position from where you take the photo; and the time of day, are all creative decisions. It's certainly easier to let the camera make some of those decisions for you. However, if you want to elevate your images from simple record shots of your travels to the next level of quality and individuality, then you need to take control of all the elements that go into creating photographs.

Whatever your approach to travel photography, be prepared to cover an expansive range of subjects including people, landscapes, cities, markets, festivals and wildlife. Some people specialise in one or two subjects, but travel photographers need to be confident photographing the full range of subjects that are encountered on the road. Additionally, the successful travel photographer requires several contrary skill sets:

· The ability to plan every detail but be totally flexible in order to respond quickly to new and/or unforeseen events.

· The energy to walk for hours on end and the patience to wait around for just as long (sometimes days) for the right light or the right subject, or both.

· Strong social skills to make quick connections with people, as well as being comfortable with your own company for long stretches of time.

· Finally, technical and creative abilities need to be complemented with at least some understanding of business and marketing. You can have the greatest pictures in the world, but they'll remain unseen unless some business skills are applied.

You need to develop an eye for all sorts of images: from tiny details to sweeping panoramas, from carefully composed portraits to action shots of people and wildlife. The travel photographer has to be comfortable in crowded market

places and empty deserts, high in the mountains and in dimly lit caves. Pictures have to be produced in conditions as varied as snow and below zero temperatures, to torrential rain, high humidity and the glare of the midday sun.

○ *The continuing challenge is to take consistently good photographs in very inconsistent conditions.*

Travel photography is also about equipment and films, exposures and composition, weather and light, but most of all it's about being there, and your personal response to the places and events you have the good fortune to visit.

6x7 SLR. 200mm lens. 1/250 f11. Fujichrome Velvia

A SHORT HISTORY OF TRAVEL PHOTOGRAPHY

The connection between photography and travel runs deep. The oldest surviving image produced by a camera was made around 1826 when Joseph Nicephore Niepce photographed a street scene at Saint Loup de Varennes, in France. Arguably, this is also oldest surviving travel photo. The photograph, taken in daylight, required an eight-hour exposure.

In Paris in 1839, Louis Jacques Mande Daguerre introduced the photographic process now known as the Daguerreotype. The process was complicated, requiring lots of equipment and handling of chemicals, but was embraced quickly. Each Daguerreotype was unique and recorded scenes with excellent detail. It also allowed people to travel with cameras. The first owners photographed their local area, Notre Dame Cathedral, the Seine River and the Pont Nuef; subjects that are considered a 'must take' by today's tourists. The appeal of photography was as obvious to travellers in the middle of the nineteenth century as it is today. Daguerre himself suggested that his camera could easily be taken along on a journey. He was

« Sunset at Portsea, Point Nepean National Park, Australia

«

right, but it wasn't quite that simple. The travelling photographer also had to carry a portable darkroom tent and enough chemicals to stock a small laboratory.

Around the same time, Daguerre's English contemporary, William Henry Fox Talbot, invented the Calotype (better known today as a negative). This made multiple copies of an image possible, but without the detail achieved in a Daguerreotype. Talbot too imagined the appeal his invention would have to travellers writing:

> *... the traveller in foreign lands, who like most of his breed, cannot draw, would benefit immensely from the discovery of such a material. All he has to do is to set up a number of small cameras in different locations and a host of interesting impressions are his, which he did not have to draw or write down.* (Masters of Early Travel Photography, *R Fabian & H Adam, 1983*)

In 1851, Frederick Scott Archer invented the wet collodion plate that became the standard photographic process until 1880. This new process, which reduced exposure times to a mere two seconds, matched the detail possible with a Daguerreotype and the ability of the Calotype for reproduction, and overcame the long exposure times required by both. It didn't, however, ease the burden for the travel photographer. Each glass plate had to be prepared in the field and processed immediately while still damp. A standard outfit in the 1850s included a camera (on the large size), tripod, glass plates and plate holders; a tent-like portable darkroom; chemicals for coating, sensitising, developing and fixing the plates; and dishes, tanks and water containers. Even so, photographers carted their equipment around the world. The Great Wall, feluccas on the Nile, the temples on the Ganges at Varanasi, high passes in the Himalaya and the Grand Canyon had all been photographed in great detail by 1860.

Many of the travel photographs taken in the mid-1800s were recorded during scientific and exploratory trips, but they also served to create public interest in distant lands. Although cumbersome in the field, the collodion process produced good quality images that were easily reproduced. As tourism increased, so did the demand for pictures as souvenirs, and photographers began shooting for commercial reasons. The first postcard was introduced by the Austrian postal service in 1869. In 1910, France printed

123 million postcards and the world's mail systems processed around 7 billion in the same year. (*METP*)

The bulk, weight and messiness of the photographic process restricted the gathering of images in the early years to a small group of people, who were part adventurer, part scientist, part camera technician and part artist. But, by the end of the nineteenth century tourists could take their own pictures. In 1888, George Eastman, the founder of Kodak, invented a camera using a roll of film. He launched the first point-and-shoot with the now famous slogan: 'You press the button we do the rest'. The camera came loaded with a 100-exposure film and a memorandum book that had to be filled in to keep count of the photos. When the film was finished the camera was posted back to the factory. The camera was returned with the prints and loaded with a fresh roll of film. In the first year Eastman sold 13,000 cameras. Proving instantly popular with tourists, one testimonial stated:

It is the greatest boon on earth to the travelling man, like myself, to be able to bring home, at so small an outlay of time and money, a complete photographic memorandum of his travels. (The Birth of Photography: The Story of the Formative Years 1800-1900, *B Coe, 1977*)

Further refinements saw the introduction of the Kodak Brownie camera in 1900, which made the photographic process accessible to millions of people around the world. Photography had become a mass medium and tourists were travelling with small, easy to use cameras. According to some, by the start of the twentieth century, the world had been photographed to death.

Of course the world wasn't photographed to death a hundred years ago, and it still hasn't been. It's true there aren't many places left that haven't been photographed and we all know what the world's most famous destinations look like even if we haven't been there ourselves. The content of our pictures rarely surprises the travel-savvy society we live in, yet images are published every year that cast a new light on old subjects and push our visual awareness into new territory. And so what if everyone you know has photographed the Taj Mahal and the Eiffel Tower? There's nothing quite like the thrill of seeing places yourself and making your own version of the classic shot.

PART ONE: FIRST THINGS FIRST

There are many things to consider before you hit the road that will have an impact on the pictures you take, and the enjoyment you experience taking them. Selection of camera, lenses and film are the most obvious, but there are lots of other pieces of equipment and photographic accessories that can help you return home with the photos you want.

Apart from preparing your equipment and film, some time spent researching your destination will also pay off. If you're on a set schedule, say a group tour, your options may be limited, but that's even more reason to do some pre-planning with photography in mind. If your itinerary is flexible, why not time your visit to coincide with the weekly market? A little preparation is all it takes to avoid turning up the day after and being told how wonderful it was.

EQUIPMENT

What equipment to take is not an easy decision, especially if you're starting from scratch. There's a huge selection of cameras, lenses and accessories to choose from. You can narrow the selection down by identifying your goals, the kind of pictures you want to take, and how you intend to show them. If all you require is a record of your trip in the form of colour prints for an album, a fully automatic compact camera will probably do the job. If you have ambitions to make large prints to hang on the wall, spend as much on lenses as you can afford. If you're trekking in Nepal and want to photograph the first rays of sun on the snowy peaks of the Himalaya, you'll need a tripod to do it well.

Until you've made several trips and are confident anticipating your needs, what you actually take will have to be a compromise between what you think you need, what you can afford, and how much weight you're prepared to carry. Finding the balance is the trick. Aim to keep things simple, accessible and manageable. If your equipment is a burden you won't enjoy taking pictures. You don't need

《 *Stone relief, Wat Phnom, Phnom Penh, Cambodia*

tons of expensive gear to take great photos; you just need to know how to get the best out of the equipment you have and to use it within its limitations.

CAMERAS

There's a staggering choice of cameras available in various formats and types in all price ranges, and new models are released regularly. Consult a buyer's guide published by a photographic magazine for a thorough overview of what's available at the time you're ready to buy. Also see the Buying Guide chapter later. All camera formats and types have their strengths and weakness, but most travellers have to settle on just one to do everything for them. Outlined below are the camera formats and types that are of most interest to travellers.

CAMERA FORMATS

Camera formats are based on the size of the film frame.

Advanced Photo System (APS) The smallest and newest format, launched in 1996. APS has a film frame size of 17x30mm.

35mm The most popular format and the film size upon which the majority of camera systems are based. Produces 24x36mm negatives and slides.

Medium Formats There are a range of medium format cameras that use roll film known as 120. The most popular formats are 6x4.5cm (known as 645), 6x6cm (2 1/4 inches square) and 6x7cm. Depending on the camera, you get a different number of frames per roll, ranging from 10 to 15. Medium format cameras offer a considerably larger negative or transparency than 35mm, an important consideration if very large prints are required.

Panoramic Available in 35mm and medium format. A true panoramic camera has a format ratio of at least 1:3 (ie, the film is three times as wide as it is high). Two 35mm frames side by side would be panoramic. In medium format a 6x12cm panoramic camera gives six frames per roll. A 6x17cm panoramic camera produces only four frames per roll, that are almost three times as wide as they are high.

Many compact and SLR cameras now offer the possibility of 'Panoramic', or long and thin, pictures as a feature. The image is actually exactly the same as the standard image, but the top and bottom of the frame are masked and cut off, giving the impression of a panoramic image. You can do exactly the same thing by cropping any negative or slide.

CAMERA TYPES

ADVANCED PHOTO SYSTEM CAMERAS (APS)

Incorporating the latest technologies, APS cameras are very compact and gaining in popularity. One of the key features is that information about each picture is recorded onto magnetic data stripes on the film when it's taken. The data informs the printing machine about the conditions under which the photograph was taken, such as if the flash fired and what zoom setting was used, in theory eliminating bad prints. APS cameras are available in compact and SLR models. Film cartridges contain 15, 25 and 40 exposure lengths and colour negative film is readily available in 100, 200 and 400 ISO.

ADVANTAGES
· Cameras are 10-15% smaller than comparable 35mm models.

· Choice of three picture frame sizes, which are selected at the time of exposure and can be changed from frame to frame: classic (4x6cm prints), horizontal (4x7cm prints) and panoramic (4x12cm prints).

· Easy to use with most models fully automatic with built-in flash and zoom lenses.

· Film comes in a cartridge and provides foolproof film loading.

· Processed film is returned in the cartridge so is never handled, protecting it from fingerprints and scratches.

DISADVANTAGES
· Advanced features are reflected in higher prices.

· Film and processing costs are higher than for 35mm.

· Film needs to be processed with special equipment, which may not be widely available in all countries.

· Range of colour slide and B&W film very limited.

· Range of SLR models available is limited.

COMPACT 35MM CAMERAS

Compact 35mm, or point-and-shoot, cameras are ideal for taking photos with a minimum of fuss. Perfect if you want to travel light and only require colour prints of your travels.

ADVANTAGES
· Easy to use and most models are fully automatic with built-in flash and zoom lenses.

· Wide range of films to choose from.

· Small, light and easily carried in a pocket or small bag.

· Models available to suit all budgets.

· Good option as second camera.

· Doesn't require accessories.

CAMERA FORMATS

These photos illustrate the different camera formats:

Mirima National Park, Australia
Linhof Technorama 6x17 Format

Cape Naturaliste, Australia
Noblex 6x12 Format

Sanur, Bali, Indonesia
Pentax 6x7 Format

Blue Mountains, Australia
Bronica SQ 6x6 Format

Hunter Valley, Australia
Bronica ETRs 6x4.5 Format

Bumburet, Pakistan
Olympus OM4Ti, 35mm SLR Format

Sydney, Australia
Olympus i ZOOM 75 APS Format

35mm

APS

6x6cm

6x4.5cm
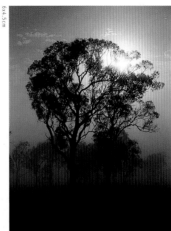

DISADVANTAGES

· Cheaper models have low quality lenses.

· You can't change lenses.

· Limited automatic override features.

· Not suitable for colour slide film.

· Subjects are seen through a viewfinder (not the lens) so accurate framing is limited particularly at close range and it's possible to photograph your fingers or thumbs without realising.

35MM RANGEFINDERS

These cameras sit between compacts and SLRs in terms of size and features but are considerably more expensive than compacts. Rangefinder refers to the focussing system, which splits or doubles the image on the focussing point. Correct focus is achieved by superimposing the double image. Manual and auto-focus rangefinders are available.

ADVANTAGES

· Accepts interchangeable lenses.

· Compact and well built.

· Continuous viewing of subject through viewfinder, not through the lens.

· High quality lenses.

· Very quiet operation.

DISADVANTAGES

· Expensive.

· Limited features for the price compared to SLRs.

· Limited range of lenses.

35MM SINGLE LENS REFLEX (SLR) CAMERAS

There's no doubt that the ideal camera for serious travel photography is a 35mm SLR, preferably one that allows you to manually override all of the automatic features. This will let you take complete control of the technical side of photography if you choose. SLR cameras are available in APS, 35mm and medium formats.

ADVANTAGES

· Automatic SLRs are easy to use, even for those who are technically challenged. Most new models have sophisticated light meters, autofocus and built-in flash units as standard features, as well as a host of other automatic features letting you use them as easily as the point-and-shoot cameras.

· Interchangeable lenses and accessories to suit every application.

· Manual SLRs (or auto models with manual override) are great for gaining an understanding of the technical aspects of photography and the ideal tool for creative photography.

- Models available to suit all budgets.
- Subject is viewed through the lens.
- Wide range of films to select from.

DISADVANTAGES
- Heavier and bulkier than compact cameras.
- The starting price of a basic model SLR is more expensive than a compact.

LENSES FOR SLR CAMERAS

The ability to interchange lenses is one of the most persuasive reasons for buying a SLR. It increases your creative options and ability to solve photographic problems. Don't compromise on lens quality. If you're on a tight budget, go for a camera with fewer features and buy the best lenses you can afford. Lens quality determines image sharpness, colour and the light-gathering capacity of the lens, which can determine how you shoot in various lighting conditions.

LENS LINGO
All lenses have a designated focal length and maximum aperture, which are used to describe the lens. The focal length is the distance from the centre of the lens when it's focussed at infinity to the focal plane, the flat surface on which a sharp image of the subject is formed. Film is stretched across the focal plane. A normal, general-purpose camera lens is designed to have a focal length approximately equal to the diagonal of the negative or image area. With 35mm film the image area is 24x36mm and the diagonal measures 45mm. Consequently, a 50mm lens is regarded as standard for 35mm cameras and covers about the same field of view as the human eye looking straight ahead. Wide-angle lenses provide a wider field of view and closer focussing than a standard lens. Telephoto lenses have a narrower field of view and a greater minimum focussing distance than standard lenses.

The maximum aperture describes the widest opening available on the lens and is described as an f-number. (See the Aperture section in the Exposure chapter.) The wider the maximum aperture the greater the light-gathering power of the lens. Lenses with wide maximum apertures (f1.2, f1.4, f1.8, f2, f2.8) are also considered fast. The lower

the maximum aperture the slower the lens because its light gathering ability is less. A lens with a focal length of 100mm and a maximum aperture of f2, is called a 100mm f2 lens. The wider the maximum aperture the bigger and heavier the lens is (and the more it costs).

Zoom lenses have variable focal lengths. At one end the lens may have a focal length of 28mm and at the other a focal length of 90mm. As the focal length varies so too does the maximum aperture. At its widest position (28mm) the lens is at its maximum light gathering capabilities, say, f2.8, but this changes as it zooms in to its longest position (90mm) to, say, f4.5. This lens would be referred to as a 28-90mm f2.8-4.5 zoom.

Lenses can be grouped by focal length into seven main categories; superwide, wide, standard, telephoto, super telephoto, zoom and special purpose lenses (which includes macro, shift, mirror and fisheye lenses). Every lens or lens group has certain subject matter that it's particularly suited to and this is noted below. In reality, you can photograph any subject with any lens as long as you can get close enough or far enough away.

SUPER WIDE-ANGLE LENSES

Super wide-angle lenses include 18mm, 21mm and 24mm focal lengths. With their very wide angle of view, these lenses lend themselves to landscape, interiors and working in confined spaces. The 18mm and 21mm are a bit too wide for general photography. Unless they're used well, it's easy to include unwanted elements in the composition and for subjects to appear too small. The 24mm produces images that have a distinctly wide-angle perspective, but can be used in many situations. Particularly suited to taking environmental portraits they allow you to get close to your subject to create a sense of involvement in the picture but still include the location.

WIDE-ANGLE LENSES

Photographers often use 28mm and 35mm wide-angle lenses as a standard lens. They produce pictures with a natural perspective, but take in a considerably wider angle of view than standard lenses. Fixed focal length compact cameras commonly use a 35mm lens, as it's considered suitable for a wide range of subject matter.

STANDARD LENSES

Standard lenses have focal lengths of 50mm or 55mm, which have an angle of view that is close to what the eye sees. Before zoom lenses became the norm, SLRs were commonly sold with a 50mm f1.8 lens. Standard lenses still have an important place, as they're compact and are the fastest lenses available, making them ideal for low light photography.

TELEPHOTO LENSES

Telephotos range from 65mm to 250mm. Their most common characteristics are increased magnification of the subject and a foreshortening of perspective. Medium telephotos range from 85mm to 105mm and make excellent portrait lenses. They give a pleasing perspective to the face and let you fill the frame with a head and shoulder composition without being in the face of your subject. The long telephotos, from 135mm to 250mm, are ideal for picking faces out of a crowd, details on buildings and in landscapes. They also allow the frame to be filled when moving closer is not possible, such as at sporting events or when you're on the edge of a canyon. They clearly compress distances making distant objects look closer to each other than they actually are.

SUPER TELEPHOTO LENSES

Ranging from 300mm to 1000mm these lenses display significant foreshortening and have a very narrow angle of view. Apart from the 300mm, the super telephotos are specialist lenses. If the weight doesn't bother you then the price probably will. A 300mm lens magnifies the subject six times more than a standard lens and is commonly used by wildlife and sports photographers. For serious bird photography (that is, if you want to take pictures where you can actually see the bird) a 500mm lens, at the very least, is required.

ZOOM LENSES

Zoom lenses offer convenience and flexibility by giving an unlimited choice of focal lengths within the given range of the lens. The many and varied focal length options have made zooms extremely popular and the ideal choice for the traveller. A standard outfit would typically include a 28mm wide-angle lens, a 50mm standard lens and a 135mm

telephoto lens. Use a 28-150mm zoom and you can carry one lens instead of three, and you have the added bonus of all the focal lengths in between. This allows various framing possibilities from a fixed position, including the ability to hold a moving subject in frame without having to move with it, so that it appears the same size. This is very useful for action and wildlife photography. Many zooms also have a 'macro' setting which allows close focussing.

Extreme focal lengths are now available including 28-300mm and 80-400mm. They're generally heavier, larger and have greater minimum focussing distances to the more moderate zooms. Two zooms, such as a 24-90mm and 70-210mm, will cover most subjects. If that's one lens too many, and the 28-200mm doesn't suit you either, a wide to medium zoom such as 35-105mm or 28-80mm is the best single lens option. Most new cameras are packaged with a zoom lens around these focal lengths.

The main drawback with zoom lenses is they're slower than comparable fixed focal lengths. This often results in unsharp pictures as a result of camera shake – especially at the telephoto end of the zoom range and when using the close-focussing feature (see the Camera Shake section in the Exposure chapter). Fast film can help solve this problem and is a good solution if you're taking colour prints. For colour slides you have to weigh up the advantages of fast film against the disadvantages of increased grain and loss of image quality (see Film Speed in the Film chapter). Consider complementing your zooms with a fast standard lens, such as a 50mm f1.4. This will increase your options in low light situations. More compact than a zoom, it's easier to slip into a bag for those times when you want to take your camera but are put off by its weight and bulk.

MACRO LENSES

If you have a special interest in photographing very small things, like insects or individual flowers, consider equipment made for macro photography: macro lenses, extension tubes or close-up filters. Macro lenses are described by the degree of magnification possible. A macro lens with 1x magnification is capable of 1:1 reproduction (ie, it reproduces objects life size). A lens capable of 0.5x magnification reproduces objects at half-life size. Macro lenses are available in various focal lengths including 50mm,

which can be used as a standard lens for 'normal' photography. Extension tubes go between the camera body and the prime lens, which determines the magnification. With a 35-80mm zoom, magnification of 0.3x to 0.5x is possible. The least expensive, but optically inferior, option is close-up filters, which screw on the front of a prime lens. Available individually, or as a set of three with magnifications of 0.1x, 0.2x and 0.4x, they can be used in any combination for a magnification up to 0.7x.

TELECONVERTERS

Teleconverters are optical accessories that fit between the camera body and the lens to increase the focal length of the lens. They're available to increase magnification by 1.4x or 2x. Used with a 200mm lens, a 1.4x teleconveter turns your lens into a 280mm, and a 2x converter increases its focal length to 400mm. Used with a 70-210mm zoom lens a 2x teleconverter will change the focal length to 140-420mm. They provide an ideal solution for people who need access to focal lengths in the super telephoto range for a one off event such as an African safari. Tele-converters will save you a lot of money, packing space and weight – but you can't have all that without giving something up. It's inadvisable to buy a cheap teleconverter because the inferior optics will have a noticeable effect on the sharpness of your pictures. And why put a cheap piece of glass between your good lens and the film?

As with zooms the main drawback, even with high quality teleconverters, is loss of lens speed, or light gathering power. With a 2x converter your 70-210mm f3.5/5.6 suddenly becomes a painfully slow f8/11. Fine in bright, sunny conditions but it won't take much variation in the brightness of the sun for you to be reaching for fast film or a tripod.

FILTERS

Filters are optical accessories that are attached to the front of the lens, either via a filter holder, or they're screwed directly onto the lens. Every lens has a filter size and it's ideal if your different lenses have the same filter size to reduce the number you need to carry. Filters are available for a wide range of technical and creative applications, but the filters discussed here are those favoured

Shop window, Penang, Malaysia

➤ Without a polarising filter this is an ineffective photo. The reflection from the window reduces colour and contrast.

✔ Add a polarising filter and there's still a little reflection, but it's been minimised and moved away from the main subject area.

by professional travel and landscape photographers. If you want to keep your gear simple, only two, the skylight and polariser, are really necessary for general travel photography using colour film.

If you do carry four or more filters, consider carrying them in a filter pouch. Although filters are neatly packaged in individual cases, a pouch is much more practical taking up less room and giving quicker access.

The use of filters should be handled carefully, they don't automatically improve pictures, and often they do the opposite. Good filtration should not be noticed. It's good practice not to stack, or to use more than one filter at a time – making the light pass through more layers of glass than necessary will result in loss of image quality. Also, when using wide-angle lenses stacking, screw-in filters may cause you to photograph the filter mount itself, which will show up in the photograph as a vignetting or darkening of the corners.

SKYLIGHT (1B) & ULTRAVIOLET (UV) FILTERS
Technically, skylight filters reduce the excessive bluishness that often occurs in colour photography outdoors, especially in open shade. UV filters absorb ultraviolet rays, which can contribute to hazy and indistinct outdoor photographs.

○ *A Skylight or UV filter should be on every lens you own.*

Use one not only for technical reasons, but to protect your lenses from dirt, dust, water and fingerprints. Lenses are expensive, filters aren't. It's much better to clean a dirty big fingerprint off a filter than off a lens.

POLARISING (PL) FILTERS
A polarising filter is an essential item in any camera bag. Polarisers eliminate unwanted reflections by cutting down the light reflected from the subject. This increases the colour saturation and the contrast in the picture, intensifying colours and increasing contrast between different elements. The level of polarisation is variable and is controlled by rotating the front of the filter and the position of the sun in relation to the camera lens. As you view your subject through the lens you can see exactly what effect the filter will have at different points in the rotation. A polariser has its most marked effect when the

sun is shining and is at ninety degrees off axis with the sun. It has its minimum effect when the sun is directly behind or in front the camera.

Although the effect produced by polarisers can be very seductive in the viewfinder, they shouldn't be treated as standard filters and left on lenses. They don't enhance every photo, but should be used as a creative tool. Additionally, they reduce the amount of light reaching the film by two stops. On lenses wider than 28mm it's important to note the position of the filter, particularly in clear areas of the picture such as the sky. If it's not positioned properly one part of the sky may appear darker than another, which translates to very unsatisfactory prints or slides. Also, when the contrast of a scene is already high, such as white snow against a deep blue sky, over-polarisation can result in the sky recording as an unnatural looking black.

There are two types of polarising filters, the standard PL and the circular polariser (PL-CIR). The PL-CIR is designed to avoid problems with TTL autofocussing. Check your camera manual, but if in doubt, use a circular polariser.

81 SERIES FILTERS

The 81A, 81B and 81C filters are amber coloured, light-balancing filters referred to as warming filters. Essentially strong skylight filters, they're commonly used to reduce the bluish cast from shadows under a clear sky, for portraits in open shade and in snow scenes. The 81C is the strongest of the three and is the one to carry as a good general warming filter. It reduces the light reaching the film by two thirds of a stop.

82 SERIES FILTERS

The 82A, 82B and 82C filters are blue coloured, light-balancing filters referred to as cooling filters. They reduce the warm tones of incandescent and early morning or late afternoon light to give a more natural look to interiors and portraits. The 82C is the strongest of the three. If you're going to take a lot of interiors using the available light (rather than flash) and don't like the yellow/orange cast, the mid-strength 82B is a good option. It reduces the light reaching the film by half a stop.

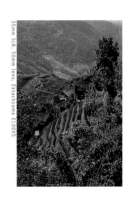

35mm SLR, 50mm lens, Ektachrome E100VS

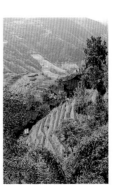

Longshen village, China

∧ In the middle of the day the leaves and village roofs reflects the bright sun-light and all colour is lost.

∨ A polarising filter cuts the glare from the reflective surfaces and intensifies the colours.

Half Dome detail, Yosemite National Park, USA
An 81C filter warmed up the colours of Half Dome's sheer rock wall rising above Mirror Lake. Until you're really sure what effect a filter will have, try shooting frames with and without so you can see the difference when you have the film developed.
< With 81C > Without 81C

GRADUATED FILTERS

Graduated filters are clear in one half and coloured in the other half. The density of the colour decreases towards the centre of the filter to prevent the boundary between the two halves showing up in your photograph. Available in many colours, they are special effect filters that have to be used very carefully or the result will be unnatural. For example, if you put a sunset coloured filter on to change the colour of the sky to orange, but the shadows in the picture are short, the use of the filter will be obvious and the effect amateurish.

The most useful graduated filter is the grey or neutral density (ND) filter. ND filters don't add colour to the image, but reduce the light reaching the film in half the scene. It's used by landscape photographers to even out exposure differences where the contrast between two areas of a scene is too high for the film to record detail in both areas (see the Exposures chapter).

When using graduated filters it's important not to stop down too much, especially with wide-angle lenses, as this can result in a sharp line across the picture. If your camera has a depth of field preview button use it to ensure the line isn't visible.

Graduated filters are much more useful and easier to control in the square, slip-in holder style than the screw-in style. It allows you to move the filter up and down for more accurate placement of the line between the coloured and clear areas.

TRIPODS

There's no question that a good tripod is an extremely important piece of equipment for the serious travel photographer. Whether or not you actually take one comes down to the kind of pictures you hope to take and if that overrides the hassle of packing and carrying the extra weight. You can take the majority of travel pictures without a tripod. During most of the day there's plenty of light and hand-holding the camera will present few problems. In low light conditions indoors or on city streets, switching to fast film will let you continue hand-holding the camera. But if you want to use fine grain films in low light indoors or out, maximise depth of field and use slow

shutter speeds for creative effects, a tripod is needed.

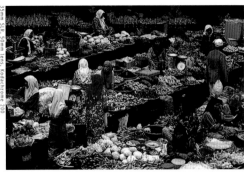

The most common travel subjects that call for a tripod are landscapes and cityscapes, which nearly always look best on fine grain film. Many of the most successful pictures of these subjects are taken early or late in the day when light levels are low and maximum depth of field is required to render the whole scene sharp. If you have a special interest in landscape photography you'll need a tripod. Look for a tripod that you're happy to carry – they're useless if you keep leaving them behind. Anything too flimsy will let you down by not keeping the camera steady. Check them out at full extension and with your camera and longest lens attached. Make sure you can splay the legs for ease of use on unlevel ground.

TRIPOD HEADS

Tripod heads attach to the camera base and allow movement of the camera in any direction. Buy a reasonably good tripod and you'll have a choice of heads. It's worth checking out the options to find one that you feel comfortable with. You'll have a choice between a ball head and a tilt/pan head. The ball head is ideal for travel photography because they're more streamline and easier to pack. Make sure that switching between horizontal and vertical positions is smooth, that it locks into position easily and is strong enough to support your biggest lens in both positions.

Another feature worth its weight in gold is the quick release plate. The release plate is attached to the base of the camera and this then slides into the tripod head and is locked in position. This saves a lot of time attaching and removing the camera from the tripod.

OTHER CAMERA SUPPORT OPTIONS

If you don't want to take even a small tripod there are several options worth considering. Table-top tripods support the camera around 15cm above the surface. These tiny tripods are suitable for compact cameras that have auto

The Central Market, Kota Bharu, Malaysia

⌄ Indoors at Kota Bharu's Central Market there seems to be plenty of daylight, but incandescent lighting is dominant. Daylight film records the scene with a yellow cast.

» With an 80B filter, the colour cast is reduced and colours appear more natural.

exposures running to several seconds and for small SLRs with wide-angle or standard lenses. They need to be used in conjunction with a wall or table … unless you want to take all your low light pictures lying on the ground looking up.

Monopods are a single leg camera support. They're well suited for street and action photography and are often used by sport photographers. They can provide support in crowded places where setting up a tripod would be impractical. The down side is that they're longer than many tripods preferred for travelling because they're made to extend to eye level.

Alternatively, you can improvise a camera support. Jackets or sleeping bags can be bundled up and the camera nestled into the folds. A pile of stones will do a similar job. These suggestions will work better using SLRs with zoom or telephoto lenses so that the front of the lens can be positioned clear of the support. When you've finished getting organised, just hope that the elements of the scene that attracted you haven't disappeared. You can also try bracing yourself against trees, buildings, fences or anything else that is solid and in the right place. It's worth practicing some hand-held low light photography, shooting at speeds of 1/15 of a second and slower to find out how steady your hand is and just how far you can push your luck (See Camera Shake in the Exposure chapter for more information.) These compromises may or may not work for you, but don't expect the consistent sharpness, speed and ease that the use of a tripod provides.

AUTOWINDERS

Most modern compact cameras and SLRs have built-in autowinders that advance the film automatically. If you own a SLR that doesn't have this feature check your camera manual to see if it's possible to attach an accessory autowinder. If you can it's well worth spending the money, especially if you're interested in photographing people, wildlife or action. You can shoot without having to remove your eye from the viewfinder between frames, which lets you keep your eye on the subject, maintain your composition and the camera shutter is always

cocked. The small price to pay for this convenience is a little extra weight and the need to carry a few more spare batteries.

HAND-HELD EXPOSURE METERS

Most modern cameras have built-in exposure meters that measure the amount of light reflected from the subject. You can do the same thing with an accessory light meter, which some photographers prefer to do, but for the traveller there isn't really much point carrying around the extra piece of equipment (see the Measuring Light section in the Exposure chapter later for more information).

FLASH UNITS

Available light is the primary source of illumination for travel photographs but it still pays to carry a compact flash unit (also called flashguns or speedlights). There will be times when it's inconvenient, impractical, prohibited or simply too dark (even for fast films) to set up a tripod.

All flash units have a guide number (GN) that indicates its power with 100 ISO film. Guide numbers range from 16m to 50m. The higher the guide number the more powerful (and expensive) the unit. The majority of new cameras have built-in flash units and these provide a convenient light source, ideal for candid photos such as in restaurants and at parties, but they have limited value for creative photography. (See Flashlight in the Light chapter for more information.) Remember to always work within the limitations of the flash. Most have a GN of 10-15 and illuminate subjects between 1m and 5m from the flash.

If you don't have a built-in flash or need more power, there are many accessory flash units to choose from that are either mounted onto the camera via a hot-shoe or are off-camera on a flash bracket, connected to the camera with a flash lead. Manual flash units are available, but far more popular are automatic and TTL (through the lens) units.

MANUAL FLASH UNITS

Manual flash units deliver a constant amount of light and require a simple calculation to determine the aperture setting to achieve correct exposure. The shutter speed is irrelevant (except for the synchronisation speed – see Flashlight in the Light chapter for more information) because the flash duration is very fast, typically 1/10,000 a second or faster. With 100 ISO film, divide the GN of the flash unit by the subject's distance from the camera. For example, if the GN is 32 and the subject is 8m away, then the aperture will be f4. The intensity of flashlight falls off rapidly as it travels away from the unit so the further away the subject is the wider the required aperture. Most manual flashes have a scale on the back of the unit that shows the aperture required based on the film's ISO rating and subject distance. This saves adjusting the GN if you're using a film other than 100 ISO.

AUTOMATIC FLASH UNITS

Automatic flash units, which can be used on any SLR, have sensors that read the amount of light reflected from the subject and quench the flash as soon as the correct amount of light has reached the subject. Most units offer a selection of f-stop settings and indicators that confirm correct exposure, or alert you to over- or under-exposure.

TTL FLASH UNITS

TTL flash is a more sophisticated form of automatic flash. The sensor that determines the exposure is in the camera body, not on the flash unit. This means that the light that actually exposes the film is measured automatically, taking into account the aperture setting and filters on the lens. Any aperture can be used (restricted only by the unit's capacity and the distance from the subject) and the need for film speed and aperture settings on the flash unit is eliminated.

The camera manufacturers all make dedicated flash units with TTL functions for use with their cameras, and sometimes only for a specific model. Independent flash manufacturers produce units that can be dedicated to most cameras via an adaptor. To simplify flash work, TTL

flash units are recommended (if your camera has TTL flash capabilities). Look for a unit with a manual mode that will let you experiment further with the possibilities of flash.

DIGITAL IMAGING

○ *The burgeoning world of digital imaging is beyond the scope of this book, but the primary issues are discussed here.*

DIGITAL CAMERAS & IMAGE STORAGE

Available in compact or SLR models, digital cameras store images on removable and reusable memory cards instead of film. The photograph can be viewed immediately via the camera's image display screen. This allows you to reshoot if you're not happy, and delete the inferior shot. When you run out of space on the camera memory card, the images you wish to keep can be transferred to a computer for storage, manipulation and printing. Images can then be transferred to another storage medium such as CD or ZIP, or you'll soon fill up your computers hard drive.

RESOLUTION

Cameras have CCD (charge coupled device) chips or sensors, which along with the lens and built-in software, determine the resolution or image quality, which is seen in the detail and sharpness of the image. Resolution is measured in pixels. The more pixels, the higher the resolution. The camera's total pixel count is described in megapixels. The higher the resolution or megapixel, the higher the price of the camera. The megapixel is usually displayed on the camera body (eg, 2.3, 2.1 or 1.5 megapixel).

Cameras with three megapixel CCD sensors deliver photo quality prints up to 8x10 inches and cost from US$765 to US$1175. Cameras with 1.5 megapixel CCD sensors will deliver photo quality prints up to 4x6 inches and cost from US$530 to US$880. A high-resolution image requires 1MB (megabyte) but five low-resolution images can be stored on 1MB. Most cameras come with 4 or 8MB cards, which offer limited storage, but keep the price

down. Additional cards with different storage capacity are available in 4, 8, 10, 15, 20, 24, 32, 48, 64 and 96MB. Cameras in the US$235-$295 price range offer low resolution and should only be considered for electronic use such as Web pages or electronic postcards.

ADVANTAGES
· Ideal for Web use.

· Images can be downloaded straight into a computer without scanning.

· Images can be manipulated.

· No film and processing costs.

· Print the best pictures only, rather than paying for the whole roll to be printed.

· View the image immediately and delete on the spot and reshoot if you're unhappy with the result.

DISADVANTAGES
· Data storage is expensive. Memory cards cost around US$120 for 32MB and US$645 for 96MB.

· Expensive to print out images.

· For the traveller, regular access to a computer is required to transfer the images off the camera's memory card to make room for the next set of pictures or enough memory cards have to be carried for the entire trip.

· High prices. A camera with features equivalent to a 35mm compact costs over US$590.

· High-resolution images require large amounts of digital storage space. Costs will be incurred for storage devices to free up computer hard drive. Need minimum 64MB RAM in computer for efficient speed.

· Limited range of models and lenses.

At this point digital cameras are not suited to the needs of most travellers. Film is much more versatile, sharper and offers better colour and contrast for considerably less money. As with all other equipment, ask yourself why you're taking the pictures and what you intend to do with them. If you want to put prints in an album, make enlargements or give slide shows, go with film because it delivers the best results at lower cost. If you want pictures for emails, Web use or business presentations you'll appreciate the speed and convenience of digital capture. The best option for those who need digital images but don't require them instantly, is to use film to take the photograph and then scan it for digital use. This gives you the best of both worlds.

The old adage of 'you get what you pay for', can certainly be applied to camera equipment. Higher prices usually mean more features, better quality components and optics, and better construction. Shop around because retail prices can vary considerably, especially when a model is about to be superseded. Always check the warranty. This is particularly important if buying outside your own country or if you're going on a long trip and may require repairs while travelling. If you do buy camera equipment overseas, leave yourself time to put a roll of film through to check everything is working (and to sort the problem out if there is one).

BASIC COMPACT CAMERAS

The 35mm compact range starts with simple point-and-shoot cameras with a fixed wide-angle lens. The flash fires when the light is low, and can't be turned off. The auto focus has one sensor in the middle of the frame. Prices range from US$45 to US$95. Not recommended for anyone interested in taking good pictures. Spend a little more money and you can add a zoom lens or features that allow some flash and exposure control. It's not until you move into the advanced compact bracket that you get all the features in one camera.

ADVANCED COMPACT CAMERAS

More highly recommended is the next level of compacts, available in APS (Advanced Photo System) and 35mm formats. In automatic mode they are point-and-shoot cameras, but have a number of features that give some control over composition and exposure. Cameras in this category range in price from US$200 to US$300 and should feature:

· moderate zoom lens around 38mm-90mm

· built-in flash with optional settings for red-eye control, fill-flash, night flash and flash off

· focus and exposure lock for accurate focussing and exposure of the main subject

· mid-roll rewind

· multi-point auto focus sensors to handle off-centre subjects

· self-timer

35MM SLR CAMERAS & LENSES

So, you want to buy a new SLR? Is that with 10 segment 3D matrix metering, 14 segment honeycomb pattern metering or

○ The prices given in this book are particularly vulnerable to change and intended as a guide only. Special deals come and go and you should get opinions, quotes and advice from a number of places before you part with your hard-earned cash. The prices given should be regarded as pointers and are not a substitute for your own careful, up-to-date research.

six segment multi-pattern metering? Or maybe you'd prefer a 35-zone evaluative system? And, what about the Vari-Brite focus area display, on-demand grid lines, predictive auto focus and eye controlled focus? Buying a new SLR could easily be an unnerving experience. A glance at the glossy brochures will reveal so many choices you may want to run back to the old camera you're trading in or stick to the compact you've had for years. However, with a bit of research and the help of a good salesperson you'll have no trouble finding the perfect camera for you.

Apart from the features, compare the weight, size and feel of the camera. If it's too heavy you may be inclined to leave it in the hotel room. Don't compromise lens quality for camera features. The lens determines image sharpness, contrast and colour rendition. Buy the fastest lens you can afford for superior optics, strong construction and maximum flexibility in low light situations. Many cameras are sold as a package with a zoom lens at the bottom end of the quality scale to keep the price down. Inquire about what other options are available.

SUGGESTED SLR SYSTEMS

Outlined below are four suggested camera outfits for general travel photography. The camera body should come from the mid-range aimed at camera enthusiasts, and retail between US$550 and US$950 with a zoom lens made by the camera manufacturer. These cameras are one step down from semi-professional equipment and one step up from the entry-level cameras. In this price range cameras have a host of features, they are well built and should withstand the rigours of travel and perform reliably in most conditions. Look for a camera whose features include; multi-zone auto-focus, multiple exposure modes, spot metering, built-in flash, automatic film advance and rewind, mid-roll rewind and depth of field preview button. Confirm that all automatic features can be overridden with manual settings. The suggested systems should all fit into a compact camera bag (except the tripod) when the equipment is removed from its individual cases, along with 20 rolls of film. There are numerous other camera lens combinations, so use this as a place to start as you consider your own budget, needs and photographic goals.

BASIC SYSTEM

The minimum SLR outfit for those who want more than a compact can offer, but with minimum weight and bulk.

· 35mm SLR camera body
· 35-80mm f4-5.6 or 28-105mm zoom lens f4-5.6
· polarising filter

STANDARD SYSTEM

A popular system with many travellers. This is the recommended minimum outfit for covering most situations.

· 35mm SLR camera body
· 28-80mm f3.5-5.6 zoom lens
· 70-210mm f4-5.6 or 70-300mm f4-5.6 zoom lens (if wildlife is a priority subject)
· polarising filter for both lenses

STANDARD PLUS SYSTEM

The addition of a fast standard lens and tripod create flexibility in low light and greater control over depth of field.

· 35mm SLR camera body
· 28-80mm f3.5-5.6 zoom lens
· 70-210mm f4-5.6 or 70-300mm f4-5.6 zoom lens (if wildlife is a priority subject)
· fast standard lens 50mm f1.4
· polarising filter for all lenses
· compact tripod

ADVANCED SYSTEM

A versatile outfit for the traveller who places a high priority on picture taking and is not concerned with the weight and bulk of the camera bag. The extra body is a great backup but also increases speed and flexibility while shooting. The fast lenses and tripod will increase picture opportunities and give greater control over depth of field in the majority of low light situations. The bounce flash kit provides natural looking flash pictures.

· two 35mm SLR camera bodies
· 28-80mm f3.5-5.6 zoom lens
· 70-210mm f4-5.6 or 70-300mm f4-5.6 zoom lens (if wildlife is a priority)
· fast standard lens 50mm f1.4
· fast wide-angle lens 24mm f2
· polarising filter for all lenses
· compact tripod
· compact dedicated flash with tilt head
· bounce flash reflector kit

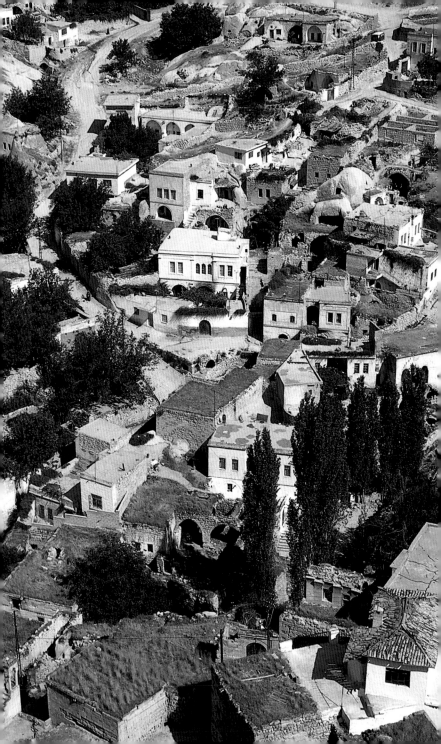

ACCESSORIES

Once you've got your equipment organised, you'll need a convenient and practical way of carrying it. Then, when you've got your camera bag, there are a few other bits and pieces worth throwing in.

CARRYING EQUIPMENT

If you've got anything more than a simple SLR outfit, the choice of carrying equipment is very important for comfort, security and ease of access.

BAGS

Lots of bags look good but are not necessarily functional or comfortable. The main styles available are:

Day-pack/backpack-style bags Ideal for carrying lots of equipment, but access is slow because they have to be removed from your back. Popular for trekking.

Hard-sided cases These offer the greatest protection for equipment, but are very uncomfortable to carry around. Access is slow and all your gear is displayed when you open them up. Ideal if you're carrying a lot of equipment and need to check it in on planes (but carry a soft bag for use at your destination).

« View over Ortakisar, Turkey

Soft shoulder bags Quick access and generally comfortable to carry. They conform to the body and they adapt easily as the gear in the bag changes. However, they offer the least amount of protection from knocks.

When buying a bag take all the equipment you intend carrying on your travels to the shop and try out the options. Aim to fit all your gear and film into one bag, but ensure that it's easily accessible. It can then be carried onto planes as hand luggage, and you only have one bag to worry about. Try not to select a bag that looks so good it's worth stealing. Look for bags with wide straps and accessory shoulder pads – they make carrying a weighty bag much more comfortable.

It's important to have a trial run with your bag of choice loaded up with everything you intend to take. Don't just wander around the lounge room for five minutes. Carry it and use the equipment to see how comfortable and easy it is.

Many travellers prefer to carry their camera and lenses in their regular day-pack. Unless you're prepared to carry your camera on your shoulder whenever you're out, having to remove the camera from the day-pack every time you want to take a photo is slow and inefficient.

POUCHES

If you only have one camera and a zoom lens, consider carrying it in a pouch worn on a belt. Pouches provide quick access and take the place of the camera maker's case. Film, and other items less regularly used, can then be carried in a day-pack.

JACKETS & VESTS

Photographer's jackets and vests have numerous pockets, which distribute the weight of the gear evenly over the shoulders. Quick access is assured ... that is, if you can remember in which of the 400 pockets you have put what you need. They're useful in crowded situations and permit greater agility in more adventurous environments than a bag swinging from the shoulder.

STRAPS

Cameras straps should be wide. Those provided by the camera makers are not always comfortable, especially for cameras with heavy telephoto and long zoom lenses.

CLEANING KIT

Lens tissues and a blower brush are sufficient for most cleaning requirements. For really stubborn marks on lenses,

a lens cleaning fluid may be required. Generally though, it's not worth carrying on the road.

BATTERIES

O *Always carry spare batteries for each piece of equipment.*

This is important the farther off the beaten track you go, especially if your camera uses lithium batteries (they last longer but are not readily available in smaller places). The most common reason a camera stops working is that the batteries fail. Often it's because the battery is getting old and a build up of dirt is interrupting the flow of energy. If you don't have spares, remove the batteries, wipe the battery ends and the contacts in the camera and try them again.

CABLE RELEASES

A cable release is an accessory that lets you fire the shutter without physically touching the camera, reducing the risk of camera shake. If you have your camera on a tripod (or a pile of stones) you should use a cable release. If you don't have one, or your camera doesn't accept one, use the self-timer. By giving the camera 8-10 seconds to steady itself after the shutter release is pressed, sharper pictures will result. Don't forget though, in 8-10 seconds you could have recomposed a different shot by changing lenses, zooming in or out, changing orientation from horizontal to vertical or, worse still, the sun could have dipped below the horizon or the mountain could be engulfed by cloud.

LENS HOODS & EYE-CUPS

Lens hoods are essential and should be fitted to every lens if they're not built in. Their function is to prevent stray light entering the lens, which can cause flare, reduce sharpness and affect exposure settings.

If your camera doesn't have a built in eye-cup around the eye-piece, buy one as an accessory. It prevents light entering the eye-piece so that the viewfinder remains at its optimum brightness for accurate focussing.

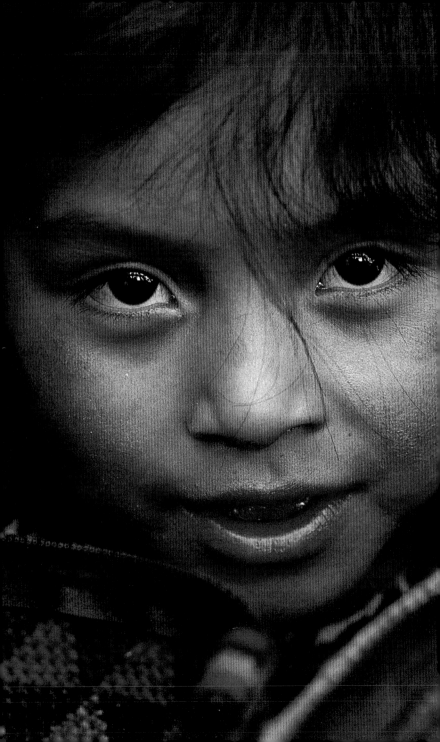

FILM

○ *Choice of film is an important creative decision and should not be left to the last minute.*

The choice you make will have a dramatic impact on how your images look. It will determine the kinds of pictures you can take successfully, when and where you can take them, and what other equipment you may need, such as flashguns and tripods.

Kodak, Fujifilm and Agfa all make excellent films and professional photographers will argue tirelessly for the films they think are best. In some cases one film might be more suited to a particular application or subject than another. Fujichrome Velvia is regarded as an excellent film for landscapes and Kodak Portra is made specifically to accurately reproduce skin tones. Additionally, film is manufactured with a particular colour balance. The majority of films are balanced for daylight and electronic flashlight. When daylight film is used in situations where incandescent light is the dominant light source the print or slide will have a yellowish or warm cast. This can be

《 Girl from Chichicastenango, Guatemala

overcome with flash, filtration or by using a film balanced for tungsten lighting.

For the traveller, it's impractical to carry different films to cover the range of subjects and lighting conditions you'll want to record. Try a few different films to see for yourself how they react to different subject matter and under different lighting conditions and settle on the one film that gives you the most pleasing results.

PRINTS OR SLIDES?

The first decision to make is whether to use prints or slides, colour or black and white (B&W). It's obviously a personal choice and depends a lot on what you want to do with your pictures and how you want to show them when you get home. Unless you have two cameras shooting two types of film at once, such as colour prints and slides, it won't be easy, and will lead to a lack of continuity in your final presentation. Even with two cameras why take everything twice even if you could? You can always make prints (colour and B&W) from slides or slides from negatives.

Be clear about your main priority for taking pictures and film choice will be easier. If you're simply recording your trip for yourself, then colour negative film, from which colour prints are made, is the most suitable choice. If you intend to submit your work to a photo library then colour slide film is the way to go.

COLOUR PRINTS

Colour prints, displayed in an album, are easy to show others and, because they are so accessible, they get looked at a lot more often than slides after the initial burst of interest wears off. Reprints, to send to people you've photographed and travelled with, and enlargements of your favourite photos, are inexpensive. Minilabs now exist in most cities and towns allowing you to develop and print film quickly and cheaply. You can enjoy your photos and get feedback immediately, and learn from your successes and failures as you travel.

On the technical side, exposing negative film is much easier than slide film, as it has wide exposure latitude and exposure mistakes can often be corrected in the printing

If you're using a fully automatic compact point-and-shoot camera, colour negative film is clearly the best choice.

The main disadvantage of colour negative film is that the amount of control you have over the finished print is limited. Unless you go to the extra expense of using a professional lab to print to your directions or you print your own negatives, you may be disappointed that the intensity of colour you remembered photographing is missing. Minilabs generally print everything as close to average as possible, so most prints have a sameness about them.

B&W PRINTS

The emphasis in this book is on the use of colour films, but B&W films are still widely available and popular. Processing B&W is not as convenient as colour negative films (few minilabs offer a B&W service, instead sending it off to a professional laboratory). The convenience of minilab processing is available if you use one of the B&W chromogenic films that can be developed and printed with the same chemicals and paper used for colour negative films. The prints often have a colour cast, which will often result in them looking slightly blue or sepia brown. Good B&W prints are possible off chromogenic negatives when they're printed onto B&W paper.

COLOUR TRANSPARENCIES

A colour transparency, or slide (also called trannie and chrome), when properly exposed and projected onto a white screen in a very dark room, is the closest you can get to reliving the depth of colour and range of tones that you saw when you took the photo. Most professional travel photographers shoot transparency film because it allows total flexibility in end use, and it's also the standard requirement of most publishers and photo libraries. Also, and most importantly, the final look of the image is determined by the type of film used and through exposure choices made by the photographer. The slide is a final product and therefore an expression of the photographer's vision and intentions. It doesn't need to be interpreted by a printer, as a negative does, before it can be viewed.

It's important to understand that different films record colour differently, and that this characteristic is especially relevant to colour transparency film. The variations between films can be quite dramatic and aren't just apparent

Buddhas at Wat Mahathat, Bangkok, Thailand
Same subjects, same light: different film, different colour. Colour films reproduce colours differently. Try various films to find the one that gives you the most pleasing results.

∧ Ektachrome E100SW
∨ Ektachrome E200

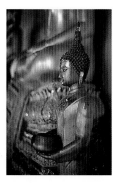

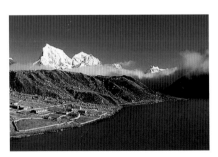

> Ektachrome 50STX

< Kodachrome 64

from one manufacturer to another. A particular Kodak 100 ISO colour slide film will not only record colours quite differently from a Fujifilm or Agfa 100 ISO film, but differently from another Kodak 100 ISO film.

When you choose one slide film over another you're actually making a creative decision that can greatly affect how your pictures look. The film type determines the way colour is recorded and the film speed (see later) determines the overall quality and sharpness of the image.

Colour prints can be made from slides, but are more expensive than prints from negatives, and as contrast is increased in the process they're often disappointing and look too dark. Good quality prints from slides can be made at a considerable increase in cost by a professional laboratory, but are well worth it if you intend to display a framed print of your favourite photograph.

Transparency film is not recommended for travellers using automatic point-and-shoot cameras. To ensure consistent results a SLR with a reasonably sophisticated built-in exposure meter is required.

Colour slides need to be projected if you wish family and friends to see them, and that requires extra equipment and preparation. Not to mention the fear you'll put into your friends when they're invited over to see the slides of your latest trip (but more on getting over that later). However, nothing beats a projected slide for brilliance and colour.

PROFESSIONAL OR AMATEUR FILM?

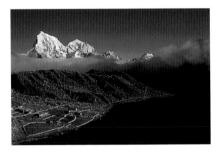

Most amateur (or consumer) colour slide and negative films, have a professional equivalent (identifiable in most retailers as it's stored in refrigerators), but both have the same chief characteristics of colour, sharpness and grain.

All colour films have emulsions made from chemical compounds that change slowly over time, which results

in a process known as ageing, where the colour balance and speed of the film changes. The film manufacturers allow for this based on the way film is used by the two customer groups. It's expected that there will be quite a delay between manufacture and processing of consumer film, as it sits first on the retailer's shelf and then for some weeks or months in the customer's camera. During this time the film ages so that it's close to its optimum during the period of its expected use.

Professional films are aged by the manufacturer and then kept in refrigerated storage so that they're released and used much closer to their intended optimum colour balance and speed. This is important for some professional applications where consistency from roll to roll is required. Many professionals buy large quantities at once to ensure this consistency, saving time and money.

For the traveller, amateur films have many advantages. It's impossible to keep film refrigerated on the road so the batch consistency of professional film can't be guaranteed, especially on a long trip and, perhaps more importantly, amateur film is considerably cheaper. Processing costs are the same for professional and amateur film.

As with choice of film, it's well worth trying and comparing a couple of different amateur and professional films to establish which will meet your needs best.

FILM SPEED

All film has an International Standards Organisation (ISO) rating that designates the speed of the film. Film is light sensitive and the more sensitive it is to light the higher the film speed or ISO.

Film speed is recorded numerically. For example, there are 64 ISO, 100 ISO and 400 ISO films. Doubling of the number shows the doubling of film speed, 100 ISO film is twice as fast and twice as sensitive to light as 50 ISO. The 50 ISO film requires twice as much light to achieve the same exposure as the 100 ISO film.

Forest Detail, Inca Trail, Peru
❯ Kodachrome 25 ISO
❮ Fujichrome 1600 ISO

Same subject, same light: different grain, different quality. The 25 ISO film displays very fine grain (hardly noticeable), has captured the subject's intricate detail and is extremely sharp. The 1600 ISO film is clearly grainy, lacks detail, is less sharp and has more contrast.

Film is also classified more informally into slow, medium and fast. Slow films have ratings of 25 or 50 ISO. Medium (or standard) speed films are rated at 64, 100, 160 and 200 ISO, and fast films include 400, 800, 1000, 1600 and 3200 ISO films.

Film speed is also a good indication of the potential overall image quality that can be expected. Slow films have a finer grain than fast films and result in much sharper images with excellent detail and colour rendition. This is particularly noticeable when making prints larger than 8x10 inches. As the image is enlarged the grain is magnified and, unless the effect has been sought for artistic reasons, the print will acquire an unsatisfactory soft, textured effect.

WHAT FILM SPEED?

The choice of film speed comes down to the conditions you expect to be shooting in, personal preference and the expected or desired end use of your photographs.

If you use a compact point-and-shoot camera for colour prints, 400 ISO film is ideal. The extra sensitivity to light over the slower films means that you can hand-hold your camera in most situations and that the effective range of the built-in flash is extended.

If you use a SLR and are interested in getting the most out of your equipment and film and intend enlarging your favourite pictures, select 100 ISO as your standard film speed. Carry a few rolls of 400 ISO film for low light situations.

For general travel photography with a SLR camera 100 ISO film is the ideal choice. It's suitable for the majority of picture taking situations. However, different situations call for different speed films. If you have a special interest in landscape photography and will be carrying a tripod, then a very fine grain 50 ISO would be best. If your interest is in photographing sport or theatre, you'll need greater quantities of faster film. Carry a few rolls of 400 for low light situations or explore the possibilities of 'push processing'.

PUSHING & PULLING FILM

Pushing and pulling film is a technique that allows you to vary the ISO of colour slide and B&W film, at the time

‹ *Interior roof detail, Santo Domingo Church, Oaxaca, Mexico*
When you're allowed to take photos but prohibited from using flash or a tripod, fast film allows hand-held photography in very dimly lit places.

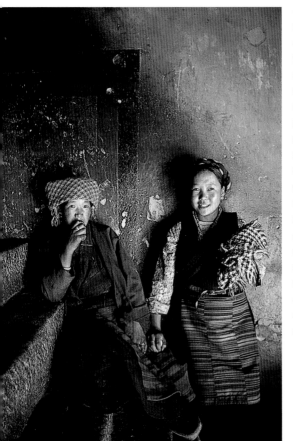

‹ *Tibetan girls on stairs, Sera Monastery, Lhasa, Tibet, China*
There wasn't much room to move on the steps leading up to the second floor of the Sera Monastery, and these girls were standing back to let others pass. The low light level meant that with my standard film an exposure of a 1/15 second would be required, which would almost guarantee an unsuccessful picture due to camera shake and subject movement. By using fast film, I was able use the available light and retain the atmosphere of the location while hand-holding the camera.

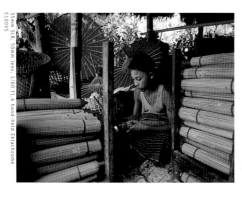

> Umbrella workshop, Pathein, Myanmar
Working in a covered but open-sided building, this young boy was facing the light. There was enough light to use my standard 100 ISO film with my fastest lens – always my first choice.

of exposure, for practical and creative reasons.

The most common technique is to 'push' film one or two stops by exposing it at a higher ISO setting than its actual film speed. (Eg, with 100 ISO film in the camera, set the ISO on 200 for a 'one-stop push' or on 400 for a 'two-stop push'.) The camera meter is tricked into thinking that you're using faster film so that less light is required for correct exposure. The entire roll must be exposed at the new setting and the film lab must be informed so that the developing time is extended. If you don't inform the lab you'll end up with transparencies that are underexposed, or too dark. If you 'push' your standard films carry stickers or devise a foolproof method of identifying the film.

Pushing film creates opportunities to take pictures in low levels of available light, instead of resorting to flash, using a tripod or having to hand-hold your camera at shutter speeds that risk camera shake (see Camera Shake in the Exposure chapter).

It also allows you to carry only one film stock and push the film as necessary in low light situations, rather than having to estimate in advance how much fast film you should carry on a trip.

Be aware that when film is pushed, contrast and grain are both increased, which is why pushing film is not recommended in good lighting conditions. It's an ideal technique when working indoors and in low light. The increase in grain often adds to the mood of the shot.

'Pulling film', rating film below its actual ISO, isn't a technique commonly used, but can be useful if film is accidentally exposed incorrectly. If you change from 400 ISO film to 100 ISO film but forget to change the setting on your camera, your pictures will be overexposed. Inform the lab and they'll compensate for the error in the processing.

Rating film incorrectly has become less of a problem since DX coding, which reads the speed of the film and sets it automatically when it's loaded into the camera. DX coding has become a regular feature on modern cameras.

REMOVING FILM MID-ROLL

35mm SLR, 24mm, 1/30 lens at f2 hand-held on Kodak E200 rated at 800 ISO (a two stop push)

There are several reasons to take film out of the camera before it's finished. You may want to change from a slow to fast film, 'push' one of your standard films, switch from colour to B&W, or remove the film before the security check at the airport. If your camera rewinds the film automatically check that it has a mid-roll rewind facility that doesn't wind the film all the way back into the cassette. If it does it's a simple job for a camera technician to adjust the auto rewind to leave the leader out.

TO REWIND A PARTIALLY USED FILM:
· Note the frame number of the last photo taken.

· Rewind the film until you feel and hear it come loose from the take-up spool.

· Write the frame number on the leader.

· Crease the last centimetre of the film leader to guard against loading the film accidentally.

TO RELOAD THE FILM:
· Note the frame number of the last photo taken.

· Set the highest shutter speed on the camera.

· Stop the aperture right down.

· Put the lens cap on or place the lens against a dark object such as a camera bag.

· Advance the film to the last frame used plus one.

X-RAYS

O *Ideally, film should not be x-rayed and should never be packed in your check-in luggage.*

Unprocessed film is light and heat sensitive and exposure to x-ray can fog the film. The amount of damage results from a combination of the ISO rating, the strength of the x-ray and the number of times the film is scanned. The good news is that Kodak have done extensive tests and found that slow and medium speed films can handle up to 16 passes through the x-ray machines used to check hand luggage at western airports. The more light sensitive,

➤ Umbrella workshop, Pathein, Myanmar
The workshop owner was working in a dimly lit area, which required an 1/8 second exposure with the 100 ISO film. Flash would have eliminated the ambience of the location and although a tripod could have been used, I find it limits the spontaneity possible when working with people. Switching to my camera body loaded with 200 ISO film, but rated at 800 ISO, I was able to hand-hold the camera and move around my subject as he worked. Workshops like this one are often dark, but in low light situations the grain of the film enhances mood and sense of place.

faster films, from 400 ISO, are much more susceptible to x-ray damage. Try and limit their exposure to four or five passes.

Be aware that in many developing countries airports are still using old technology and the dose of the x-ray may be set at higher than acceptable levels. The danger for medium and slow ISO films is the cumulative effect of x-ray. One or two passes through the scanner may not matter, but five or six may take the levels over the acceptable threshold and fog the film. It's very easy to clock up half a dozen security checks even on a short trip.

○ *Never pack film in your check-in luggage.*

High dose CT (computerised tomography) scanners are now widely used for check-in luggage at airports around the world and have been proven to fog film with just one pass. Carry all unprocessed film in your hand luggage. If your travels will take you through many security checks, or you're confronted with a machine that you're not confident is 'film safe', ask for a hand inspection.

Hand inspections are not usually a problem, but there are ways of making the request less painful for the security staff. Take all film out of the boxes and plastic containers and carry it in a clear plastic bag or box (I use tupperware containers, Tony Wheeler uses a Chinese takeaway container). Before you get to the security check remove your film and put your camera bag through the machine, making sure there's no film in your cameras. This indicates that you're doing your best to comply with security requirements and packaging of the film in clear containers makes the security staff's job easier. It's also worth getting to the security check with plenty of time to spare so you have time to wait if the security staff claim to be too busy to hand-check bags. Remember they're only doing their job, and after all it's for your protection, so be patient and courteous.

Lead lined bags may give you some peace of mind if a hand-check is refused. The lead lining stops the x-ray penetrating the bag but may cause the inspector to increase the dosage. If you're lucky, the presence of a solid black package in your bag will simply lead to a hand-check after the x-ray.

○ *The cost of film adds up when you use lots of it, but it's better to take too much than too little.*

Run out of film and you'll never forgive yourself. Compared with the other costs of travel, film and processing is relatively cheap, especially given the years of pleasure you'll get from the photographic memories. It's best to take as much as you can with you, especially if travelling to out-of-the-way places. Even if the more remote locations have the exact film you want, when you want it, it may not be fresh or it may not have been handled properly, and it will often be very expensive. Excess film can always be used when you get home, stored in the freezer for your next trip, or sold to a fellow traveller that miscalculated their requirements.

It's almost impossible to recommend how much film to take. You'll need more if you're rushing around from sight to sight than if you intend to sit on the same beach for days. A quick survey of regular travellers suggests that two to three rolls of 36 exposures a week is adequate to record a trip, but five to six rolls a week would suit someone with a keen interest in photography. I budget for 10 rolls a day on an assignment and two rolls a day on a family holiday.

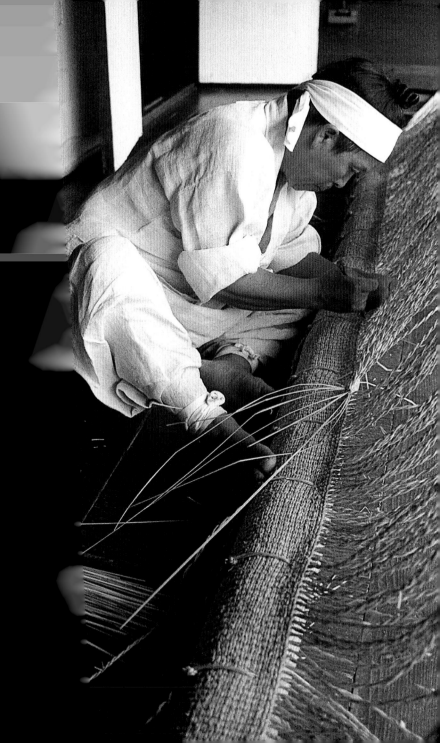

PREPARATION

If taking photos is an important part of your trip, it's worth planning your travels with your photographic goals in mind. Simply shooting as you go along will rarely provide enough opportunities to be in the right place at the right time. You should be familiar with your equipment and film and be prepared for the conditions you expect to take photos in.

Often, even with thorough research, this can mean having to stand around in one spot for ages, or going away and returning. As most people travel with friends or partners, the priority given to photography often has to be compromised.

RESEARCH

Most people do lots of research before travelling. Complement the obvious questions like how to get there, where to stay and what to see, with research into photo-friendly subjects, such as market days and festivals. Then add images from brochures, magazines and books and you'll be in a much better position to determine the order of your itinerary and how long you may need in each place to achieve

« *Craftsman working with rushmat, Suwon, South Korea*

your photographic ambitions. One day at the Pushkar Camel Fair in Rajasthan may be enough for the sightseer, but someone keen to take photographs could happily spend three days wandering around.

If you know people who have been to the same place, ask them what they did and look at their photos. This research will help you discover a great deal about your destination.

TIME

Allowing more time in any place to see the main sights has great benefits for photography. Sometimes just a few extra minutes can make all the difference. The sun may come out or go in, the right person may stop and stand in just the right place, the council's rubbish collection truck that's parked in front of the city's most beautiful building may move on, the person buying the fruit may hand over their money. If you have days rather than minutes you can look for new angles and viewpoints of well-known subjects; visit places at different times of the day; wait for the best light; and get better coverage.

EQUIPMENT

Don't travel with equipment you've never used before. Organise it in plenty of time and use it for a while before you set off. If you don't have time to become familiar and confident with the gear, at least take the camera manual with you.

O *Check and clean gear at least six weeks before you travel.*

This allows plenty of time to have cameras serviced and repaired if necessary, or to buy new equipment. A basic check and clean for a SLR is quick and easy.

· Remove the lens and set the shutter speed on the 'B' setting.

· Hold the camera up against a plain light background.

· Release the shutter and keep you finger down so that the shutter stays open. You can now look right through the camera.

· Look for hairs intruding into the open shutter area, which leave an annoying black mark on every photo.

· Release the shutter.

· Hold the camera upside down and use a blower brush to clean dust off the mirror (don't touch the mirror with anything else) and out of the film cassette space and the take up spool (wind the film lever on a couple of times while you're doing this).

- Gently clean the pressure plate on the back of the camera. Be very careful when cleaning near the shutter curtain and ensure that hair from the blower brush doesn't get left in the camera.
- Put a lens on, and with the camera in manual mode, select the one-second shutter speed and the smallest aperture on the lens.
- Still with the back open, release the shutter. You will now see the shutter open and the aperture stop down. Repeat this at various shutter speed and aperture combinations with each lens.
- Clean all lenses and filters, preferably with a blower brush. If there's dirt or fingerprints that won't blow off, breathe on the lens or filter and then wipe the lens gently in a circular motion with lens tissue. If the marks are really stubborn you'll need lens-cleaning fluid. By always having skylight filters on your lenses you should rarely have to touch the lens.
- Blow dust off the rear lens element.
- Use lens tissue to clean the eye-piece.
- Check that all the screws on the camera and lenses are tight.

To then confirm that everything is OK put a roll of film through the camera. Take shots at various combinations of shutter speeds and apertures. Test the self-timer, flash and use any other accessories you intend to take. Keep details of the shots so that if there's a problem you can easily identify which piece of equipment needs attention. This is also good practice immediately after your gear is serviced or repaired.

A compact camera or a second SLR camera body is great insurance against loss, damage and breakdown. A very basic model will do, but it must accept your system's lenses. Don't forget: it's no use having a second SLR body in your pack if all your lenses are stolen.

INSURANCE

Travel insurance is essential. Find a policy that includes coverage of your camera gear. If you're carrying anything more than a standard outfit it may be necessary to insure it separately with a specialist insurer. You'll need to list all the equipment with serial numbers and value. Carry two copies of this list on your travels. Keep one with your money and the other in your main bag. It will be very handy if your gear is stolen and you have to fill in a police report.

If you buy equipment on the road, make sure that your travel policy covers it. It's worth copying the receipts and sending one set home to prove ownership if everything is lost or stolen. If you have a dedicated policy make sure the new purchase is added immediately.

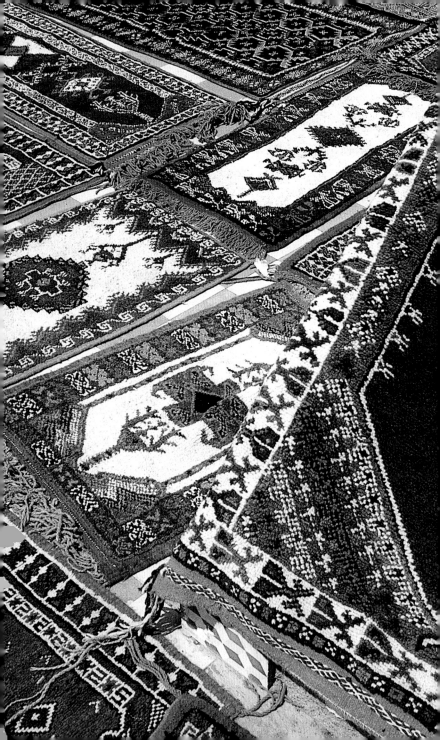

TRIP NOTES

When you finally hit the road and start taking pictures, new issues and challenges arise. If you've never been to the place before, study your guidebook maps to get a feel for where things are, the direction of the light in relation to the main sights, and the best ways to get around. If you're travelling with others you'll need to find ways to accommodate their needs with your photographic ambitions. When you're out and about there are ways of making every opportunity count. Security and camera care also need to be considered.

AT CUSTOMS

Unless you have an unusual amount of equipment and film you should have no trouble clearing customs at your destination. Don't panic if you read that you're only allowed to take in 12 rolls of film, you'll rarely be questioned. If you are, three things can help: say you're carrying the film for a group (the size of which can vary depending on how many films you have); tell them 'No

« *Carpets for sale, Marrakesh, Morocco*

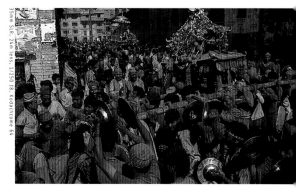

> New Year Festival, Thimi, Kathmandu Valley, Nepal
Thimi is a small town only 15 minutes by car from Kathmandu, but no-one I spoke to knew anything about the Thimi New Year celebrations. I went anyway. In the centre of Thimi I was again told there was nothing happening. So I set off for the main temple and within a hundred metres came upon the festival in full swing.

35mm SLR, 24m lens, 1/250 f8, Kodachrome 64

video' (unless you have a video camera), customs officer are much more interested in video cameras than still camera equipment; finally, explain that you have so much film and camera gear because their country is so beautiful

AT YOUR DESTINATION

When you arrive at a new destination it's highly recom mend you rush out and blaze away at everyone and every thing that moves ... while being culturally sensitive, o course. Once you've got over the initial rush of excite ment, consider the following:

· Go walking, the faster you get a feel for the place the better.

· Confirm the dates and times of events that your pre-trip research uncovered.

· Confirm opening hours of places of interest.

· Ask if anything interesting is happening in the area. There are far too many local festivals and events for guidebooks to list. Don't assume that people will spontaneously inform you of what's happening.

· If you know something is on, don't be put off by the fact that the tourist office may have no idea what you're talking about. Some loca festivals are so local half the locals don't even know they're on.

· Ask the same questions of a variety of local people, not just the tourist office. The people at your hotel, taxi drivers, waiters, in fact anyone who speaks your language (if you don't speak theirs) car often give you new and useful information.

· Check out postcards, tourist publications, local magazines and books – they provide a good overview of the places of interest, as well as a guide to potential vantage points.

· Speak to other travellers and find out what they've seen and learnt.

· Make sure you're aware of any cultural restrictions or local sensitiv ities on photography. Borders are often sensitive areas, as are air ports, bridges and anything that resembles a military checkpoint o installation.

If the weather is fine on the morning you arrive it's very easy to assume that it will still be fine in the afternoon. This is a big mistake. If you're clear about your priorities, start at the top of the list if conditions are good. If you arrive in unfavourable conditions you can start with lesser priorities that are more suited to the conditions. You can go shopping in Hong Kong any time, but you can't always get a clear, smog free view over the city from Victoria Peak. Your pre-planning will have informed you that the view from Victoria Peak is a 'must see'.

TRAVELLING WITH OTHERS

Trying to combine serious photography with a family holiday, or on a group tour, can be a challenge. Group itineraries are rarely sympathetic to the needs of a keen photographer.

However, with a little thought you can do many things within the normal parameters of a holiday with others and still maximise your time photographically. For example, many cities have observation decks at the top of buildings, or lookouts from nearby hills. A map will tell you if the direction of the sun will be best in the morning or afternoon. With this information you can suggest visiting the place at the best time for photos. Others won't care when they visit, as long as they visit, so take control of the timing. You can apply this tactic to entire itineraries.

Pick one or two themes to photograph comprehensively, and work on them within the framework of recording your trip. You could prioritise markets, allowing extra time and film for them and shooting the rest of your trip as it happens.

One of the easiest solutions to fitting in with others, but still giving photography some priority, is to get up and photograph before breakfast. The light is often at its best, the activity in towns and markets at its most intense and interesting, and you won't be inconveniencing anyone.

Use a guidebook to complement your group tour. There'll often be other attractions in the area that the tour won't visit.

ROUTINE & HABITS

Potential images come and go in front of your eyes in a matter of seconds and are easily missed. A good routine plays a big part in helping you react quickly to photo opportunities.

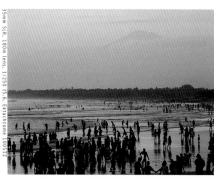

66

➤ Volcano from Kuta Beach, Bali, Indonesia
There one day, gone the next. The first time I went to Kuta beach I took one frame of the beach and distant volcano as I hurried to photograph the boats and the sunset, assuming I'd be able to do more shots the next day. I've been back to Kuta several times over several years and have never seen the volcano from the beach again.

· Have your camera around your neck with the lens cap off. You can't take pictures quickly if you have to get the camera out of a bag, remove the case and take off the lens cap.

· Be aware of existing light conditions and have your camera set accordingly. Change the settings as conditions change. If using manual settings, adjust the aperture and keep the shutter speed appropriate for the lens you're using.

· If your camera is set on auto, make sure the shutter speed doesn't drop too low for hand-held photography without you realising.

· Have the lens you're most likely to need on the camera. For example, if you're on a crowded street looking for environmental portrait opportunities, it might be a 24mm.

· Set zooms at the most likely focal length for the subject you're anticipating.

· Always wind the film on so that the shutter is cocked.

· Always change films as soon as a roll is finished, or even before. It's often worth changing from frame 33 if you think something could occur, rather than only having a couple of frames available when the action starts.

· Always rewind the film completely into the canister so it can't be accidentally reused.

· Have a notebook and pen in your camera bag for recording important information quickly and accurately. Note taking is an important part of the overall package of successful travel photography. Good notes are needed for correct labelling of the images, and as a reference for returning to the same spot at another time.

· Number each roll sequentially as you finish it.

CAMERA CARE

Unfortunately, things can go wrong. Problems are magnified in remote areas because camera repair shops and suppliers often don't exist. Problems with equipment can occur in all sorts of ways: it can get lost, dropped, stolen, or just stop working. Regular checks and cleaning help prevent some problems, but others will have to be dealt with along the way.

Do the basic check and clean described in the Preparation chapter every couple of weeks while you're travelling. Check lenses and filters daily to prevent a build up of dirt and fingerprints. These should be removed immediately, as they can cause flare and loss of definition, resulting in soft images. This is equally true for compact cameras as it is for SLRs.

On a long trip it's a good idea to get at least one roll of film processed occasionally, to make sure everything is working properly. If you're using slide film, it's usually easy

enough to buy a 12-exposure roll of colour negative film. Just processing the negatives will confirm that everything is OK.

If your camera does break down while you're travelling there really isn't much you can do about it, except take it to the nearest camera shop. If it's a new camera, trying to fix it yourself by opening it up will void the warranty. If it has jammed, the first thing to do is to rescue the film. If you're in a town most camera shops will do it for you. If not, you can make a portable dark bag by putting the camera inside a zipped-up jacket and doubling over the neck and the bottom. Access the camera by putting your hands into the sleeves the wrong way (from the outside). Alternatively, go headfirst into a sleeping bag. When you're confident no light will reach the film, press the rewind button to release the take up spool. Open the back, remove the film cassette from the camera and rewind the film manually. Clean out the back of the camera in case bits of torn film have been left behind (oh, you can leave the cosy enclave of your sleeping bag for that part).

PROTECTION FROM THE WEATHER

Weather conditions can change rapidly, so you have to be prepared. Just because it's a perfectly still, sunny day when you leave your hotel, doesn't mean that a dust storm won't engulf you an hour later. A positive attitude and a lot of patience helps and you can be rewarded with fantastic photographic opportunities. Unsettled or unusual weather often brings with it moments of spectacular light and a change in the daily activity of the locals. To take advantage of changing, unusual or difficult situations, without putting your gear at risk, additional protection is needed.

WET WEATHER

Just because it's raining, or snowing, doesn't mean you have to put your camera away. Most cameras can take a fair bit of rain, just wipe it dry as soon as you get inside. Unless someone is on hand to hold an umbrella for you, shooting with one hand from under an umbrella isn't easy – especially as the light is probably low. It's much easier to keep your camera under your jacket between shots. One quick and easy solution is the old plastic bag and rubber band trick. Cut a hole in the bottom of a plastic bag just big enough for the lens to fit though and use

a rubber band to secure it in place on or just behind the lens hood. You then access the viewfinder and shutter release through the bag's original opening. The lens hood will help protect the filter on the front of the lens from the rain or snow, but keep checking it and wiping it dry as necessary. Some camera bags have an outer-shell built in for protection against wet weather. If yours doesn't, a large plastic bag is easily carried and will do the job.

EXTREME COLD WEATHER

Most modern cameras will function properly down to 0°C. Mechanical gear will operate adequately around -10°C to -15°C. The biggest problem in very cold temperatures is that batteries will fail. You can often fix this problem by removing the batteries from the camera and warming them in your hands. To minimise battery problems, keep your camera and the batteries in the camera warm until you start shooting. If you're going out at first light, sleep with your camera, ie, keep it in your sleeping bag during the night. When you head out into the cold morning have the camera under your jacket until you need it, shoot quickly, then tuck it back into your jacket as soon as you've taken your shots.

In very cold weather film can become brittle and snap if not handled carefully. Turn off the film winder and advance and rewind the film slowly to prevent tearing it. Winding on and off too quickly can also result in static discharges that appear as clear blue specks or streaks on the film.

Condensation can also be a problem. When changing film and lenses outdoors don't breath into the back of your camera or on to the lens, and ensure snow doesn't get into the camera. Entering a warm room causes the water vapour on the cold metal and glass surfaces to condense rapidly and mist up with tiny water droplets. When you go out again this water will freeze. To prevent this wipe off as much moisture as possible, and don't open the camera back or change lenses until the camera has warmed up.

In extreme cold, don't touch the camera's metal parts with bare skin because it will stick. These problems don't usually arise above -10°C. Make sure you've got a large eye-cup on and tape over the metal parts to help prevent your face coming into contact with them. Otherwise you could find your camera stuck to your face (which would be rather unpleasant, but could make a great shot for some other photographer).

HOT & HUMID WEATHER

Extreme heat can melt the glues holding the lens elements in place, but the biggest problem is the damage it can cause to film. Film is not only light sensitive, but heat sensitive, and cooking it will result in very pink photos. Film can actually withstand much more heat than you might think, but it's still best to be on the cautious side. It's recommended that you:

· Be aware that the floors of buses and cars can get very hot on long journeys, especially around the engine.
· Don't leave it in rooms in cheap hotels that become ovens around midday.
· Never leave equipment or film in direct sunlight.
· Never leave gear or film in a car, especially the glove box. On a hot day, say 37°C, temperatures in cars can range from 64°C to 107°C.

High humidity also speeds up the natural deterioration of film, and can lead to fungus growth on equipment and film. Packets of silica gel, which absorb moisture, should always be in your bag when travelling in humid climates.

Moving from an air-conditioned room to warm temperatures outdoors causes condensation on lenses and viewfinders that can take up to 10 minutes to clear. As soon as you get outside take your camera and each lens out of your bag and remove the front and rear lens caps, so that the condensation can clear naturally. Don't wait until your first photo opportunity comes along or you'll spend precious minutes wiping the lens, including the rear lens element, which is best not touched.

SALT WATER

Salt water and sea spray can cause irreparable damage to your camera. When photographing by the sea, protect your camera with a plastic bag (see Wet Weather earlier) and keep your bag closed. Cameras can also be protected against sea spray by wiping with a cloth lightly soaked in WD40 (or any substance that displaces moisture).

When travelling by small boat, place equipment and film in strong, sealable plastic bags. If you drop a camera in the sea, the only thing you can do is wash it under fresh water as quickly as possible, to remove the salt. The camera's chances of survival aren't good.

SAND & DUST

Sand and dust are deadly enemies of photographic equipment. If you find yourself in sandy or dusty conditions when the wind is blowing, be extra protective of your

equipment and film. A single grain of sand in just the right (or wrong) place can cause a lens to seize up. If any sand gets caught in the film cassette's light seal it can scratch a straight line along the entire film.

· Blow and wipe off dust and sand as soon as possible and again before opening the camera back.

· Don't put your camera bag down on the sand.

· If conditions are really severe put your camera bag inside a large plastic bag or place equipment in plastic bags inside your camera bag. Don't leave equipment in plastic bags for more than a couple of hours when the humidity levels are high.

· Keep your camera bag well sealed.

· Avoid opening the camera back if sand and dust are in the air.

· Use the camera-in-the-plastic-bag technique for shooting and changing films (see Wet Weather earlier).

SECURITY

Tourists and their cameras are particularly attractive targets for thieves just about everywhere. Being overly concerned about the security of your equipment doesn't only take the fun out of photography; it can prevent you from taking photos at all. A camera is no good at home, or in the hotel, or at the bottom of the day-pack on your back. By taking sensible precautions and staying alert you should be able to access your camera quickly and easily and still retain possession.

· Cameras and film should be carried onto the plane as hand luggage on the way to your destination. Even if your clothes don't make it, at least you can take photos. You may choose to pack some equipment in your check-in luggage on the way home.

· Carry the camera bag across your body, not on your shoulder – it's harder to snatch.

· Carry your camera around your neck, not on your shoulder.

· Don't put your gear in an expensive looking bag with 'Nikon' emblazoned on the side.

· If travelling on overnight sleeper trains use the bag as a pillow, perhaps under a jacket.

· If you go out without your camera it's best locked in your main pack or suitcase, rather than a portable camera bag. If you have more than one camera separate them.

· If you have a top-opening bag, close it between shots.

· Never leave equipment, and especially exposed film, in an unattended car.

· Never place your gear on overhead racks on trains, boats or buses. In other words, never let it out of your sight.

· Never put film in your check-in luggage.

· Put your film with your money in the hotel's safety deposit box.

· When you put your bag down, put your foot through the strap.

PROCESSING FILM

Colour print film can be conveniently and cheaply developed and printed in most towns. A good lab will be well patronised by locals (like a restaurant), so if it's busy it's probably doing a good job.

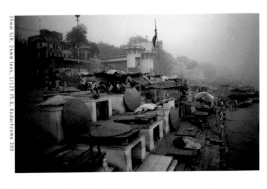

Most big cities have professional labs that process colour slide film. If you're in doubt about the lab doing a decent job, don't leave your film. Process one roll as a test before committing the film from your entire trip. Unless you're carrying a loupe (magnifier), use a lens with the front element to your eye, to magnify the slides for easier viewing. A 100mm lens is ideal.

SHIPPING FILM

If you're travelling for an extended period (over three months) you may want to consider sending film home for security and practical reasons. If you've processed it, you'll soon find that packets of prints and boxes of mounted slides take up a lot more space and are heavier than unexposed film cassettes.

If you do ship processed film send the negatives and prints separately, and post them a week apart from different post offices. If you've numbered your films sequentially, split them into odds and evens and ship them separately, again on separate days from separate places. If the worst happens, you won't lose a big chunk of images from one part of your trip.

Ship unprocessed film with one of the main air courier services, rather than through the post. The extra expense is well justified. Shipping unprocessed film raises the issue of x-rays again. Parcels may be x-rayed. Depending on the company, and the countries you're shipping between, you may be able to get an assurance from the agent that parcels won't be x-rayed, but there's some risk. Identify your parcels as having undeveloped film inside, *not to be x-rayed*.

Let someone know the film is on its way. They can take it to your lab of choice for processing or store it in a cool, dry and dark place. The refrigerator is a good place for this.

‹ Bathing Ghats, Varanasi, India
This sandstorm swept down the Ganges River from out of nowhere and the colour and quality of the light changed dramatically. It just goes to show that even on seemingly perfect days you should be prepared to be covered in sand, sea spray or rain.

TRIP NOTES

PART TWO:

TAKING CONTROL

People often say, 'Great photos, what kind of camera do you have?'. Modern cameras have reduced many of the technical aspects of photography. Common mistakes like leaving the lens cap on, not putting film in the camera, setting the ISO incorrectly, inaccurate focussing and poor exposures, were addressed as cameras became more sophisticated. But still people are disappointed with their photos. It doesn't matter how much you pay for a camera, it won't make creative decisions for you, nor will it get you to the right place at the right time.

For pictures to be more than straight record shots of a trip, it's important to understand some of the technical aspects of photography. If you're using a fully automatic camera your ability to influence the technical side of photography is limited. If you have a SLR that allows you to manually override the camera's exposure meter, you can take control of the exposure settings to more accurately and consistently record what you see. No matter what camera you use, time spent thinking about composition and the importance of light could make a dramatic difference to your photographs.

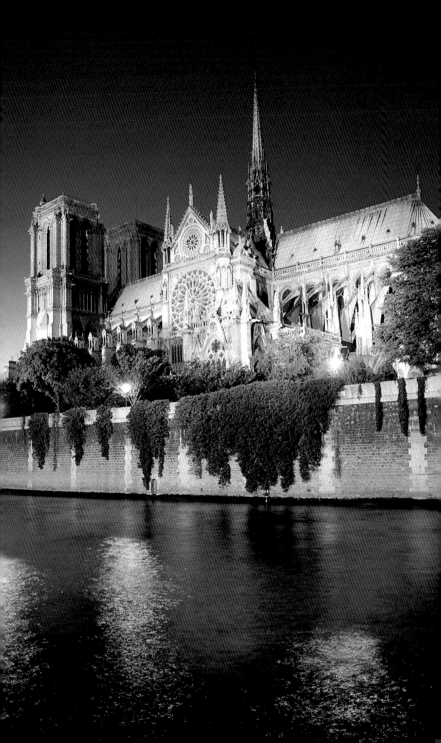

EXPOSURE

O *Setting the exposure is more than a technical necessity – it's a creative decision that controls the mood, quality and feel of the photograph.*

When you take a photograph you're translating what the eye sees, through the lens and onto the film. The choices you make when setting the exposure play a big part in determining if this actually happens.

Correct exposure means the film is exposed to just the right amount of light to record the intensity of colour and details in the scene that attracted you to take the photo in the first place. It's achieved through a combination of the film's ISO rating and the selection of the aperture and shutter speed.

SHUTTER SPEED

The shutter speed is the amount of time that the camera's shutter remains open to allow light onto the film. Shutter speeds are measured in seconds and fractions of seconds and run in a standard sequence: one second, 1/2, 1/4, 1/8,

⌃ Lamayuru, Ladakh, India
As the last rays from the
sun broke through the clouds
the two elements that a travel
photographer lives for came
together: a great subject
and great light. Because
the scene contained very
light and very dark areas,
the camera's automatic meter
reading averaged out the
light levels. This resulted in
some detail in the shadow
area in the foreground, but
the highlights in the
monastery are washed out.
The image lacks drama and
colour/depth.

⌃ I used the camera's spot
metering facility to take a
reading from the building,
choosing to retain the detail
in the highlights, and allow-
ing the darkest areas of the
composition to go black. The
result is a much stronger
image with natural vignetting
that takes the viewer's eye to
the main subject.

1/15, 1/30, 1/60, 1/125, 1/250, 1/500, 1/1000, 1/2000
and 1/4000 of a second. The higher the number,
the faster the shutter speed and the less
amount of light allowed in. Many modern cam-
eras allow intermediate settings such as a 1/90
of a second in automatic modes, but with man-
ual cameras you can't set shutter speeds
between these standard settings.

APERTURE

The aperture is the lens opening that lets light
in to the camera body. The aperture is variable
in size and is measured in f-stops. The most
familiar f-stop sequence, from the widest aper-
ture to the smallest, is f1.4, f2, f4, f5.6, f8, f11, f16 and f22.
As you go up the scale to f22 you are 'stopping down', and
with each step you halve the amount of light that will
reach the film. As you go down the scale to f1.4 each step
doubles the amount of light that will reach the film, and
you are 'opening up' the lens until it's 'wide open' at its
maximum aperture.

MEASURING LIGHT

Most modern cameras have built-in exposure meters that
measure the amount of light reflected from the subject.
All meters work on the principle that the subject is a mid-
tone, ie, not too light or dark. In practice, most subjects
are a mix of tones, but when the meter averages out the
reflected light, a mid-tone reading results in a properly
exposed image. When very light or very dark subjects
dominate scenes, exposure compensation is required (see
Determining Exposure later).

Centre-Weighted meters These meters read the light reflected from
the entire scene and provide an average exposure setting biased
towards the centre section of the viewfinder. Generally, readings
are accurate unless there are very large light or dark areas in the
scene.

Multi-Zone meters (also called matrix, evaluative, multi-segment,
multi-pattern or honeycomb pattern) Now common in new mid-
range SLRs. This sophisticated metering system divides the scene
into zones, reads the light in each zone, sends the information to
the camera's computer, which recognises the extreme tones and
gives a reading based on what it evaluates as the most important
parts of the scene.

Spot Meters These meters take a reading from a small defined area and are ideal for taking a reading of your main subject when it's part of an unevenly lit scene (backlit or spotlit).

EXPOSURE MODES

The exposure meter reads the light and recommends appropriate settings. Depending on your camera, you can prioritise the settings by selecting manual, semi-automatic or fully automatic exposure modes.

Manual Mode You set both the shutter speed and the aperture. Adjust either of the controls until the meter indicates correct exposure.

Shutter Priority Auto Mode (semi automatic) You select the shutter speed and the camera automatically selects an appropriate aperture.

Aperture Priority Auto Mode (semi automatic) You select the aperture and the camera automatically selects an appropriate shutter speed.

Program Auto Mode (fully automatic) The camera selects both the shutter speed and the aperture.

Subject Program Exposure Modes (fully automatic) You select a program mode to suit the subject (usually portrait, landscape, close-up, sport or night scene). The camera sets the appropriate shutter speed and aperture combination.

DETERMINING EXPOSURE

Point your camera at a scene and the meter will recommend appropriate settings depending on the exposure mode. You can accept the meter recommendation or override it. One of the easiest and best methods of determining exposure is to expose for the main component of the image. In many cases the main component dominates the frame and exposure is straightforward. Difficulties arise when a scene contains large areas that are very light or dark, when shooting into the sun, when light sources are included in the frame or the subject is black or white. Try the following techniques when the lighting is difficult:

· Use the spot meter to take a reading off the subject.

· In manual mode, fill the frame with your subject, either by moving closer or zooming in, take a reading, then recompose ignoring the meter readout.

· In automatic mode you can use the same technique but you must lock the exposure before you recompose or the meter will adjust the settings.

· On some fully automatic SLRs it's possible to override the meter settings using an exposure compensation dial that allows over or underexposure of the film by 1/3 or 1/2 stops up to two or three stops. Turn the dial to +1 and you'll increase the amount of light reaching the film by one stop. Turn it to -1 and you'll decrease the amount of light by one stop.

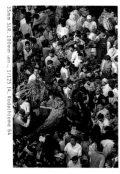

35mm SLR, 100mm lens, 1/125 14, Kodachrome 64

∿∿ *New Year Festival, Asan*
Tole, Kathmandu, Nepal
By changing the combination
of shutter speed and aperture
the same scene can be inter-
preted quite differently. To
ensure a sharp image I used
my standard settings. I wanted
to convey the feeling of move-
ment as the people circled
around the chariot, The
second photograph is a
much slower shutter speed,
which recorded movement in
the crowd as a blur. For this
technique to work, something
needs to be sharp to contrast
with the blur, so it's still
important to focus on the key
element in the composition. At
1/15 second, a tripod is essential.

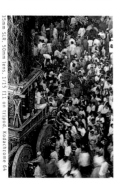

35mm SLR, 50mm lens, 1/15 f11 on tripod, Kodachrome 64

· If you can manually adjust the film's ISO rating you can trick the meter into allowing more or less light onto the film. This can only be done on automatic cameras if you can override the film speed setting automatically selected by the DX coding. To overexpose 100 ISO film by one stop: change the ISO setting to 50, doubling the amount of light that will reach the film. To underexpose by one stop: set the ISO to 200, and half the amount of light will reach the film. After adjusting the exposure compensation dial or the ISO setting remember to reset them.

If the subject is black or white, the meter will average out the scene to a mid-tone. Your black or white subject will be rendered as a mid-grey if you don't compensate or override the meter's recommended settings. For white subjects take a reading off the subject and overexpose by one or two stops. For black subjects underexpose by one or two stops.

Understanding the subtleties of exposure control is particularly important when using colour slide film. Slides can be unacceptable if they're overexposed (too light) or underexposed (too dark) by anything more than half a stop. However, as a general rule colour slide film produces the best results when it's slightly underexposed. Slightly darker slides always look better than slides that are too light. This is easily achieved by exposing for the highlights, which ensures detail is retained in the lightest parts of the picture and produces more saturated, or stronger, colours. Many photographers also uprate their colour slide film slightly by setting the ISO 1/4 or 1/3 of a stop above the actual film speed. Typically, 50 is rated at 64 ISO, 64 at 80 ISO and 100 at 125 ISO. Make sure you experiment with your own equipment and preferred film before shooting an entire trip worth of film at an uprated ISO.

In contrast, negative films are much more tolerant to exposure errors. It's possible for satisfactory prints to be made from negatives that are two stops over or underexposed. In fact, mistakes often go unnoticed because they're corrected automatically by the minilab when the prints are made. Although exposure latitude is greater with negative film, best results are produced when it's slightly overexposed. Expose for the shadows and the highlights will take care of themselves.

SHUTTER SPEED/APERTURE COMBINATIONS

Film speed, shutter speed and aperture are all closely interrelated.

○ The film's ISO rating, or speed, remains constant and is the foundation from which the variable settings of shutter speed and aperture are based.

An understanding of the relationship between these variables, and the ability to quickly assess the correct combination required for a particular result, is fundamental to creative photography. With 100 ISO film in your camera, point your camera at a subject and your light meter may recommend an exposure of 1/125 at f4. But you could also expose the film correctly at 1/60 at f5.6, or 1/30 at f8, or 1/15 at f11. If you chose to use 400 ISO film under exactly the same conditions you could select 1/500 at f4, or 1/250 at f5.6, or 1/125 at f8, or 1/60 at f11. All of the above combinations will ensure the film is exposed to just the right amount of light. You have to decide which combination will give you the best result by giving priority to one element over the other. A photograph of a waterfall taken at 1/250 will look quite different taken at 1/8. The combination you select is a creative decision.

DEPTH OF FIELD

Aperture is also a key component in controlling the depth of field in a photograph. Depth of field is one of the least understood aspects of photography, but one of the most important creative controls available to the photographer.

○ Depth of field refers to the area of a photograph that is considered to be acceptably sharp.

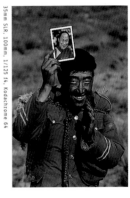

❯ Man with Dalai Lama photo, Tibet, China
Built-in exposure meters set on automatic are perfect for when the lighting is even, the subject fills the frame and you've only got a split second to take the photo.

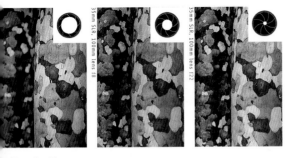

⌃ Tree detail sequence
This sequence clearly shows the dramatic effect the aperture has on the depth of field. Without changing the lens or point of focus, the tree on the left can be in or out of focus, creating quite a different image. From left to right: f2 - f8 - f22

The smaller the aperture, the greater the depth of field, and vice versa. An aperture of f16 will give maximum depth of field, while f2 will give minimum depth of field. For general photography use f8 or f11 as your standard aperture setting. These apertures will generally allow you to use a shutter speed of 1/125, give enough depth of field for most shots and even give you some latitude against inaccurate focussing.

When you look through the viewfinder of a modern SLR you're viewing the scene through the lens at its widest aperture or 'wide open'. This allows focussing and composing through a bright viewfinder. The lens doesn't 'stop down' to the selected aperture until the shutter is released. As a result, you'll be seeing your composition with very little depth of field. If your camera has a depth of field, or preview button, you can get an idea of what will be in focus at any chosen aperture by manually stopping down the lens before taking the shot. Select an element of your composition that appears out of focus and watch it come into focus as you stop down from f4 to f5.6 to f8. With each stop the viewfinder will get darker, but as you practice this technique the usefulness of controlling depth of field will soon become apparent.

Two other variables affect depth of field: the focal length of the lens and the distance between the camera and the subject. At the same f-stop, shorter focal length lenses such as 24mm or 35mm, will give greater depth of field than telephoto lenses, such as 135mm or 200mm. The farther away your subject is, the greater the depth of field. Move in close and you will reduce depth of field. So,

⟩ *House of Tiles, Mexico City, Mexico*
Late in the day the amount of available light in the restaurant was too low to hand-hold the camera and a bad case of camera shake was the result.
⟩⟩ By returning the next morning when the light level was higher, I was able to shoot at a comfortable shutter speed (1/30 second) with a 24mm lens.

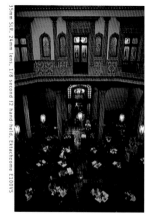

35mm SLR, 24mm lens, 1/8 second f2 hand-held, Ektachrome E100VS

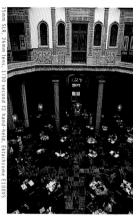

35mm SLR, 24mm lens, 1/30 second f2 hand-held, Ektachrome E100VS

maximum depth of field can be achieved by focussing on a subject over 50m away using a wide-angle lens at an aperture of f16. Depth of field will be minimised by focussing on a subject under 5m away using a telephoto lens at an aperture of f2.

CAMERA SHAKE

A practical consideration when selecting shutter speeds is to ensure that your pictures don't suffer from camera shake as a result of the shutter speed dropping too low. This is a very common problem when cameras are used on automatic. If hand-holding the camera, good standard shutter speeds are 1/125 second or 1/250 second. However, be prepared to vary your shutter speed depending on the lens you're using.

O *Avoid camera shake by selecting a shutter speed the same or higher than the focal length of the lens.*

With a 24mm lens, a shutter speed of 1/30 is recommended, with a 200mm lens, 1/250 is the desired minimum shutter speed. With zoom lenses the minimum shutter speed should vary as you zoom in and out. The longer the lens, or at the telephoto end of zoom lenses, the higher the minimum shutter speed required.

BRACKETING

Bracketing is an important technique used to ensure that the best possible exposure is achieved. A standard bracket requires three frames of the same scene. The first is at the recommended exposure, say 1/125 at f11, the second at 1/2 a stop over (1/125 at f8 1/2) and the third at 1/2 a stop under the recommended exposure (1/125 at f11 1/2).

Bracketing, of course, increases film quantities and costs dramatically. Use it when the lighting is really difficult, or if you're photographing subjects you consider important enough to justify the extra film. If the shot really matters, then bracketing is the best way to guarantee that the image you see is the image you get. For professional photographers bracketed film is not wasted film. As a backup against loss, damage or processing problems the extra frames can be invaluable.

35mm SLR, 24mm lens, Ektachrome E100VS

> *The Temple of the Grand Jaguar, Tikal, Guatemala*
A three-frame bracket shows the difference a stop either side of the camera meter's recommendation makes.
1 1/125 at f8. The mix of dark and light areas has resulted in a good exposure.
2 1/125 at f5.6. One stop over and the light areas have lost the depth of colour and the image looks weak, but there is detail and colour in the shadow.
3 1/125 at f11. One stop under and the light areas still look good with lots of detail, but the dark areas have lost their colour and detail.

USING COMPACT CAMERAS

Compact, or point-and-shoot, 35mm cameras are extremely popular and the top-quality models are capable of producing good results. To get the most out of these cameras use the override features provided.

FOCUS & EXPOSURE LOCK

The auto-focus sensor is usually in the middle of the view finder, which tends to prompt people to put their subject in the middle of the frame. This isn't a recommended place for the majority of striking compositions (see the Composition chapter later). Unfortunately, when the main subject is not in the centre it's often out of focus. The focus sensor misses the subject and focuses on something in the background. Additionally, if the lighting is uneven the meter may take a reading from areas other than the main subject.

Darling Harbour, Sydney, Australia

∨ The camera doesn't know if you're photographing the boat in the foreground or the city in the background, so it gives an average reading that has overexposed the skyline but stopped the boat going too dark. The image lacks colour and depth and isn't at all representative of how the scene looked to the eye.

⟩ By overriding the meter with the exposure and focus lock, and exposing for the buildings, the photograph is much stronger.

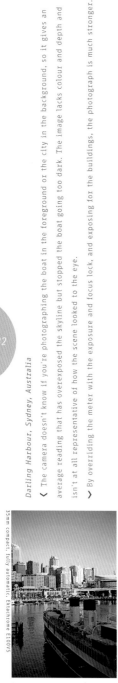

35mm compact, fully automatic, Ektachrome E100VS

35mm compact, exposure and focus lock on city buildings, Ektachrome E100VS

Most advanced 35mm compacts have a combined focus and exposure lock that can solve these problems and allow you to produce more creative and technically better pictures. Check your camera manual to learn how to engage the lock. Usually it involves selecting a 'spot mode', positioning the auto-focus mark on the subject, depressing the shutter button half-way and holding it there while you recompose. Press the button fully when you're happy with the composition. The camera will focus and set the exposure for the subject you spot-metered.

FLASH CONTROL

Most advanced compacts have five flash modes: auto, red-eye reduction, fill-in, night scene and flash off. The auto mode is always on and fires the flash automatically in low light and back light situations. You can take control of the flash so that it only fires when you want it to. Too often the flash on compact cameras fires when it doesn't need to, overriding the available light to produce flat, brightly lit pictures that lack mood and render the background dark and uninteresting.

Most compacts have automatic shutter speeds from 1/500 second down to at least one second. By turning the flash off, you can access these slower shutter speeds and take advantage of the available light. The camera probably won't tell you the shutter speed it's using, so in low light be aware of camera shake. Experiment in different conditions to learn how low the light has to be before needing a tripod or some other support. Further control can be achieved with the fill-in mode. (See the Flashlight section in the Light chapter for techniques relevant to both compact and SLR users.)

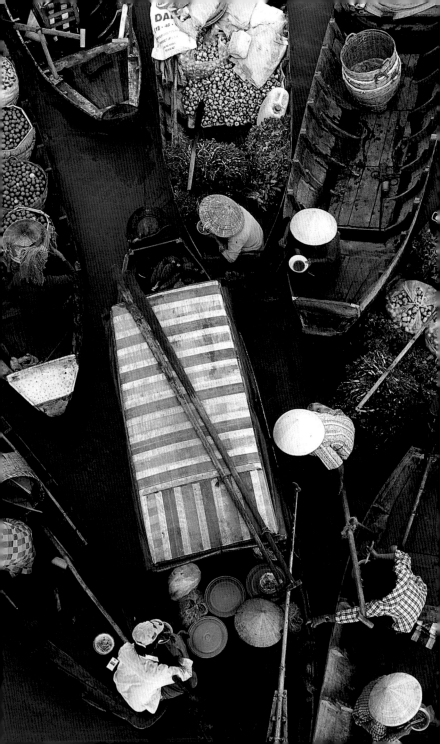

COMPOSITION

O *Good composition is a key element in creating striking photographs.*

Every time you expose a piece of film you'll have made a series of decisions resulting in a composition. You'll have selected a lens with a particular focal length, or zoomed in and out, decided where to take the photo from, included some elements and excluded others, and made a decision to take the photo vertically or horizontally. By considering these interrelated variables (which all defy automation) before you press the shutter, you can put your own interpretation on the subject.

For any given subject or scene there's never one correct composition and it's often worth taking several different compositions. Photographers regularly work the subject, exploring the different possibilities, all the time taking photos. Even at famous tourist sights where there's a certain place to stand to take 'the' photo, it's amazing how different people's photos can be.

O *Aim to have the main point of interest positioned away from the centre of the frame and avoid elements that conflict with the main subject.*

« *Cai Rang floating market, Cantho, Vietnam*

"THE RULE OF THIRDS"

35mm SLR, 24mm lens, 1/125 f11, Kodachrome 64

❯ Village and mustard fields, Lamayuru, Ladakh, India

The mustard fields, the mountains and the sky form three distinct horizontal thirds. The monastery, at the high point of the village, is on a grid intersection. Most scenes can have different elements placed on the grid intersections. Try various options, especially those that feel right instinctively, and study the results at home.

As you work through the options keep in mind the rule that has traditionally been the starting point for successful composition:

○ *The 'rule of thirds' teaches that the main elements of a composition are placed at points one-third of the way from the sides of the frame.*

As you look through your viewfinder, imagine two vertical and two horizontal lines spaced evenly creating a grid of nine rectangular boxes. Try placing the main elements, such as the horizon in a landscape or the eyes in a portrait, on or near the points where the lines intersect. Avoid placing the main element right in the centre of the frame – this can result in a very static image.

FRAMING

FRAMING SUBJECTS

Framing subjects is a common practice, but if not executed well it can weaken a composition. The framing device must have some relevance to the subject. Very often it's just something at the edges of the picture that distracts the viewer's attention.

○ *The frame shouldn't be so overpowering in colour or shape that it competes with the subject.*

FILL THE FRAME

○ *Once you've decided what you want to photograph try to fill the frame with it.*

❮ Getty Museum, Los Angeles, USA

This building is framed by another building. The framing device is relevant to the main subject, because it's part of it. It doesn't overpower the subject, but rather, leads the viewer's eye into the composition.

35mm SLR, 24mm lens, 1/60 f8, Ektachrome E100VS

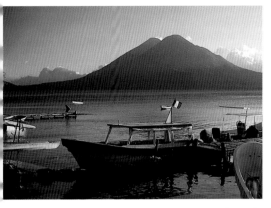

Lake Atitlan, Panahachal, Guatemala

⟩ The framing in this picture is quite ineffective, adding nothing to the image. There is no connection between the framing device and the scene in terms of colour or content. The trees simply clutter the edges of the frame.

⌃ By taking a couple of steps forward down the bank I was able to avoid the trees and make a much cleaner picture with greater harmony between the elements and the colours.

A common mistake is to leave the subject too small and insignificant, in turn leaving the viewer wondering what the photograph is supposed to be of. Often just taking a few steps towards your subject will make an enormous difference.

VIEWPOINT

○ *Don't assume that your eye level or the first place you see your subject from is the best viewpoint.*

A few steps left or right, going down on one knee or standing on a step, can make a lot of difference. Varying your viewpoint will also add variety to your overall collection.

CONTENT SELECTION

○ *What you leave out of the frame is just as important as what you leave in.*

Do you really want power lines running through the sky at the top of your picture? It's fine if you do, but not if you didn't see them in the first place. Get used

˅ *Playing dominoes, Havana, Cuba*
All three photos are taken with the same lens, but with each shot I moved in a couple of paces. The first shot provides more information about where the game is being played, but the third gives a much greater sense of immediacy and shows clearly what the photograph is about.

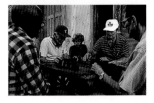

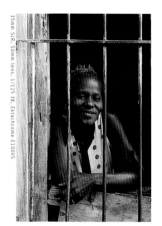

35mm SLR, 50mm lens, 1/125 f8, Ektachrome E100VS

35mm SLR, 50mm lens

Woman from Trinidad, Cuba

➢ The main subject is clearly taller than wider. Although the horizontal shows a little more of her surroundings, the lighter wall is a distraction from the main subject.

➢➢ By taking a couple of steps towards the woman and framing vertically, the context is not only retained but also enhanced. The vertical bars and window frame are emphasised and the viewer is drawn to the expression on the woman's face.

to scanning the frame before pressing the shutter release, looking for distractions and unnecessary elements. Use the depth of field button (if you have one) to bring the background into focus, which will help you spot distractions behind the subject.

ORIENTATION

Horizontal or vertical? It feels much more natural to hold the camera horizontally, so it's not surprising that people forget to frame vertically. Start by framing vertical subjects vertically.

O *Consider the option of camera orientation as another tool for filling the frame and minimising wasted space around the subject.*

FOCUS

Take care when focussing.

O *If something other than the main subject is the sharpest part of the composition the viewer's eye will rest in the wrong place.*

There are five reasons why unsharp images are so common:

- The lens is not focussed accurately, particularly at wide apertures.
- The lens is focussed on the wrong part of the composition.
- Shutter speed is too slow for hand-holding and camera shake results.
- The subject moves.
- The operator jabs the shutter release, wobbling the camera. Press the shutter release gently.

One of the traps with the rule of thirds for auto-focus cameras is if the subject is not in the middle of the frame, the main subject may not be in focus. Most auto-focus cameras have a focus lock facility, which you should be confident using. This allows you to lock the focus on the main subject then recompose without the camera automatically refocussing.

CHOICE OF LENS

Lens choice determines the angle or field of view, image size, perspective and depth of field potential.

See Lenses for SLR Cameras, in the Equipment chapter, for more information on the features of different types of lenses.

ANGLE OF VIEW

The focal length determines the angle of view and refers to the image area that the lens provides. On a 35mm camera a standard 50mm lens covers an angle of 46°, which gives about the same angle of view and image size as the human eye. Wide-angle lenses provide a wider angle of view and smaller image size than a standard lens. Telephoto lenses have a narrower angle of view and a larger image size than standard lenses.

PERSPECTIVE

Perspective refers to the relative size and depth of subjects within a picture. When the angle of view is wide (with wide-angle lenses), the perspective becomes more apparent as it's stretched. Near objects appear much larger than those in the background. With a narrower angle of view (with longer focal lengths), the perspective is foreshortened and becomes less apparent – far objects look like they're directly behind closer ones.

DEPTH OF FIELD POTENTIAL

The wider the angle of the lens, the greater its depth of field potential. The longer the focal length of the lens the more its depth of field potential is reduced.

35mm SLR, 100mm lens, Ektachrome E100SW

35mm SLR, 24mm lens, 1/250 f11, Ektachrome E100SW

35mm SLR, 180mm lens, 1/250 f8, Ektachrome E100SW

∧ *Fisherman's Wharf, San Francisco, USA*
On the fourth of July Fisherman's wharf is packed. The wide perspective of the 24mm lens gives a sense of place and the space between the people on the street is apparent.

∧ The 180mm lens shows only a small part of the scene. The foreshortened perspective brings the people on the street closer together, making it seem more crowded than it actually is.

Statues at the Grand Palace, Bangkok, Thailand

≫ Everyone takes this shot or something very similar. There's nothing wrong with that: it's a very attractive and interesting subject. To find a new angle on an old subject is one of the great challenges for the travel photographer.

≻ Not everyone takes this shot. A change of lens and a new camera angle is a quick and efficient way to create a completely new image from the same subject.

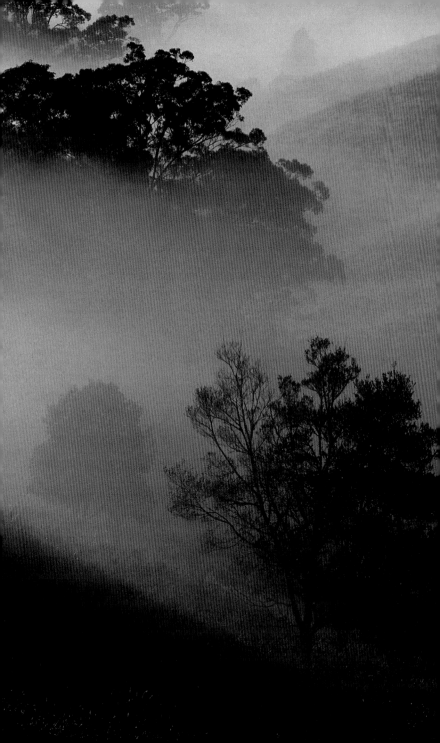

LIGHT

Once you're comfortable with the technical aspects of exposure and the various components of composition, you need to become familiar with the different aspects of lighting.

O *Light holds the key to the next level of creativity and personal expression.*

The majority of travel pictures are taken with the natural light of the sun, but you'll also use incandescent lighting indoors or at night and flashlight when the available light is too low. There's light and there's the 'right light'. The key elements to the 'right light' are its colour, quality and direction. Once you understand these elements and the way they interrelate you can predict the effect they may have on a subject. This will help you decide what time of day to visit a place. The trick to shooting in the 'right light' is to find a viewpoint where you turn the conditions to your advantage, rather than struggle against them.

« *Morning fog, Tweed Valley, Australia*

> *San Cristobal cityscape, Mexico*
> The significance of photographing at different times of day can be clearly seen in these photographs. By mid-morning the town was lit by the normal light of direct sun, fairly high in the sky. In the late afternoon, with the sun low in the sky, the city was bathed in a warm yellow light.

NATURAL LIGHT

COLOUR

The colour of the light changes as the sun follows its course through the day. On a clear day when the sun is low in the sky (just after sunrise or just before sunset), the colour of the light is warm and subjects can be transformed by a yellow-orange glow. This light enhances many subjects and it's worth making an effort to be at a pre-determined place at the beginning and end of the day. As the sun gets higher in the sky, the colour of daylight becomes cooler, and more 'natural'. If heavy cloud is blocking the sun, the light will be even cooler and photographs can have a bluish cast. This will also happen on sunny days if your subject is in shade.

QUALITY

The quality of natural light is determined by the position of the sun and the weather. Light quality can vary from one moment to the next. Direct sunlight becomes indirect as a cloud blocks its rays. A small break in heavy cloud just above the horizon can transform a scene from ordinary to spectacular in a split second.

⌄ *The Potala Palace, Lhasa, Tibet, China*
I was pleased to get a good standard shot of the Potala, but was keen to capture something a little different. The weather was changing away to the west, so I decided to stay and see what happened. Two hours later I was rewarded with an unusual quality of light caused by the low angle of the sun and a dust storm.

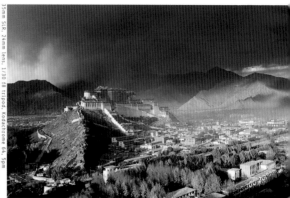

Direct sunlight produces a harsh light, especially noticeable in the middle of the day. Shadows are short and deep and contrast will be high. Colours are strong and accurate, but can also be washed out by the intense, overhead sunlight.

In the two to three hours after sunrise and before sunset, direct sunlight is not quite as harsh and colours are still reproduced naturally. The lower angle of the sun gives shadows with some length, brings out textures and adds interest and depth to subjects.

At sunrise and sunset the very low angle of direct sunlight produces long shadows, and texture and shape become accentuated. Combined with the warm colour this is an attractive and often dramatic light.

Indirect sunlight produces a softer light. On overcast but bright days, or when the sun disappears behind a cloud, shadows become faint and contrast is reduced making it possible to record details in all parts of the composition. Colours are saturated and rich especially in subjects close to the camera. Rain, mist and fog produce an even softer light. Shadows disappear, contrast is very low and colours are muted. If the cloud cover is heavy and light levels are low the light will be dull and flat.

35mm SLR, 50mm lens, 1/125 f5.6 Ektachrome E100VS

35mm SLR, 100mm lens, 1/125 f8 Ektachrome E100VS

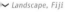
∨ *Landscape, Fiji*

A mid-afternoon downpour produces a very soft light. Contrast is reduced and colours are muted. The 1/30 second shutter speed has recorded the rain as streaks and has softened the landscape even further. Rain streaks are much more noticeable against a dark background.

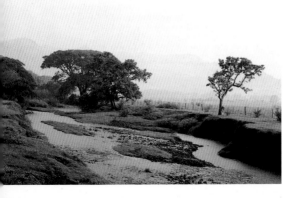

≻ *Rickshaw men, Durban, South Africa*

Photographed within minutes of each other, one man was in direct sunlight, the other in indirect light. Direct sunlight has stronger, more natural colours, but the shadows on the face are harsh. The indirect light provides better lighting for a portrait, but the colour of the light has changed. There is excessive bluishness (common in open shade).

35mm SLR, 100mm lens, Ektachrome E100VS, f15.6m, back lighting

35mm SLR, 100mm lens, Ektachrome E100VS, 9.20am, front lighting

⌃ *Bang'gann village, Philippines*
In this instance, I changed viewpoint to alter the direction of the light in the picture. A 200m walk along the road took me to the other side of the village – from shooting against the light to shooting with it. If you can visualise how changing your position will alter the light on the subject, you'll be able to decide if the walk is worth it (not so important for a flat 200m, very important if it's up the side of a hill for an hour).

❯ *Planting rice, Lombok, Indonesia*
Even though the light in the middle of the day isn't always ideal it's often a case of now or never for the traveller. Except for when the sun is absolutely directly above your subject there will be a better side to photograph your subject from. Slight underexpose and a polarising filter help retain the colours in the scene.

DIRECTION

As the colour of light changes through the day, so too does the direction of light. Considering where light strikes your subject will improve your pictures significantly. Although the direction from which light strikes a subject is constantly changing, there are four main directions to consider: front, side, top and back. If the light is striking your subject in the wrong place you have several options: move the subject, move yourself, wait or return at the appropriate time of day.

Back lighting This occurs when the sun is directly in front of your camera. Silhouettes at sunset are a classic use of back light. Back light has to be carefully managed or your subjects will lack colour and detail.

Front lighting This gives clear, colourful pictures. However, shadows fall directly behind the subject causing photographs to look flat and lack depth.

Side lighting This brings out textures and emphasises shapes, introducing a third dimension to photographs.

Top lighting This occurs in the middle of the day and is rarely flattering, giving most subjects a flat, uninteresting look.

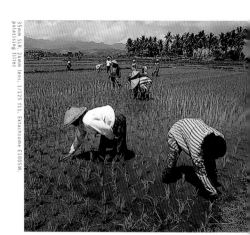

35mm SLR, 24mm lens, 1/125 f11, Ektachrome E100SW, polarising filter

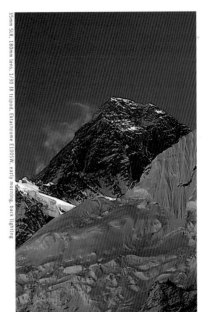

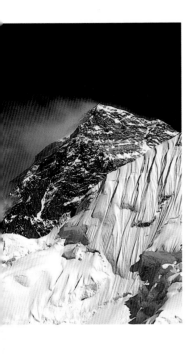

˄ Mount Everest, Kala Pattar, Nepal

The view is spectacular. However, the sun rises behind the mountain so it's not until mid-afternoon that direct light strikes the mountain. The side lighting is worth waiting for because it brings out the colours of the rock and the texture in the snow. This increases the contrast between the snow, black rock and sky so that the mountain stands out from the sky. To get both shots you have to wait for a few hours or return later in the day.

˂ Autumn leaves, Australia

Back lighting has brought out the translucent nature of the leaves, colours and details not normally seen.

> Medicine man, Banjarmasin, Kalimantan, Indonesia
I prefer to use available light whenever possible, rather than flashlight. However, for those occasions when I happen upon a man who's just eaten razor blades and is standing on his wife's stomach (and she's lying on a bed of rusty nails in a very dark room featuring a stuffed wild cat of some sort) ... well, I can be talked into using my flash.

FLASHLIGHT

Flash provides a convenient light source that will let you make a photograph even in the darkest places without having to change films or use a tripod. Most modern compact cameras and SLRs have built-in flash units. Otherwise a separate flash unit can be mounted on the camera via the hot-shoe or off the camera on a flash bracket with a flash lead.

Pictures taken with flash from built-in or hot-shoe mounted units are usually unexceptional. The direct, frontal light is harsh and rarely flattering. It creates hard shadows on surfaces behind the subject and backgrounds are often too dark. To improve the look of your flash photographs get to know the features of your particular unit. If you have a SLR, explore the possibilities of off-camera flash, bounce flash and fill flash.

TECHNICAL CONSIDERATIONS

Built-in flashes and compact accessory units have limited power output. Subjects generally need to be between 1m and 5m from the camera for the flash to be effective (check your camera manual for exact capabilities). Photographing an event in a big stadium at night with flash is pointless. If your picture comes out it will be because there was plenty of available light on the subject, not because your flash fired. Your flash will only have enough power to light up the four or five rows in front of you. Faster film will extend the effective range of your flash or let you work with smaller f-stops for greater depth of field.

SYNCHRONISATION (SYNC) SPEED

If you use a SLR on manual, or a non-dedicated flash unit, you must select a shutter speed that synchronises with the firing of the flash. This has traditionally been a maximum of 1/60 second. In recent times sync speeds have increased, but check your manual. If you select a shutter speed above the sync speed, part of your picture will be black. It's OK to select speeds slower than the designated maximum sync speed.

RED-EYE

If you use direct, on-camera flash when photographing people your portraits may suffer from red-eye. The flash is in line with the lens and the light reflects off the blood vessels of the retina straight back onto the film. Red-eye can be minimised with the following techniques:

· Ask your subject not to look directly into the lens.
· Increase the light in the room, which causes the pupil to close down.
· Move the flash away from the camera lens.
· Bounce the flash off a reflective surface.

Many modern cameras have a red-eye reduction feature, which triggers a short burst of pre-flashes just before the shutter opens. This causes the pupil to close down. It's a sophisticated way of increasing the light in the room.

OFF-CAMERA FLASH

Off-camera flash gives more pleasing results because the light is moved to the side and above the lens so that it's angled towards the subject. Red-eye is eliminated and shadows fall below the subject (rather than directly behind). A sync lead connects the flash to the camera, and although you can hold the flash and shoot one-handed, mounting the flash on a flash bracket makes life a lot easier. This will limit the angle you can use, but you'll soon be able to anticipate how the flash will light your subject.

BOUNCE FLASH

Even more pleasing results are possible if bounce flash techniques are employed. You need a flash unit with a tilt head or the ability to mount the flash off-camera on a flash bracket. The flash is aimed at the ceiling, wall or flash reflector, which bounces the light back at the subject. The light is indirect and soft and shadows are minimised. Walls and ceilings come in varying heights and colours and this can present some problems. If ceilings are too high you won't be able to bounce the flash. Dark coloured walls and ceilings will absorb too much of the light. The surface you bounce off should be white – coloured surfaces will give your picture a colour cast.

To overcome all these problems a bounce flash kit is worth the small investment. By using a flash with tilt head, the flash is bounced off a reflector attached to the flash head. The reflectors are interchangeable and available in different colours. A gold reflector will bounce warm light and a silver reflector will bounce cooler light.

FILL FLASH

Fill flash is a technique used to add light to shadow areas containing important detail that would otherwise be rendered too dark. The flash provides a secondary source of light to complement the main light source, usually the sun. If executed well, the flashlight will be unnoticeable, but if it overpowers the main light the photo will look unnatural.

Fill flash techniques have long been the domain of professional photographers. Now most compact cameras, SLRs with built-in flash units, and advanced SLRs with dedicated flash systems, have a fill flash feature. Some activate automatically, others require you to decide that fill flash is needed. Use the fill flash feature when:

· Your subject is in shade, but the background is bright.

· Your subject is back lit and you don't want to record it as a silhouette.

· The light on your subject is uneven, such as when a person's hat casts a shadow over their eyes but their nose and mouth are in full sun.

Remember your subject must still be within the effective range of your particular flash unit.

If you're using a less sophisticated SLR and accessory flash, you'll need to override the flash so that it delivers less light than it would if it was the main light source (usually one to 1 1/2 stops less). Set your exposure for the brightest part of your composition, say 1/60 second at f8, but set the flash on f5.6 or f4.5. Alternatively, you can change the ISO setting on the flash unit, from say 100 to 200. Both techniques trick the flash into thinking that the scene needs less light than it actually does. Output is reduced, which prevents it becoming the main light source, but still gives enough light to fill in the dark areas.

INCANDESCENT LIGHT

When taking photographs indoors or after dark we often have to rely on incandescent, or artificial, light sources such as electric light bulbs, floodlights or candles. The concepts of colour, quality and direction discussed earlier are just as relevant to incandescent light – it's just that the light source is different.

When you find yourself in dimly lit locations don't assume you need flash. As a rule: if you can see it you can photograph it. By using a tripod and a fine grain film you will be able to shoot in low light situations. Alternatively, fast film will allow you to hand-hold a camera in very low light.

There are good reasons for being prepared to work with the available light. Most importantly, you'll be able to take pictures in many places where the use of flash is impractical (floodlit buildings, displays behind glass), prohibited (churches, museums, concerts), intrusive (religious ceremonies) or would simply draw unwanted attention to your presence.

If you use daylight film in incandescent light your photos will have a yellow-orange cast. The strength of the cast varies depending on the actual light source. The cast can be neutralised by using film (tungsten) balanced for incandescent light (see the Film chapter), or light balancing filters 82A, 82B or 82C (see Filters in the Equipment chapter). More often than not, the warm colours are appealing and help capture the mood of the location.

35mm SLR, 24mm lens, 1/30 f2, Ektachrome P1600

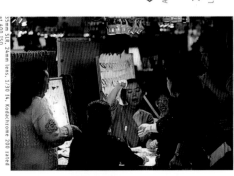

35mm SLR, 24mm lens, 1/30 f4, Kodachrome 200 rated at 400 ISO

∨ *Jade market, Hong Kong, China*
A mix of incandescent lights create a pleasing colour that retains the ambience of the place.

≫ *Festival, Bangkok, Thailand*
Lit only by candlelight, the daylight film reproduces the light as a strong orange colour.

PART THREE:

ON THE ROAD

There are countless subjects to photograph when travelling. On the Road illustrates and considers specific issues related to successfully photographing the most popular travel subjects.

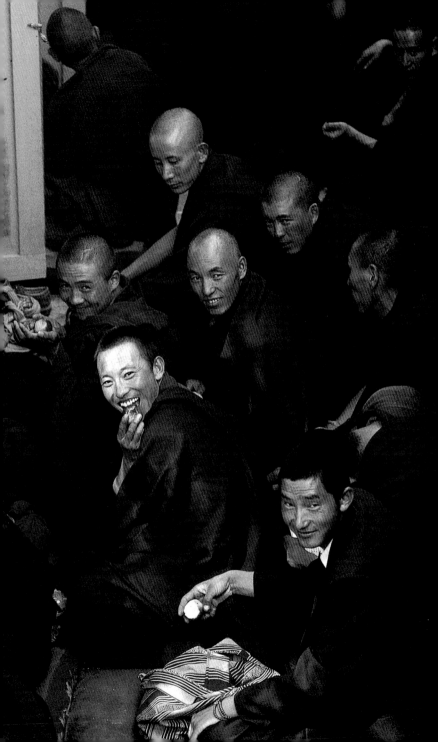

PEOPLE

Photographing people well is one of the most difficult tasks faced by any traveller. Hundreds of potential subjects surround you daily, yet the step from seeing a potential photograph to actually capturing it on film doesn't come easily to many people. Often travellers are reluctant to photograph people because they're too shy or self conscious to ask permission, or fear they won't be understood, or that they're invading people's privacy. They sometimes feel guilty, especially when the people being photographed are living in poverty.

Photographs of people can be simply categorised into two groups: portraits and environmental portraits. Portraits are close-up studies of a subject's face. Environmental portraits include the subject's surroundings as an integral part of the image, providing a context for the portrait.

There are two ways to go about photographing people. One is to get to know the people by spending time with them, or at least spending time in the locality. In theory,

« *Monks, Sera Monastery, Tibet, China*

These monks were spectators at a debate but were happy to play up for the camera. The way people respond to the presence of a camera is always interesting. Some pose, some turn away, some just carry on. It's the varied responses that give character and personality to a collection of people pictures.

this should lead to better access and more relaxed natural photos. The other is to jump straight in, get the pictures, and get out. Travellers will find themselves in the second category most of the time, whether they like it or not.

O *You'll become more comfortable photographing people, and enjoy better results, if you're able to compose and make technical decisions quickly.*

Ensure you're completely comfortable with your equipment. A good way to miss people photos is to start messing around with gear and settings in front of them. People quickly become self-conscious and often stop what they're doing and go into their 'camera pose'. It's important to develop techniques that make photographing people easier and minimise the intrusion into your subject's day.

Plan the shot before you approach your subject. Should it be portrait or environmental, horizontal or vertical? Have an idea of the viewpoint you intend to use. Study the light on the person's face and check where it's coming from, this will allow you to position yourself correctly in the first instance. Once you have permission to take a photo the person will follow you with their eyes if you move. The slightest change of camera angle can make all the difference. If your subject is wearing a hat in a sunny location half of their face will be in heavy shadow. Overcome this by asking them to look up slightly or to push the hat back a bit.

Lots of things can go wrong with people pictures, including: unsharp photos due to inaccurate focussing or subject movement; closed eyes if your subject blinks; an unflattering expression, especially if the person is talking; and loss of eye contact if your subject is distracted or shy. People often relax a little after they hear the click of the camera thinking you've finished; a second frame may capture a more natural pose.

COMMUNICATION

Some photographers ask before shooting, others don't. It really is a personal decision and often decided on a case by case basis. Asking permission allows you to use the ideal lens, get close enough to fill the frame, provides the opportunity to take several shots, as well as to communicate with your subject if necessary. Relatively speaking, very few people refuse to be photographed when asked.

Even if you are refused, which can be very discouraging, it's a mistake to assume that everyone will refuse to be photographed. Of course, you should make sure there aren't any religious or cultural reasons that discourage or prohibit photography. If in doubt ask a local.

How you approach people will affect the outcome of your request for a photo. Simply smiling and holding your camera up is usually sufficient to get your intention across. You may choose to learn the phrase for asking permission in the local language, which is the polite thing to do, but it can be less effective than sign language. Trying to speak the language has its own complications, like having to repeat the sentence 10 times to make yourself understood.

Approach the person with confidence and shoot quickly. By working quickly you'll increase the possibility of capturing more spontaneous and natural images. There's nothing more frustrating than seeing someone you think would make a great photograph, only for them to change position when they realise you want to photograph them. If people stiffen up in front of the camera it's up to you to get them to relax. Often it's a good idea to take one frame however they have posed themselves, then put your camera down and wait or talk to them before trying again. Demonstrate the pose you want by doing it yourself.

The direct approach of asking permission results in more satisfactory images than trying to sneak them from a distance. People will be more suspicious of your intentions and less cooperative if they spot you pointing a long lens at them from the shadows. The reality is you still have to be fairly close, even with a 200mm lens, to get a frame-filling portrait. It's best to be open about what you're doing.

A good way to get started with portraits is to photograph people who provide goods or services to you. After a rickshaw ride, or buying something from a market stall, ask the person if you can take their photo. Very rarely will they refuse.

PAYING FOR PHOTOS

In popular destinations you could be asked for money in return for taking a photo. This may be considered a fair and reasonable exchange, but it can become tiresome and

discourage you from photographing people. Certainly don't hand out money if it's not requested, but if it is be prepared to pay or walk away. It really comes down to how important or unique the potential image is. I don't give money to children, but I do make donations to the sadhus, or holy men, of the Sub-Continent. I also give to beggars and people in poverty when asked, and wherever there's an official donation box.

Agree on the price beforehand to avoid problems afterwards (and make sure you're working in their economy, not yours). Always have coins and small denomination notes with you in an easily accessible pocket (a different pocket from where you carry the rest of your money).

People often ask you to send them a photo. If you take peoples names and addresses with the promise of sending a photo, make sure you do. If you don't, it makes it harder for the next traveller, and gives tourists a bad name. Just remember that when you get home, organising photos for a dozen strangers in distant lands is much more of a chore than it appears when you're collecting names and addresses.

>> Beggar outside temple, Amristar, India

It was pouring with rain and I was running down the street looking for shelter when this man caught my eye, huddled in a doorway under his blanket. He spoke English and was quite happy to be photographed in return for a little backsheesh, or donation, needed to buy pills for his heart condition.

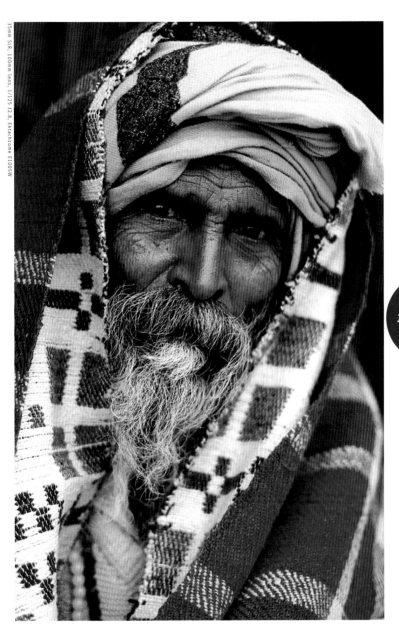

Capturing close-ups of people is a challenging and some times daunting proposition, but if done successfully i will add a great deal of depth, interest and personal satis faction to your travel pictures.

O *Concentrate on filling the frame with your subject an you'll be rewarded with a stronger image.*

Avoid backgrounds that are too busy or have very ligh or very dark patches of colour. Your eyes should not be distracted from the subject's face. Always focus on the eyes. It doesn't matter if other features are out of focus: i the eyes aren't sharp the image will fail.

Expose for your subject's face: it's the most importan part of the composition. The ideal focal length lens fo shooting portraits is between 80mm and 105mm. Lense in this range are often called portrait lenses because o the flattering perspective they give to the face. They als allow you to fill the frame with a head-and-shoulder com position while working at a comfortable distance from your subject. If using a zoom lens on a SLR or compac camera, preset it to 100mm, then position yourself to sui – this will guarantee a pleasing perspective. Set you shutter speed to at least 1/125 to prevent movement by the subject, which will result in a blurry photo. A wide aper ture (f2-f5.6) will ensure that the background is out o focus and help minimise any distracting elements Compose the photo vertically, which will minimise empty, distracting space around your subject. In low ligh situations when it's not possible to hand-hold your cam era consider using a faster film rather than flash.

If you're using a compact camera remember not to ge closer than the minimum focussing distance (usually 1m)

Overcast weather is ideal for portraits. It provides even soft light that eliminates heavy shadows and is usually quite flattering to the subject. It allows you to take pic tures of people in all locations and to work on auto to shoot quickly.

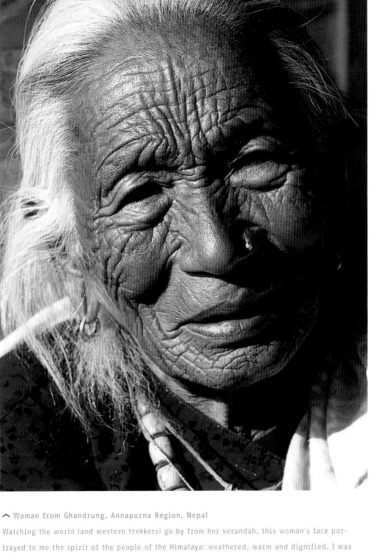

35mm SLR, 100mm lens, 1/125 f8, Kodachrome 64

⌃ Woman from Ghandrung, Annapurna Region, Nepal

Watching the world (and western trekkers) go by from her verandah, this woman's face por-
trayed to me the spirit of the people of the Himalaya: weathered, warm and dignified. I was
staying in the village and first saw her sitting with her back to the sun. I returned later in the
day to find her back on the verandah, only now the sun had come just far enough round to light
her face evenly. There was just enough side light to emphasise the lines on her face.

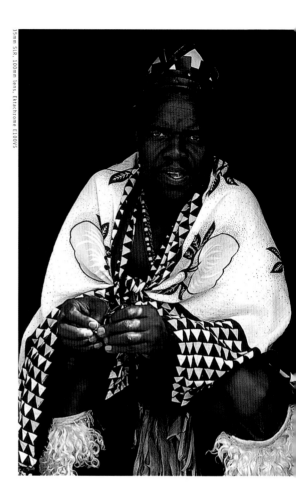

35mm SLR, 100mm lens, Ektachrome E100VS

∧ *African chief, Phe Zulu, Umgeni Valley, South Africa*
On a visit to the village of Phe Zulu we were invited to the chief's hut.
He sat at the back in almost total darkness explaining what his role in
the village was. In the darkness a built-in flash would have used its
maximum output to light the scene and caused badly overexposed photos.
On request, the chief was perfectly happy to move to the entrance of his
hut for a photograph.

≫ *Woman from Zinacantan, Mexico*
I had read that the Tzotzil Indian village of Zinacantan had banned
photography. Local inquires suggested this wasn't the case, but there
were some restrictions and extra sensitivity was called for. To avoid
potential problems I chose to visit with a local guide. He introduced me
to a family who were quite happy to be photographed.

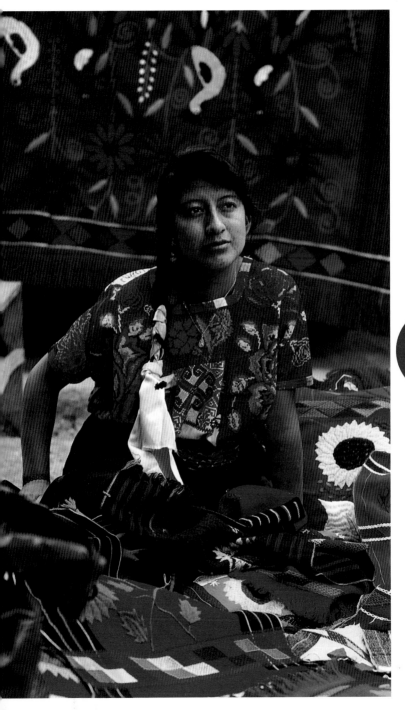

Environmental portraits add context and allow the viewer to learn something about the person. This kind of portrait lends itself to the use of wide-angle lenses. The wider field of view offered by 24mm, 28mm or 35mm lenses allows you to get close, but still include plenty of information about where they are. Slower shutter speeds can be employed to maximise depth of field. This is important because the location is an integral part of the picture. Get close so that nothing comes between the camera and the subject. This technique is great for crowded situations such as markets and busy streets.

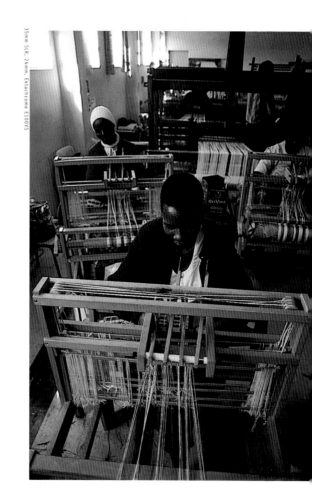

35mm SLR, 24mm, Ektachrome E100VS

〉 *Weavers, Bulawayo, Zimbabwe*

At Bulawayo Home Industries, the weavers were working on looms. I chose to photograph this weaver because she was working by a window. The available light ensured natural looking colours and retained the atmosphere of the environment.

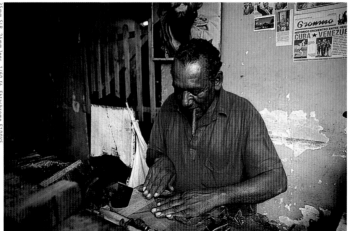

⌃ *Cigar maker, Trinidad, Cuba*

People at work make excellent subjects for environmental portraits. They're often less self-conscious in front of the camera because they're occupied. This cigar maker was working in a dim room, but by opening the window shutters on one side of the room I had just enough light to hand-hold the camera and use standard 100 ISO film.

⌄ *Potters, Bhaktapur, Kathmandu Valley, Nepal*

Newly made pottery is placed in the sun to dry in the Potters' Quarter of Bhaktapur, the third major town of the Kathmandu Valley. This portrait clearly shows what these men do and where they do it. The 24mm wide-angle lens allowed me to get close to show the detail of the work and still include background for context.

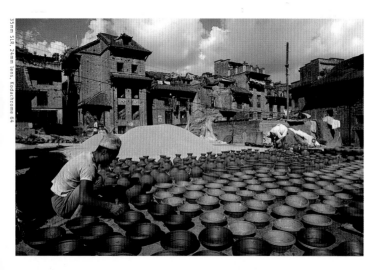

GROUPS

People gather in groups large and small for all sorts o
reasons: to wait for a bus, watch a street performance
make a purchase at a market stall, even just to stan
around and watch the foreigner take photos. Unlike the
formal groups we like to pose at home, groups encoun
tered on the road are best treated as informal; photograph
them how you find them. The larger the group the les
chance you have of getting a shot where everyone look
good, so take as many frames as you can.

When you've taken the group shot consider moving, o
zooming in on, individuals for portrait shots.

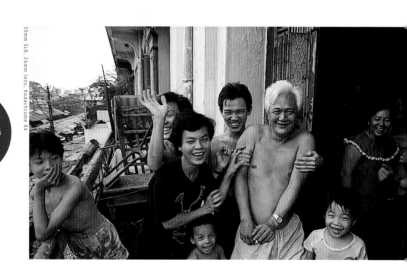

⌃ *Family at home in Cholon, Ho Chi Minh City, Vietnam*

In my search for a viewpoint over Cholon Market, I was invited into a house overlooking the street
The whole family joined me on the balcony. Before asking for permission to photograph, I put a
24mm lens on and set the shutter speed and aperture. My suggestion to photograph them resulted
in great hilarity and while they organised themselves I was able to shoot a group shot with lots of
life and a spontaneous sense of fun. You can't ask people to pose like this.

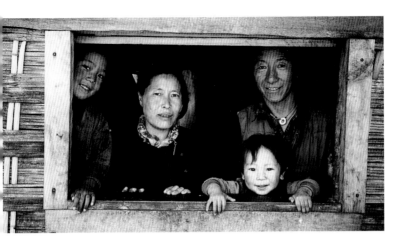

∧ Family in shop window, Bhumtang, Bhutan

This family appeared at the window of their shop upon hearing English spoken outside. I had the compact camera in my hand and quickly took a frame rather than risk losing the shot while I changed cameras.

∨ Father and children, Istanbul, Turkey

This family was sitting in a quiet spot near the Blue Mosque. My request for a photo was happily received but the mother didn't want to be included. Once the family had rearranged themselves I took one shot — my film budget didn't stretch to multiple shots when I first started. With groups, especially featuring children, it's very hard to get everyone looking good in the first frame. Fourteen years later I would use four or five frames on a group like this.

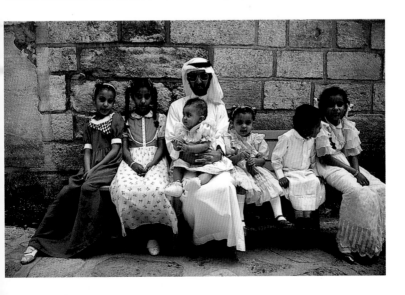

Many people feel more comfortable taking pictures of children than adults. They're usually very enthusiastic about being photographed and will often give you the time to take several frames.

A great way to break the ice with children, and to give them something in return, is to let them look through the viewfinder. This is especially exciting for them if you have a telephoto lens on. It's a good idea, if you can, to turn the camera off – some children are very quick to figure out how to press the shutter!

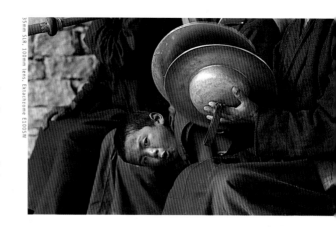

› Novice monk, Tengboche Monastery, Khumbu Himal, Nepal
During preparation for the annual monastery festival, this novice monk was quite happy to play peek-a-boo with the tourist, disappearing between his friends every time the camera went to my eye. Fortunately, he peeked once too often and lost.

35mm SLR, 100mm lens, Ektachrome E100SW

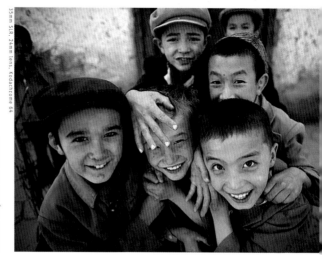

› Schoolboys, Kashgar, China
On their way home from school these young Uiyger boys were only too willing to pose for the camera – in fact, it was their ideal! If you're walking the streets hoping to take photos it's much better to have your camera out – they only asked because they saw the camera.

35mm SLR, 24mm lens, Kodachrome 64

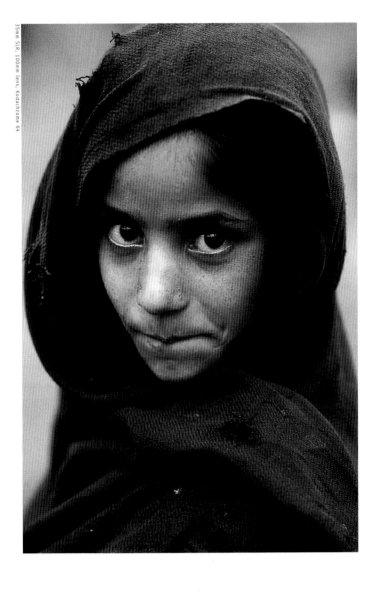

∧ *Girl from Sonamarg, Kashmir, India*

This image has all the elements I aim for in a portrait. An interesting face, a natural pose, a unique expression, eye contact, no distracting elements and a background that complements the colours of the subject. She gave me one frame before running off to join her friends.

Treat taking pictures of your friends as seriously as the other people pictures you take. A great way to get good shots of your companions on the road is to look out for situations where they are interacting with the locals or are occupied with something of interest. This will create much more rewarding shots than by getting them to look at the camera. Look for instances where your friends are bargaining for a souvenir, loading packs on the bus roof or looking at temple statues, etc. Your photos will capture the travel experience in an active rather than passive way.

>> *Street market, India*

Every village we stopped at while cycling in Rajasthan brought crowds out. To capture this I looked for a suitable location where I could get a viewpoint without being engulfed in the crowd myself. I asked a fellow traveller to look at the goods for sale. Within a minute a crowd had gathered.

>> *Cycling in Rajasthan, India*

To contrast the crowds of the town a peaceful, rural image was required. Anticipating the place where the cyclists and the woman would meet I composed the shot and waited for the subjects to pass each other.

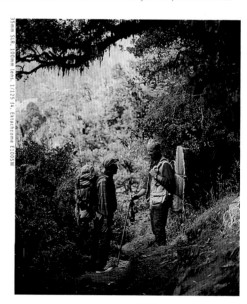

35mm SLR, 100mm lens, 1/125 f4, Ektachrome E100SW

> *Trekker and guide, Kanchenjunga region, Nepal*

Natural looking shots of your friends should be easy. If you don't manage to catch them in the right place at the right time, organise the elements yourself. The hardest thing about it is remembering to do it, or if you're trekking, finding the energy.

PEOPLE

TRAVEL COMPANIONS

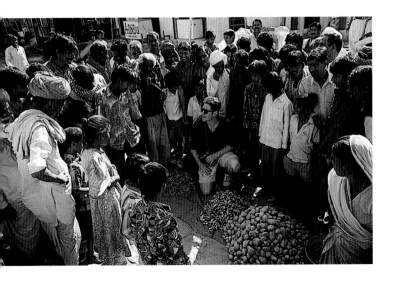

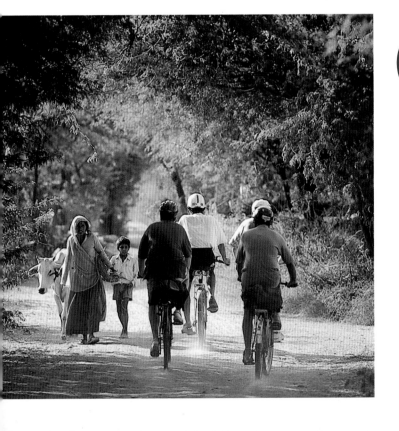

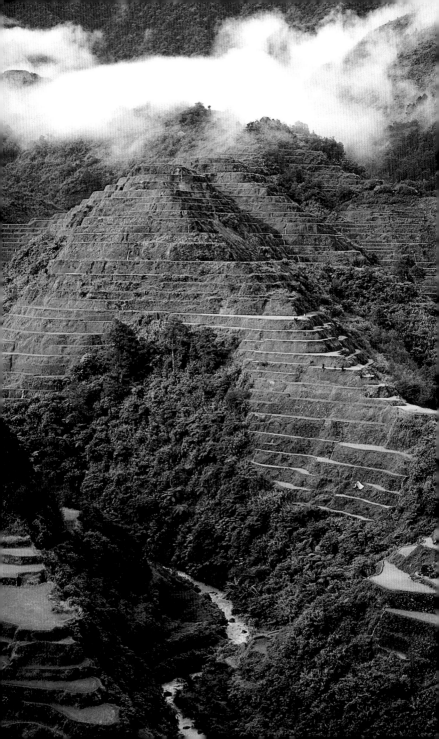

LANDSCAPES

When we look at a scene we scan a wide area noting the colour, beauty, scale and main features – we see straight through power lines and rubbish bins and create in our mind's eye a perfect impression of the scene. The camera sees everything, it doesn't know you didn't mean to include the toilet block on the left or the 'Keep Out' sign on the right.

When you're confronted with a beautiful scene it's very tempting to put on the widest lens to try and get every-thing into your composition. Remember that landscapes don't have to always take in the big scene. Isolate ele-ments that say something about the environment and complement the panoramic views.

As with all good compositions, there needs to be a point of interest in the landscape, a main feature that can hold the viewer's attention. Choice of an appropriate lens plays a major part in achieving this.

Wide-angle lenses increase the foreground and sky con-tent, exaggerate sweeping lines and make the subjects in

« *Rice terraces, Banaue, Philippines*
The rice terraces of Banaue have been referred to as the eighth wonder of the world. Often after heavy rain there will be a period of beautiful light. This shot was taken in that fleeting moment between downpours.

a landscape smaller. Make sure that the foreground and sky are interesting and relevant to the composition. Telephoto lenses allow you to select a part of a scene and to flatten the perspective making the foreground and background elements appear closer to each other. What you focus on will become larger.

Generally, the aperture is given priority when shooting landscapes, to ensure sharpness from front to back. For maximum depth of field, focus on a point one-third into the scene, just beyond the foreground subject, and stop down to f16. Use the depth of field button to confirm visually what you're hoping to achieve. At this aperture, with 100 ISO film, shutter speeds will drop below 1/15 second. A tripod and cable release are essential equipment for the serious landscape photographer. On windy days slow shutter speeds will record movement in the landscape. Swaying branches will blur at 1/15 second or slower depending on how strong the wind is. This can be very effective if desired. Clouds may also blur if exposures are longer than half a second, which isn't so effective. As you compose landscapes pay particular attention to the horizon and check the elements in the frame.

· Place horizons carefully. Start with the rule of thirds to ensure the horizon is placed away from the middle of the frame. If the sky is dull and lacking detail it will look flat. Place the horizon in the top third of the frame. If the foreground is uninteresting place the horizon on the bottom third. If both do nothing for the photograph eliminate them by moving closer or zooming in.

· Horizons should be straight.

· Scan your viewfinder before you release the shutter to check for unwanted elements, particularly at the edges of the frame.

· Don't accidentally photograph your shadow in the landscape. You have to be especially careful when shooting very early or very late in the day with wide-angle lenses. Shoot from a low angle or position your shadow in a natural shadow area of the composition.

Because landscapes don't walk off like other subjects you can spend time experimenting with composition and exposure. Return to the same place at a different time to experiment with light. Professional landscape photographers habitually rise early for first light and return two or three hours before sunset to make the most of the warm, low angle light. This light is available to everyone. You don't need expensive equipment to get up early ... just a good alarm clock and a lot of will power.

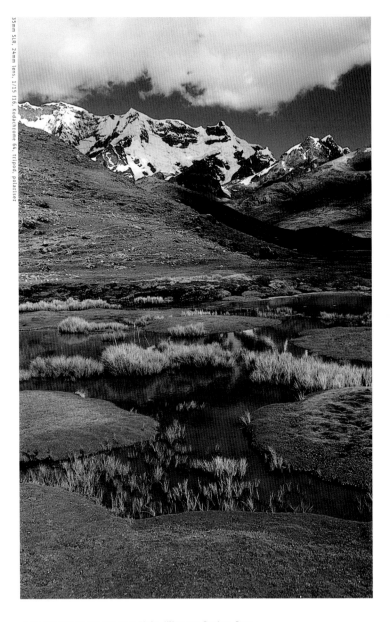

⌃ Mt Ausangate and the Upis Plain, Vilcanota Region, Peru

The aperture is usually given priority in landscape photography to achieve maximum depth
of field. In order to keep the ground cover *and* the mountains sharp, with the foreground so
close to the lens, a very small aperture was required. You can't achieve this depth of field
if you're using slow, fine grain film and a polarising filter, without the use of a tripod.

There's nothing quite like being in the right place to photograph the first and last rays of warm light on snow capped mountains.

Big mountains always look impressive, but when they're lit by the early morning or late afternoon sun and they glow pink or gold you'll be glad you packed that extra film. These colours don't last long and frequently occur at the same time as a build up of clouds, particularly in the evening. Rapidly changing and unpredictable weather is standard issue in the mountains and demands that photographers are patient, organised and fully prepared before the light show begins.

· Be in position at least half an hour before sunrise and an hour before sunset.

· Mount your camera on a tripod.

· Spend time, while you're waiting, experimenting with different compositions and lenses and decide which composition you'll start with. You may only get one chance, so make the first shot count.

· If cloud is threatening to engulf the mountain take a photograph every couple of minutes in case it disappears completely before the light peaks.

· Ensure you have plenty of frames left. The mountain can disappear in cloud in the time it takes to change films.

∨ *Sunrise in the Annapurnas, Dhampus, Nepal*
One of the great advantages of trekking in the mountains is that you often don't have far to go, after you've dragged yourself out of bed, to catch the sunrise. I shot this from outside my tent (I wish it were always that easy). Mountains are more likely to be clear in the mornings and the intense colours don't last long.

35mm SLR, 100mm lens, 1/8 f11, Ektachrome 50STX, tripod

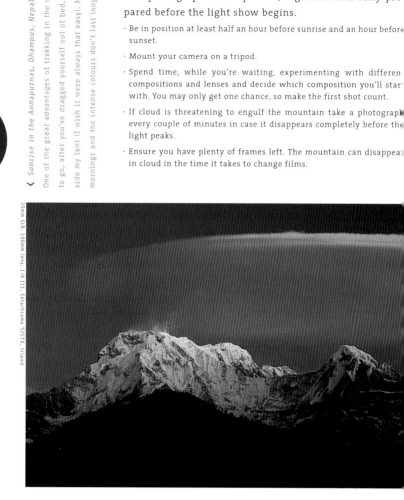

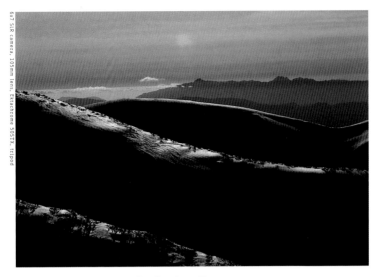

∧ *Ranges to Mt Buffalo, Victorian Alps, Australia*

Back lighting has highlighted the tops of the snow-covered ridges emphasising their shape and separating one from the next. The exposure difference between the highlights and shadows was too great to even think about retaining detail in the shadows. By exposing for the highlights (with slide film), the detail in the snow and the colour in the sky were retained. The shadows were allowed to go black to create a dramatic image.

∨ *Inca trail peaks, Peru*

Each frame brings something different when photographing mountains – shadows, light and cloud come and go. Patience will be rewarded with a photograph that captures just the right mix of mountain, cloud, shadows and highlights.

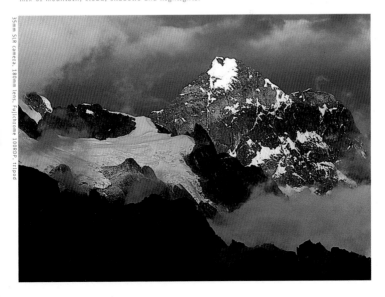

125

Snow causes a high level of reflection when it's the dominant element in a shot. The camera meter will underexpose the film, particularly on sunny days. To compensate, override the meter and overexpose by one or two stops. Bracketing in half stop increments is recommended to guarantee an accurate exposure, and is shooting early or late in the day. The lower angle of the sun will bring out detail and texture in the snow and the contrast levels are more manageable.

In overcast conditions snow will record with a bluish cast. An 81B warming filter eliminates this colour shift and helps keep the snow white. Be careful using polariser filters for snow scenes. Often blue skies are already very dark and can go almost black.

When shooting landscapes in snow be aware of where you're walking – you could leave your own footprints in an area you want to photograph. (See Protection from the Weather in the Trip Notes chapter for information on photography in the cold.)

>> *Mt Hotham, Australia*
Bright snow will usually cause the meter to underexpose the scene. The snow gums in the foreground helped balance out the meter reading and I overexposed the meter reading by one stop. Even with the latest multi-zone metering systems, it's always wise to bracket in difficult lighting conditions, particularly with slide film.

>> *Phortse after snowfall, Khumbu Himal, Nepal*
A very cold Himalayan morning, just after a snowfall, is accentuated by the way film records colour in open shade. The blueness could have been reduced with an 81C-warming filter, but I wanted the photograph to show just how cold it was.

Crossing Thorung La is the high point of the Annapurna Circuit, one of the most popular treks in Nepal. I slept with my camera in my sleeping bag and then walked with it under my jacket in the freezing cold at 4.30 am. By the time I was on the pass the sun was up. The side lighting has retained some texture in the snow but with such a large expanse of bright snow filling the frame it was necessary to overexpose the camera's recommended setting by 1½ stops. This retained the whiteness of the snow and the little colour that there was in the porter's clothing.

< *Porters on Thorung La, Annapurna Region, Nepal*

35mm SLR, 28-90mm lens, Kodachrome 64

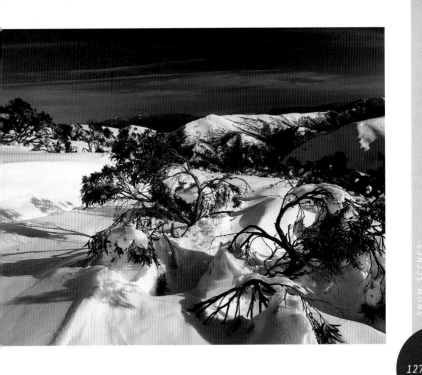

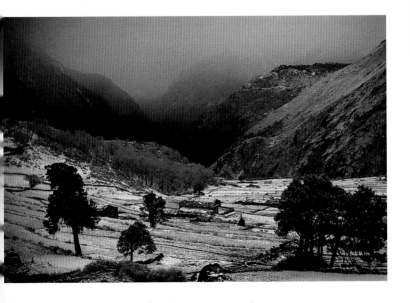

Photographing deserts is a little like photographing snow except you'll probably be too hot instead of too cold. If conditions are really bright, bracket exposures, favouring overexposure up to one stop. As usual, early morning and late afternoon sun will make desert landscapes much more interesting. The low angle of the sun's rays will emphasise the contours of the dunes and bring out the details and textures in the sand. Remember to watch where your own shadow is falling and not to leave foot prints in areas you want to portray as pristine. Look for a vantage point to survey the area and walk around the edges of potential picture subjects. Climb dunes on the shadow side, as you're less likely to make it a feature of the landscape. Extra attention must be paid to camera care. (See Protection from the Weather in the Trip Notes chapter.)

>> Pinnacles Desert, Nambung National Park, Australia

Limestone pillars are a feature of this coastal, desert national park and many people come to photograph them. It can get crowded during the day and it's hard to avoid other people in the background and footsteps in the sand. The only way to get pristine-looking images is to get there before everyone else or walk a lot further from the road.

∨ Camels on dunes, Jaisalmer, India

Riding camels in the Thar Desert is a popular activity for travellers visiting Jaisalmer. Take a sunset trip – the weather will be more pleasant and the light is ideal for photography. Protect your camera equipment before you start walking on the dunes. The day after I took this shot my auto-focus lens was made unworkable by a single grain of sand.

LANDSCAPES

DESERTS

35mm SLR, 28mm-90mm lens, Kodachrome 64

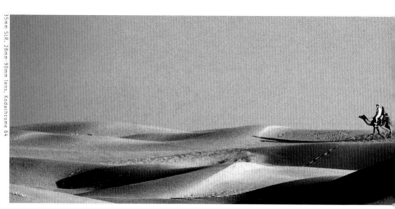

6x7 SLR 45mm lens, 1/8 f16, Ektachrome 50STX, polariser, tripod

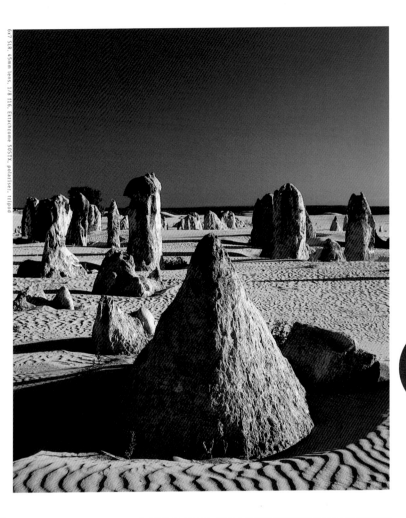

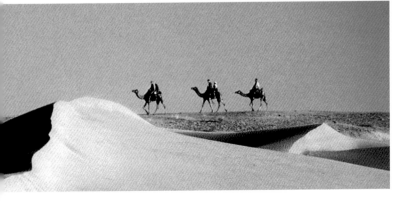

High cliffs, rugged coastlines, pounding seas, still rock-pools, beaches, boat harbours and lighthouses ... the coast has enough photographic possibilities to give you no time to lie around on the beach all day. The sea adds an intriguing new element to landscapes. Unlike the rock-solid landforms it meets at the shoreline, the sea is in a constant state of change. Not only does the light change throughout the day, so does the subject. Fast shutter speeds (higher than 1/250 second) will stop the motion of the waves and freeze sea spray. Slow shutter speeds (less than 1/2 a second) will blur the waves and soften the seascape. A polarising filter will often improve the colour and contrast in photographs taken around water by reducing the glare of the light reflecting off the water. (See the Protection from the Weather section in the Trip Notes chapter for information about protecting your equipment around salt water.)

35mm SLR, 24mm lens, 1/125 f8.
Ektachrome E100VS

1/125 f4 1/2

To get the most out of a trip to the coast, try some of the following:

· Head down to the waterfront in the morning to catch the colourful and interesting fishing boats.

· Explore fish markets and shops until lunchtime.

· Walk along the beach in the afternoon and then head out to photograph the natural beauty of the coast a couple of hours before sunset.

Before you know it another day in paradise has whizzed by.

∧ *Sand dolphin, Varadero, Cuba*

Veradero is Cuba's most popular international beach destination, attracting thousands of Canadians and Europeans who fly directly to the international airport. The beach and blue Caribbean sea are the main attractions. Bright sand, if it's dominating the scene, will cause the meter to underexpose the film. Compensate by increasing exposure by 1/2 to 1 1/2 stops.

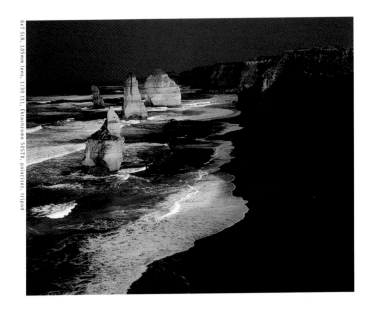

6x7 SLR, 105mm lens, 1/30 f11, Ektachrome 50STX, polariser, tripod

^ *The Twelve Apostles, Port Campbell, Australia*

The natural rock formations known as the Twelve Apostles are a major attraction, but few people see them in great light. This shot was taken in the early morning with a storm threatening. Getting up early may not be the thing to do on holiday, but it's the thing to do to when you're chasing great landscapes.

∨ *Table Mountain, Cape Town, South Africa*

It took three trips out to Blouberg beach to get a view of Table Mountain unobscured by cloud. A slow shutter speed has recorded movement in the waves and softened the foreground, which has been emphasised by placing the horizon high in the frame.

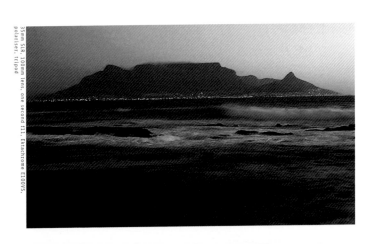

35mm SLR, 100mm lens, one second f11, Ektachrome E100VS, polariser, tripod

In many coast and beach destinations you'll find that some of the attractions are under the water. Serious underwater photography requires specialist photographic equipment such as Nikonos cameras or underwater housings for conventional cameras, macro lenses, sports finders and bulky flash equipment. It also helps if you're a good diver.

For the non-diving traveller you can use underwater APS or 35mm compact auto-focus cameras, single use, or disposable cameras (the cheapest option). These cameras are capable of acceptable results on sunny, calm days at depths of 2m to 3m, making them suitable for recording your snorkelling or shallow dive experience. Even with these cameras, it's worth remembering that water acts as a filter on sunlight, reducing its intensity and changing its colour. The deeper you go the more light is absorbed and the bluer your pictures will become. Colours should record naturally down to 2m or 3m, but in deeper water a flash is essential to capture the natural colours of marine life. To increase the number of successful shots without diving and underwater photography experience, aim to:

· Shoot in the middle of the day, between 10 am and 2 pm, when the sun is at its brightest and the maximum amount of sunlight penetrates the water.

· Look for subjects in shallow areas.

· Use fast 200 ISO or 400 ISO film and fast shutter speeds to prevent camera shake and subject movement.

· Get as close as you can to your subjects. Colours will be stronger, contrast higher and pictures sharper, if you keep subjects within 3m or 4m.

· Soak your camera in fresh water as soon as possible when back on dry land.

If you're keen to experiment and learn more about underwater photography, some dive destinations hire underwater camera equipment and offer introductory lessons. This is an excellent way to use professional equipment without the expense of buying it.

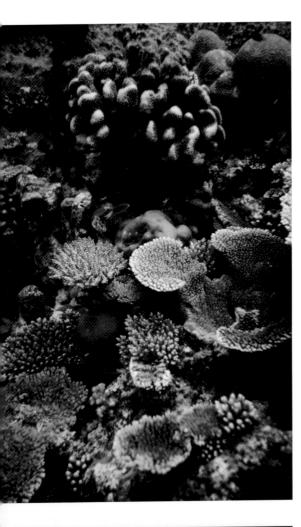

< Yellow-tailed fusiliers,
Great Barrier Reef, Australia

< Coral, Great Barrier Reef, Australia

Snorkelling provides the traveller with an accessible window into the world of underwater photography. I don't shoot underwater regularly, but when you're somewhere such as the Great Barrier Reef it's hard to resist. Be patient – let the fish come to you and you'll get much better results than chasing them around.

6x7 SLR, 105mm lens, Ektachrome 50STX, tripod

Rainforests are one of the most difficult land-scapes to photograph well. Often the light is too low to hand-hold the camera and causes automatic flashes to fire. If the sun is shining strongly enough to break through the canopy, the trees become speckled with uneven light and pictures will look colourless and messy. The best time to take pictures in a rainforest is after it's rained, or in light drizzle. The cloudy skies guarantee an even light and the water on the leaves adds life and emphasises the colour. With fine grain film, polariser and low light, shutter speeds will be too low to hand-hold. Use a tripod to get maximum depth of field. The polariser will cut down the reflection off the wet leaves, increasing the intensity of the colours.

Without a tripod, or with compact cameras, look for brighter areas of the rainforest where hand-held photo-graphy may be possible. You'll find these around the edges of the forest or in clearings near streams, rivers and waterfalls.

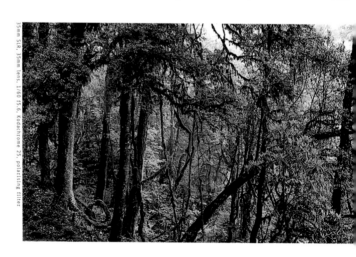

35mm SLR, 35mm lens, 1/60 f5.6, Kodachrome 25, polarising filter

⌃ *Rainforest above Bakkhim, Sikkim, India*
In a more open patch of rainforest like this it's possible to hand-hold the camera.

⌃ *Palm leaf, Daintree, Australia*
If the lighting is patchy or you can't find a suitable viewpoint for a scenic shot, look for details that are evenly lit.

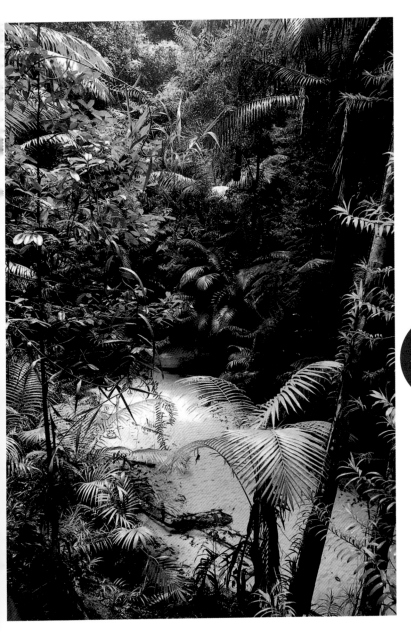

∧ *Wangoolba Creek, Fraser Island, Australia*

Wangoolba Creek on Fraser Island is one of the most beautiful and atmospheric patches of rainforest in Australia. In the soft light of a rainy day the colours are intense and detail is easily recorded in all parts of the scene.

The flowing water of rivers and waterfalls can be interpreted in different ways through shutter speed selection. To give the impression of running water experiment with shutter speeds from 1/30 to one second. If the flow is fast a 1/30 second will do and you may be able to hand-hold the camera using a wide-angle lens. For best results and maximum depth of field use a tripod. Start at 1/15 second and go down to one second depending on the rate the water is flowing and the amount of blur you're after. Quite a different effect is achieved with fast shutter speeds (1/250 second and higher), which 'freeze' the water in mid-flow bringing out colour and detail in the water. Like rainforests, waterfalls photograph best in the even light of a bright overcast day. Contrast between the water and the surroundings is often naturally high, and the soft, indirect light allows detail to be recorded in the highlights and the shadows. A polarising filter can improve the images by cutting out reflections from the wet rock and surrounding vegetation.

» Bridal Veil Falls, Yosemite National Park, USA
When a high waterfall is flowing fast even fast shutter speeds don't completely freeze the water. The tight vertical framing of this waterfall isolates it from its environment and emphasises its height.

6x7 SLR, 45mm lens, 1/2 ill, Ektachrome 50STX, polarising filter, tripod

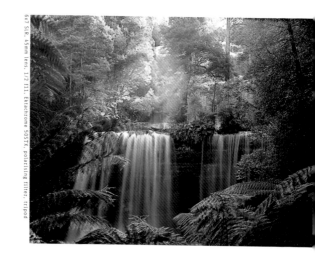

∧ Russell Falls, Mount Field National Park, Australia
The shutter speed and the speed the water is flowing control the amount of blur. Longer exposures provide a softer and milkier effect than short exposures.

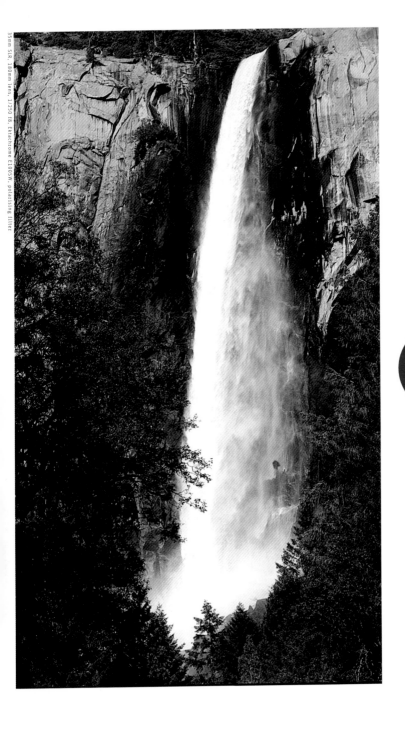

LAKES & REFLECTIONS

Lakes add a dynamic element to a landscape. Be aware
that a gust of wind can change the look of the lake sig-
nificantly – a mirrored landscape can quickly become an
abstract interpretation of the same scene. Reflections
can't be guaranteed, but are more likely early in the day.
See what effect a polarising filter has on the reflection as
you rotate it. You can sometimes get two different look-
ing photos by changing the position of the filter. The
reflected part of the landscape is often darker than the
actual subject. Take your meter reading from, and focus
on, the landform rather than the reflection so that the
landform is sharp and correctly exposed. If there's more
than two stops difference between the two parts of the
composition a graduated neutral density filter will even
out the lighting.

> *Ulun Danu Bratan Temple, Bali, Indonesia*
In the early morning this beautiful Hindu/Buddhist temple is reflected in the waters of Lake
Bratan. Sometimes placing the horizon in the centre of the frame does work, especially with
reflections at it emphasises the symmetry of the scene.

6x7 SLR, 105mm lens, Ektachrome 100STS, tripod

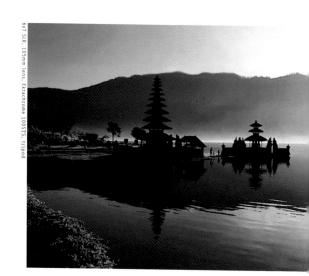

>> *Bungle Bungles, Purnululu National Park, Australia*
Wherever there is water lying around there is the possibility of a reflec-
tion. A reflection in the little water left in the essentially dry riverbed
adds a surprising element to the landscape.

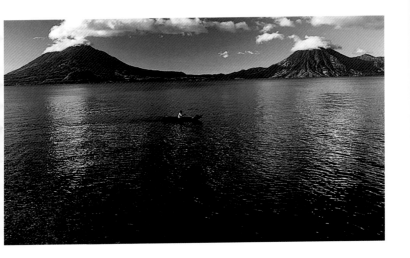

^ Lake Atitlan, Panahachal, Guatemala

The choppy waters of Lake Atitlan denied me a reflection of the volcanoes. It wasn't until the fourth morning and the appearance of clouds that I was able to take a photograph with added interest in the water. Although the sky was also interesting, I placed the horizon in the top part of the frame to emphasis the size of the lake. I used a polariser at half strength to increase the contrast between the clouds and the sky, but still retain some reflection off the water.

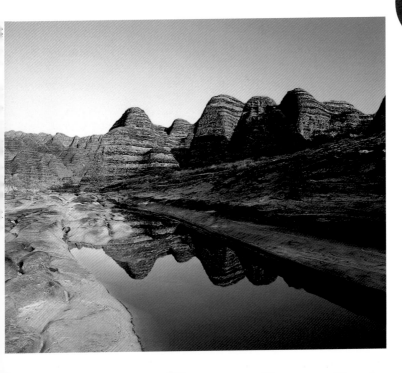

RAINBOWS

Fleeting and colourful, rainbows add a surprising element to a landscape. Like colourful skies, a rainbow in your composition doesn't automatically make it a good photo. The landscape itself should be interesting, and then enhanced by the inclusion and careful placement of the rainbow. Use a polarising filter to increase the contrast between the rainbow, clouds and sky. It will strengthen the colours of the rainbow and cut down distracting reflections in the landscape. In some cases rainbows will not record on film without the aid of a polariser. Rainbows will really test your ability to work quickly – they rarely last more than a few minutes – and be prepared to get wet.

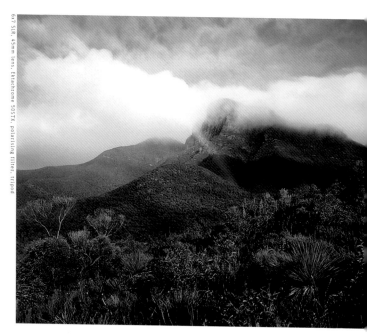

6x7 SLR, 45mm lens, Ektachrome 50STX, polarising filter, tripod

⌃ Bluff Knoll, Stirling Ranges, Australia

The up side of a rainstorm is that when it ends there's often a period of wonderful light as the sun breaks through the clouds. When it does the chance of rainbows is high, but the trick is to find a landscape to include with the rainbow. A rainbow alone won't make any photograph worth looking at. A polarising filter intensifies the colours of rainbows, but in this landscape it also cut out the reflections from the wet vegetation.

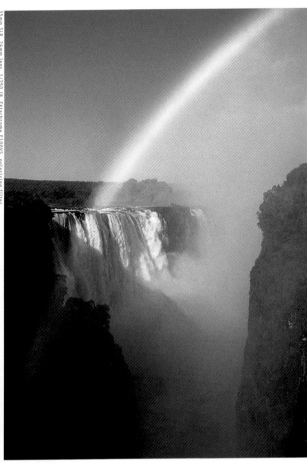

35mm SLR, 24mm lens, 1/250 f8, Ektachrome E100VS, polarising filter

〈 Victoria Falls, Zimbabwe

Rainbows also appear on waterfalls if the sun strikes the rising spray at just the right angle. Around mid-afternoon is a good time to see the dramatic rainbows that form on Victoria Falls.

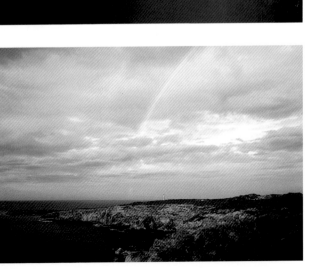

6x7 SLR, 45mm lens, Ektachrome 50CTX, polarising filter, tripod

〈 Cape Du Couedic, Kangaroo Island, Australia

The double arch of a rainbow above the lighthouse lasted about one minute. When the sky is interesting, emphasis it by placing the horizon in the bottom third of the frame.

Flowers are a common travel subject that require close focussing for impact. Without macro equipment, avoid making your pictures look like flower studies by treating the flower as one element of the picture. Alternatively fill the frame with the colour of many flowers. If there is the slightest breeze flowers move and blur, which can look great if it's what you want. Shutter speeds for hand held shots will stop most movement, but if using speeds slower than a 1/60 (on a tripod) wait for a still moment. Light coloured flowers against dark backgrounds can fool light meters, so meter for the flower to maintain detail and colour.

35mm SLR, 100mm lens, 1/2 f11, Ektachrome 50STX, tripod

∧ *Wildflowers, Nyalam, Tibet, China*

It's so easy to miss subjects like this when you've got a clear objective in mind. I was up in the hills behind the village of Nyalam photographing the mountains when the flowers caught my eye. I changed my focus from 6000m peaks to 6mm flowers (using the same lens). I spent the next few minutes quickly photographing the flowers before the sun reached this part of the hillside and the frost disappeared.

》 *Cosmos, Morioka, Japan*

If your equipment doesn't let you get close, look for expanses of flowers and go for a more scenic approach. By eliminating other elements from your composition you'll still have a flower photo. I use a 50mm standard lens and 100mm lens for taking close-ups. The 100mm only focuses down to 0.7m (20 inches), but its magnification increases the size of the subject sufficiently for the kind of general close-ups I take.

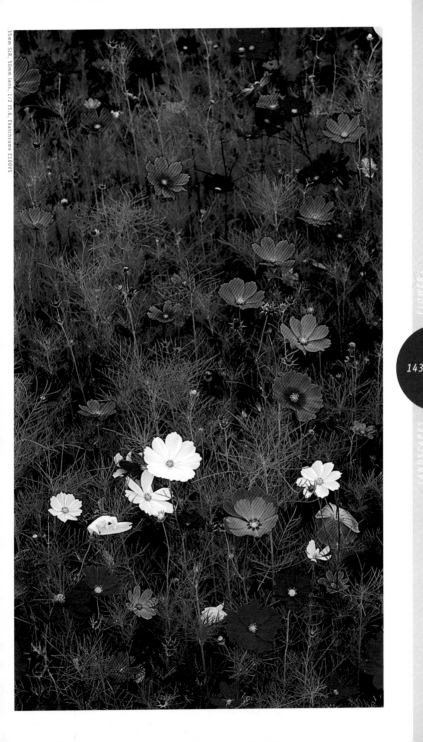

35mm SLR, 50mm lens, 1/2 f5.6, Ektachrome E100VS

Include a human element in a landscape and you add
sense of scale that is clearly understood. Place the ele
ment in the middle distance and use a standard to tele
photo lens for best effect. If the subject is too close t
the camera and you use a wide-angle lens, perspectiv
will be exaggerated. The subject will appear far bigge
than the background elements, and all sense of scal
will be lost. If you are using people to show scale, ensur
that they're looking into the scene. This will lead th
viewer's eye to the main subject rather than to the edge
of the composition.

HUMAN SCALE

LANDSCAPES

> *Walking to Vernal Falls, Yosemite National Park, USA*

Everyone told me Yosemite would be crowded in summer. I didn't really notice it until I had to queue to get to Vernal Falls. Then again, I had left it until the middle of the afternoon. By including the people on the trail, the size of the falls is emphasised and the experience of the walk is captured.

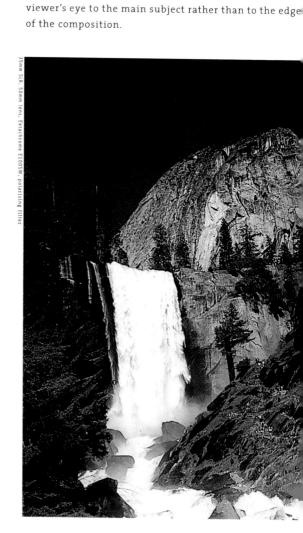

35mm SLR, 50mm lens, Ektachrome E100SW, polarising filter

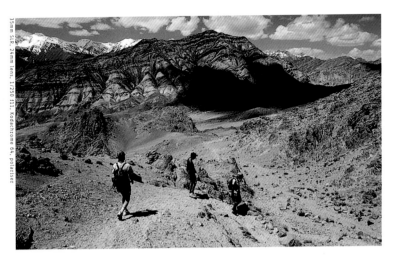

35mm SLR, 24mm lens, 1/250 f11, Kodachrome 64, polariser

∧ *Trekking from Chiling to Sumdoo, Ladakh, India*

The inclusion of the trekkers emphasises how vast the landscape in this remote part of the Indian Himalaya.

∨ *Road to Uluru, Australia*

Uluru is big, but until you've been there you don't realise exactly how big it is. The road and the car provide familiar reference points to help establish a sense of size. If the sky had been eliminated the sense of scale wouldn't be quite so clear.

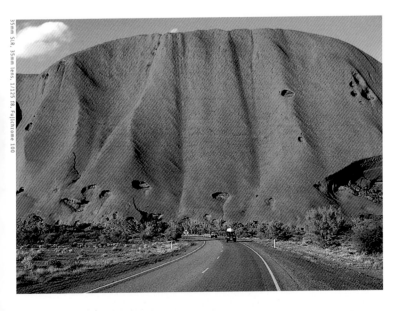

35mm SLR, 35mm lens, 1/125 f8, Fujichrome 100

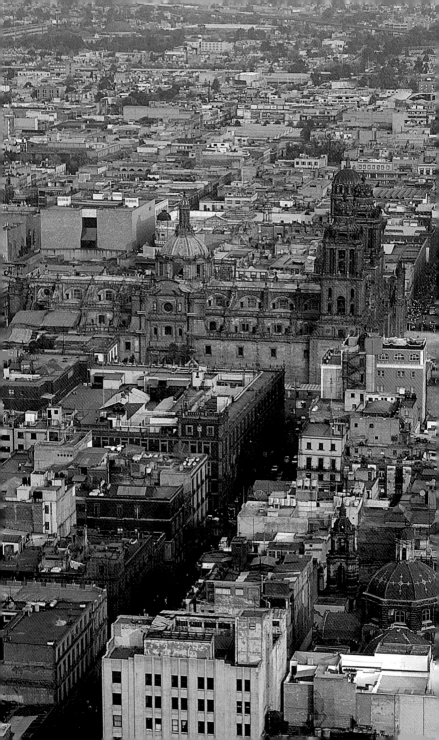

CITIES

Cities offer enormous photographic opportunities. Within all cities you'll find focal points that present scenes, buildings and activity that typify the country and go way beyond the glossy brochures. After you've seen the famous places, spend some time wandering the streets, observe daily life and delve deeper into the city atmosphere.

O *The key to photographing a city is to walk, walk, and walk.*

When you've walked everywhere: do it again in a different direction, at a different time of day, in different weather, on a different day of the week. Venture away from the regularly visited areas and you'll discover lots of people who aren't tired of having their photo taken.

City tours are offered everywhere and are useful to get a quick overview of a new city and its main sights. However, they have limited use for good photography as they're usually run in the middle of the day and give very little time at each destination. If you're budget isn't too tight forget the bus and do the same thing in a taxi.

« *View to the Zocalo, Mexico City*

« I always take the opportunity to photograph cities from their designated look-outs. The view from the Latin American Tower in Mexico City is a must for any tourist. The city disappears into the haze in all directions but the tower is close enough to the historic centre, known as the Zocalo, on one side, and the high-rise towers on the other, for a good selection of shots.

Skylines and city views are great scene setters for your album or slide show, providing a context for the photos that follow. Big cities often have official vantage points on nearby hills or at the top of tall buildings that provide great views of the city. The local postcards and tourist brochures will feature these views, so you can plan the best time to go. These places are easily accessible and you know what you'll be seeing. After taking in the official views seek out different vantage points to create unique photos. Smaller places may not advertise a lookout, but most taxi drivers will know where you can look over their town. Hotels, of all standards, sometimes have rooftop bars and restaurants, which are easily accessed. Check out a few during the day noting where the sun will set and rise, and return later to the best placed viewpoint.

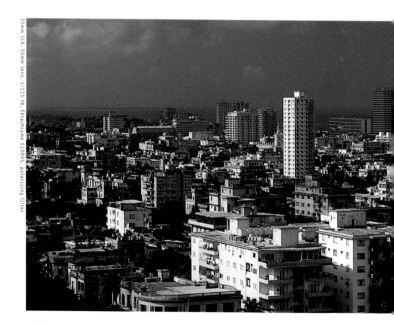

35mm SLR, 50mm lens, 1/125 f8, Ektachrome E100VS, polarising filter

⌃ *Havana, Cuba*

My guidebook listed the hotels in Central and Old Havana with rooftop bars. I picked three that were located centrally and did the rounds late one afternoon. You can try going up other tall buildings, but hotels are accustomed to foreigners and rarely ask questions.

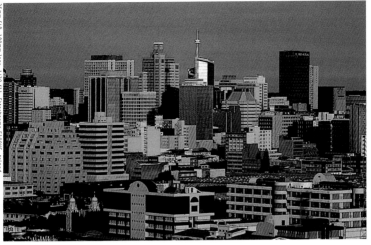

⌃ Durban, South Africa

When there are hills near a city there has to be a good view of the skyline from somewhere. With no previously published pictures as a guide I hired a taxi and explained what I was after. It took a while but eventually we found a piece of open ground with a clear view of the city. The driver had never been there before.

⌄ Paris, France

I had almost given up, the wind was cold, the light was dull and I'd been standing around for over an hour hoping the sun would break through the clouds. Fortunately, when it did the colour of the light was beautiful and I had the Paris view I had envisaged earlier in the day.

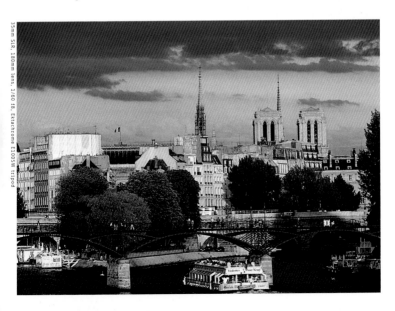

BUILDINGS

Tilt your camera up to photograph a building and it will appear to be falling backwards. Converging verticals or linear distortion can be effective when the composition exaggerates the distortion. Looking up at skyscrapers is a good example of this technique. To record buildings faithfully the camera must be level. Photographers specialising in architectural work achieve this with perspective correction (PC) or shift lenses that allow control of the angle of the plane of focus through tilt and shift movements. Perspective correction is also possible without specialist lenses by:

· Finding a viewpoint that is half the height of the building you're photographing.

· Finding an interesting foreground to fill the bottom half of the frame.

· Moving away from the building and using a telephoto lens.

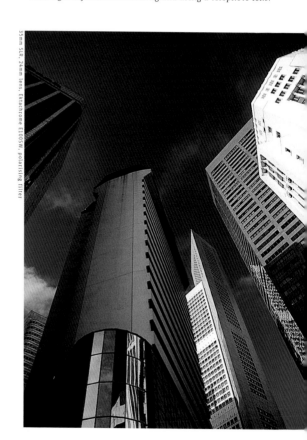

35mm SLR, 24mm lens, Ektachrome E100SW, polarising filter

> *Skyscrapers, Singapore*
Converging verticals can be used to good effect by exaggerating them.

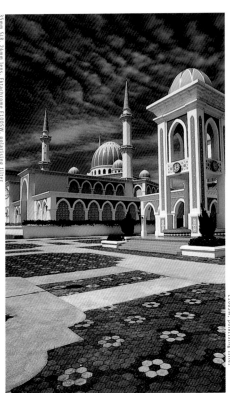

Sultan Ahmed Mosque, Teluk Chempedak, Malaysia

❮ By including an interesting foreground the film plane can be kept parallel to the building and the verticals are kept straight.

⌄ Alternatively, move back and use a telephoto lens to fill the frame with the building and keep the verticals straight.

⌄⌄ Looking up at the mosque from close range with a wide-angle lens has tilted the vertical walls and minarets backwards and inwards.

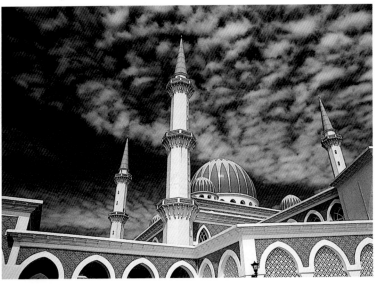

Every country has buildings on its 'must see' list. The Taj Mahal, Machu Pichu, the Great Wall, the Pyramids, the Eiffel Tower … places whose image is already deeply etched in our mind's eye years before we visit them. Photographed millions of times a year by visitors from all over the globe and printed in books, magazines and brochures, on postcards, tea towels, cups and place mats. If you want a real challenge, set yourself the double task of taking pictures of famous places that are as good as the published images, and then create a different photograph to those you've seen before.

152

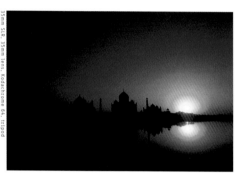

35mm SLR, 35mm lens, Kodachrome 64, tripod

❮ The Taj Mahal, Agra, India
I got the standard shots: morning, noon and evening. Now I wanted a different view. Not many visitors cross the river behind the Taj but it's the only place to be if you want to see the sun set behind India's most famous building. The price was a very uncomfortable 26km auto rickshaw ride. Take a taxi.

❯❯ Tower Bridge, London, England
Famous places always deserve more than one visit. On your first visit you'll probably be inclined to blaze away at the subject from all angles. Great, but a second visit can be approached more calmly and deliberately. A review of published material (postcards, etc) after your first visit will make a lot more sense. You'll know where things are and where the light will be. Revisiting places, especially after you've seen the results from your first attempt, is one of the best ways to improve your travel photographs.

❯❯ Machu Picchu, Peru
You sometimes have to plan ahead even for straightforward shots. I got up to the ruins two hours before they opened by organising a ride with the workers.

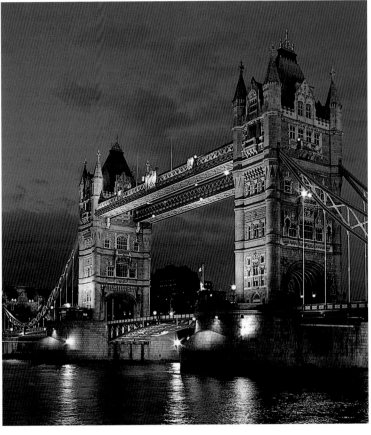

35mm SLR, 50mm lens, 2 seconds till, Ektachrome E100SW, tripod

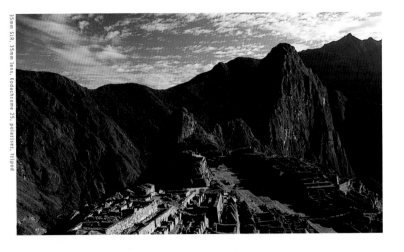

35mm SLR, 35mm lens, Kodachrome 25, polariser, tripod

154

Monasteries, temples, churches, mosques and shrines are a focus of day-to-day activity from the smallest village to the biggest city. They are great places to hang around camera at the ready. Places of worship attract a steady stream of pilgrims and devotees. At the entrances and in the surrounding streets, vendors selling religious paraphernalia, souvenirs and flowers contrast with the usually quiet, calm interiors. Around the buildings look for detail images that have relevance to the religion. Incense sticks and coils, texts and motifs on the walls all make interesting subjects and say something about the place and religion.

Visitors are generally welcome to enter and observe the activity in places of worship, and in return sensitivity and respect are expected. Find out if certain days or times of day are busier than others because you'll be far less conspicuous in a crowd. Always ask before shooting if there's any doubt as to whether photography is allowed. Religious ceremonies are not put on for the benefit of tourists and you really should take a step back and consider the situation before jumping in with all flashes blazing. It's possible to be respectful and still come away with a rewarding experience and images to match.

During ceremonies, especially those indoors, turn off the cameras film winder and flash. Take up a position where you can come and go without disturbing others and that makes the most of any available natural or incandescent light.

> *Evening prayers, Calcutta, India*
When I enter places of worship I always have my cameras out so I can shoot quickly and don't give the impression I'm trying to sneak pictures. At Tippu Sultan mosque I checked that it was OK to take pictures, took up a position on the west side and waited for the prayers to start. By arriving early I had the chance to talk to some of the men and tell them what I was doing so that when prayers began no-one gave me a second glance.

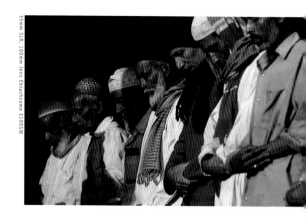

35mm SLR, 100mm lens Ektachrome E100SW

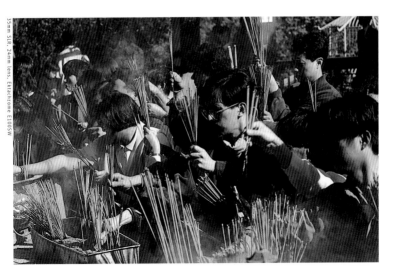

^ *Wong Sin Temple, Hong Kong*

When it's really busy at Wong Sin Temple it gets noisy and very crowded around the altar. Take advantage of these circumstances to get in close to the action and your pictures will have an intimacy about them. With this many arms and hands flying about, extra frames are well justified to ensure you get the shot.

∨ *Hain Sa Temple, South Korea*

Early morning at Hain Sa Temple there wasn't a lot going on. A solitary monk was sweeping around the temples so I followed him at a distance until he moved in front of one of the several impressive buildings in the temple grounds.

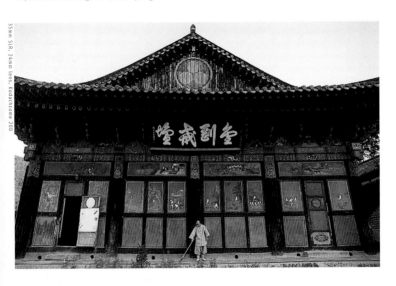

35mm SLR, 24mm lens, Ektachrome E100SW

35mm SLR, 24mm lens, Kodachrome 200

Photographing interiors requires the ability to switch from one technique to another depending on the amount of available light. Individual displays are sometimes lit with spotlights intense enough to allow the camera to be hand-held. Generally though, light levels are too low to photograph interiors with 100 ISO film hand-held. If this is the case, switch to a faster film, use flash or mount your camera on a tripod. Be prepared for all three situations. In many places flash and tripods are prohibited, so there's no choice but to use fast film or put your camera away. If flash is permitted remember to keep your subject within the range of your unit. The main advantage of a tripod is that you can use your standard fine grain film and get lots of depth of field.

Most interiors are lit predominantly with incandescent light, which records as a yellow-orange colour cast on standard film balanced for daylight. The actual colour and strength of the cast depends on the type and mix of artificial lights (see the Incandescent Light section in the Light chapter for more information). This caste creates ambience and shows that it was taken indoors. If you want to record the colours more faithfully use an 82 series colour conversion filter or tungsten film. (Unless you plan to take a lot of pictures with tungsten film it's impractical to carry on your travels.)

INTERIORS

CITIES

✓ Lima Cathedral, Lima, Peru

Interiors are rarely lit brightly enough to allow hand-held photography with slow or medium speed films. To photograph the interior of Lima Cathedral with a compact or built-in flash would be ineffective: the subject is too far away. With a tripod the amount of light available can be very low and your standard film can be used. The colour is different to the other interiors because of the varying mix of incandescent light sources.

35mm SLR, 24mm lens, 1/8 f11, Kodachrome 64, tripod

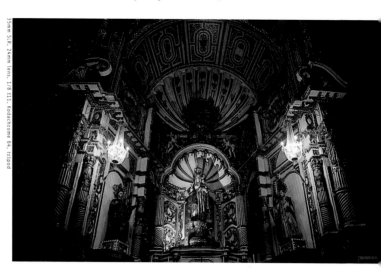

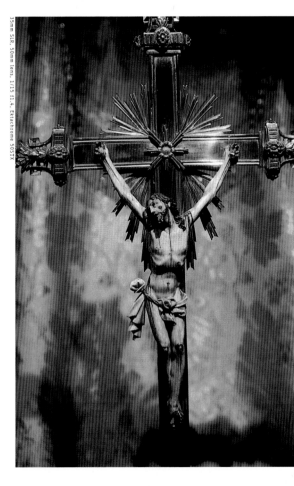

< Jesus on cross, Porto, Portugal

In the museum at Porto Cathedral this statue was displayed behind glass. By placing the lens firmly against the glass, reflections are cut out and slower shutter speeds can be used. Turn the camera's built-in flash off to prevent it bouncing light off the display cabinet.

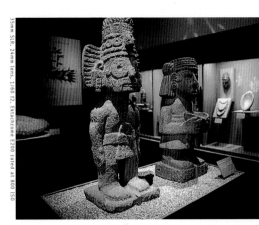

< Museum of Anthropology, Mexico City, Mexico

No flash, no tripod, no problem if you've got fast film on hand. If you haven't, look around for displays that are near windows or get close to individual displays that are lit with intense spotlights.

An itinerary that only takes in a country's main sight
will leave you with a limited experience and equally lim:
ted photo opportunities. Wandering the streets of a nev
city is one of the great pleasures of travel. In many cour
tries life is lived on the street. Meals are cooked an
eaten, clothes, bodies and teeth are washed, games playe
and business transacted, all in full view of the passin
public. As with all people photography you'll have t
develop your own approach to taking pictures of peopl
on the street, but the opportunities are many and varied

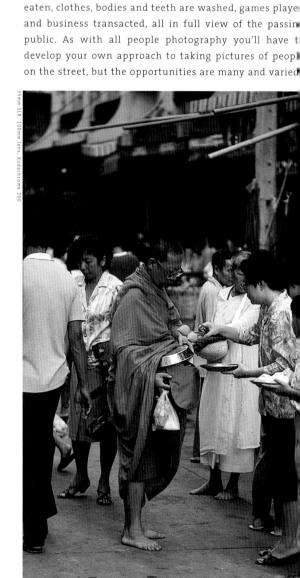

35mm SLR, 100mm lens, Kodachrome 200

> *Monk collecting alms, Bangkok, Thailand*
Every morning around 280,000 monks hit the streets of Thailand to collect alms. It's
a scene that says a lot about the country and its people. Just when you thought you
could sleep in, there's 280,000 more reasons to be up early.

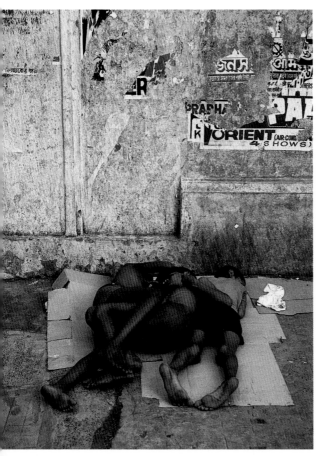

∧ *Street sleepers, Calcutta, India*

It's much harder to photograph the poor than the Palaces of Rajasthan, but both say something about India.

∧ *Monks in truck, Lhasa, Tibet, China*

You never know what you'll stumble across while walking the streets. You can be nowhere near a major tourist sight and something unique about the country will pass right in front of you. That's why your camera shouldn't be in the bottom of your day-pack.

AFTER DARK

Cities and buildings take on a completely different look and feel after dark and the images will add an extra dimension to your collection. The best time to photograph is around 10 to 20 minutes after sunset. By then the incandescent lighting provided by interior, spot and street lights will be the dominant light source, but there'll still be some light and colour in the sky. When it's completely dark, concentrate on filling the frame with well-lit subjects and avoid large areas of unlit space. Night photography requires a tripod and cable release, as exposures are generally long. To record detail, overexpose by one and two stops – otherwise the only thing that will come out will be the lights themselves. As with all difficult lighting situations bracketing is recommended.

> *Golden Temple, Amritsar, India*

The Golden Temple really lives up to its name when photographed at night. If you're going to the trouble of carrying a tripod use it for some night shots of key cityscapes and buildings. When you see the results you'll be pleased you went to the extra trouble.

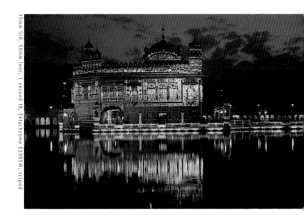

35mm SLR, 50mm lens, 1 second f8, Ektachrome E100SW, tripod

> *Times Square neon lights, New York, USA*

Fill the frame with neon lights and there'll be enough light to hand-hold the camera and automatic meter readings will usually be accurate. If you're using a fully automatic camera turn the flash off. Scan the frame to make sure you haven't left large areas of black space.

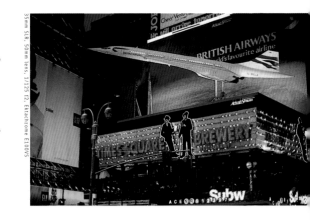

35mm SLR, 50mm lens, 1/125 f2, Ektachrome E100VS

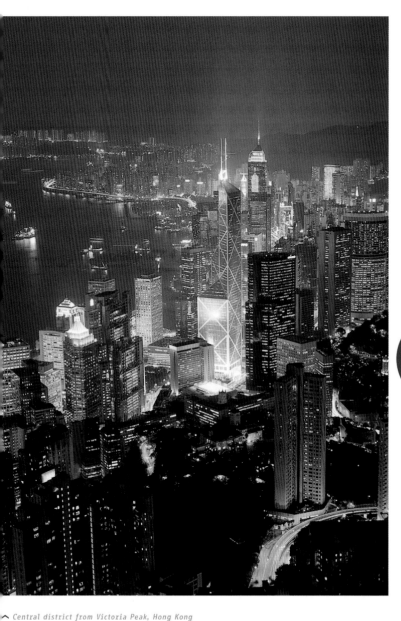

∧ *Central district from Victoria Peak, Hong Kong*

The view from Victoria Peak of the Central district of Hong Kong is spectacular anytime. At night it's quite magical. Usually skylines work best when there's still light in the sky, rather than late in the night. However, the best shot from the series of skylines I took was from the end of the session, when the light had almost faded and the city lights were at their brightest.

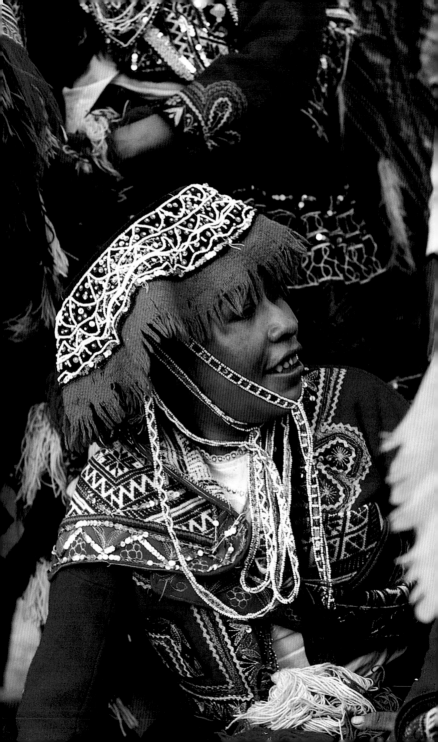

SPECIAL EVENTS

The spectacle, colour and crowds that are the hallmarks of special events around the world make them a great subject for travel photography. Research and planning will get you there on the right day and give you an idea of what you can expect to see. It's easy to be overwhelmed by the crowds and the uncertainty of not knowing exactly what, when and where things are going to happen. Early arrival at scheduled events gives you time to look around for good viewpoints, secure a seat and ask questions of local people and event organisers. Less organised events require more patience and flexibility, as it's often more difficult to find anyone who knows what's going on.

At seated events, getting close to the action can be difficult and a telephoto lens is essential. If you're stuck in one place or the participants are moving around a stage, wait for the action to come to you. Change lenses, zoom in and out, frame vertically and horizontally to get variety into your shots. Remember to turn your lens on the spectators who also make great subjects as they watch and react to the event.

《 *Inti Raymi, Cusco, Peru*

Inti Raymi (festival of the sun) takes place annually at the Inca ruins of Sacsayhuaman and attracts thousands of people. The focus of the event is a re-enactment. The central area is roped off and spectators are a long way from the action. A 300mm lens (or binoculars) is needed to see what's happening. However, once the formal proceedings are over there's a wonderful opportunity to mingle with the participants.

Festivals are fantastic events to photograph. They often occur as part of a holiday and attract local people from outlying areas. People dress up, are relaxed and in high sprits. Take advantage of the crowds and festive atmosphere to mingle with the locals and get in close to the action. There's often a lot going on, so be prepared for long days and lots of walking.

164

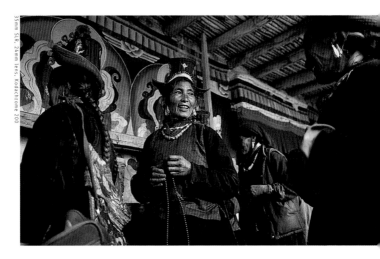

⌃ *Gompa festival, Timosgan, Ladakh, India*
On arrival at the gompa (monastery) the local people walk clockwise around the main building three times. I took up a position where the light was at its brightest and I wasn't in the way. I photographed the people as they passed. By kneeling I was not in the people's immediate line of vision, which reduced the number of people looking straight into the camera.

≫ *Woman at Pushkar, India*
The annual Pushkar Fair is one of India's most colourful events. By filling the frame with the bright colours of sari clad women, the colour and crowds are emphasised.

≫ *Thaipussam, Singapore*
If you're into body piercing, Thaipussam is the festival for you. Singapore's Indian Hindu community honour Lord Subramaniam by piecing their cheeks and tongues with metal skewers and carrying large metal and wooden frames decorated with feathers, fruit and flowers attached to their body with metal hooks.

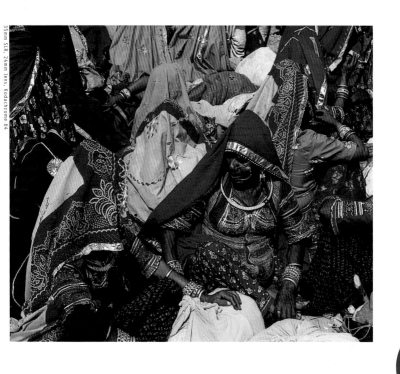

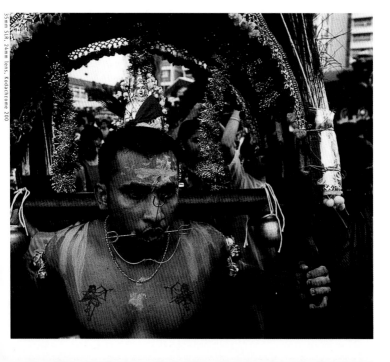

35mm SLR, 24mm lens, Kodachrome 64

35mm SLR, 24mm lens, Kodachrome 200

FESTIVALS

SPECIAL EVENTS

Parades and processions are demanding subjects. By their very nature (they're moving) you don't get a lot of time to think, compose and shoot. Big, organised parades attract big crowds and routes are roped off making it difficult to move around quickly. You may also prefer to remain in one place if you're with family or friends. If so, choose your position carefully in relation to the direction of light and the background to the parade. You don't want to find yourself looking into the sun or at a jumble of power lines unable to move. If you do have the freedom to move, try walking with the parade. This will give you the opportunity to concentrate on the elements you find most interesting and to try various viewpoints. Excellent photo opportunities are also to be found where people gather before and after the parade. This is a great time to take portraits of people in costume, which are difficult while the parade is moving.

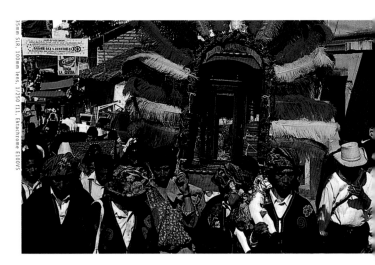

35mm SLR, 100mm lens, 1/250 f11, Ektachrome E100VS

∧ *Cofradias procession, Chichicastenango, Guatemala*

The ringing of bells alerted me to this small parade of Cofradias, a traditional religious brotherhood. Whenever I hear bells ringing I drop everything and investigate. The group was moving quickly along a small street with lots of obstacles so I decided to run ahead and let them come to me rather than walk with them. On a bright day such as this fast shutter speeds and small apertures are ideal because there's little time to think or focus.

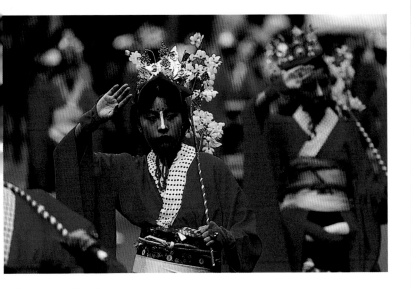

∧ Tono matsuri, Tono, Japan

If the parade isn't moving too quickly, or at moments when it comes to a standstill, look for opportunities to make portraits of the participants. In the low light of a rainy day I concentrated on the groups wearing the brightest costumes. I also narrowed my view to just one of the participants because I was working with little depth of field.

∨ Nanoo group, Sydney, Australia

If you're close to the action have your widest lens on. People will often play up for the camera when they see you're interested in them.

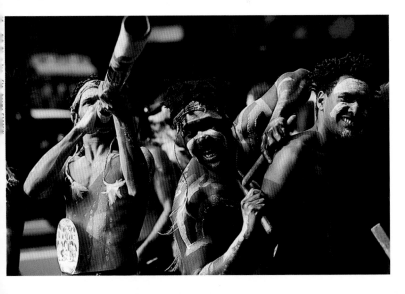

You'll come across theatre and dance indoors and out, in venues large and small, on the street in impromptu shows and in hotels accompanied by dinner. For performances indoors or at night, successful pictures are difficult to achieve unless you override the light meter. Stages and performers are rarely lit evenly. Usually the performer is lit by a spotlight and is much brighter than the background. Fast film is best for capturing the mood and colour of the event. You can use 400 ISO film, but 800 ISO will give you extra latitude to increase shutter speeds or give extra depth of field. Unless the performer fills the frame, automatic meters will overexpose the subject. This is the ideal situation to use your camera's spot metering system. Alternatively, zoom in and fill the frame with the spotlit performer, lock the exposure and recompose, or underexpose the meter's recommendation by one and two stops.

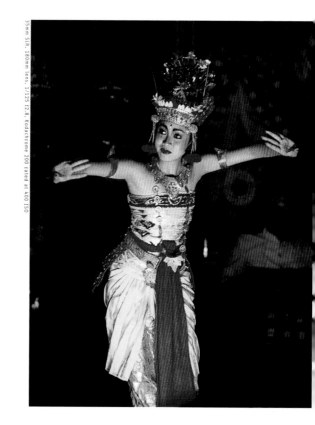

35mm SLR, 180mm lens, 1/125 f2.8, Kodachrome 200 rated at 400 ISO

> *The Ramayana, Ubud, Bali, Indonesia*
Every night in and around the village of Ubud, Balinese dances are performed. They're extremely popular and a central, clear view of the stage can only be guaranteed by arriving 45 minutes before performance time. Very weak spotlights light the front of the outdoor stage. I waited until the dancer moved close to the lights and took a spot-meter reading, eliminating the dark background from the equation.

SPECIAL EVENTS PERFORMANCES

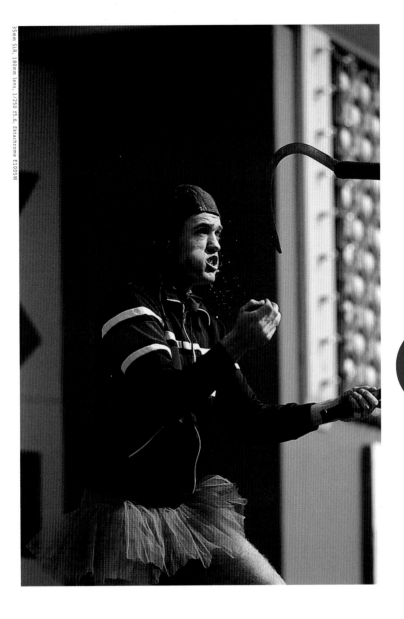

︿ *Busker, Melbourne, Australia*

A guy wearing a pink tutu, eating an apple, and juggling knives atop a 3m mono bike, deserves
to be photographed. Performance photography will test your stamina unless you know exactly
what's going to happen and when. If you don't you'll find that you have to watch the event
through the viewfinder to catch the most theatrical moments. You can't pick the camera up
when something interesting happens, it'll be over by the time it reaches your eye.

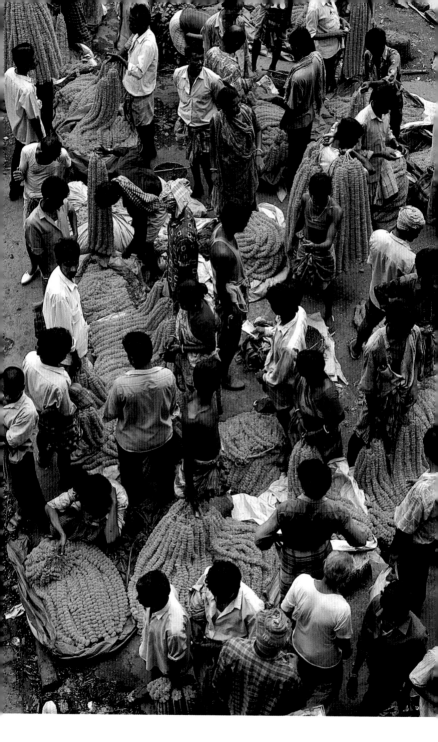

MARKETS

Markets are wonderful places to visit and photograph. There are lots of subjects, and lots of people who are too busy to notice you. Look for a vantage point for an overview of the market, move closer for shots of people at work, portraits of the vendors and close-ups of the products for sale. Wait for goods to be weighed and anticipate when money will change hands.

Markets are at their busiest and most interesting early in the morning when the produce arrives and stalls are set up. As soon as you arrive have a quick walk around and note the things that are different to what you've seen at other markets, the areas that look most interesting, and the areas that have the best light.

In cities the big markets are open daily, but in smaller towns and villages time your visit to coincide with market days. Weekly markets have a festive atmosphere as people from the surrounding areas travel into town to trade and socialise.

« Flower market, Calcutta, India

The flower market under the Howrah Bridge is one of Calcutta's most intriguing sights. Lots of stalls, under cover and in the open, and a variety of viewpoint possibilities make it a good place to spend some of your photography time.

Lighting can be difficult in markets but careful observation of where the light is falling will prevent wasting film. Umbrellas or sheets of plastic cast heavy shadows. Concentrate on finding subjects that are either in full shade or full sun. If the produce is in full sun but the vendor is in shade the photo will be unsatisfactory, unless you use flash to brighten the area in shadow.

Covered markets pose a particular problem. The light is usually very low and often comes from fluorescent tubes that turn daylight film a horrible blue-green. Flash is one option or use fast film and search out areas where there is a mix of lighting. Better still, concentrate your efforts on the stalls near the entrances and around the edges of the market. These areas are usually the brightest and the quality of light is better.

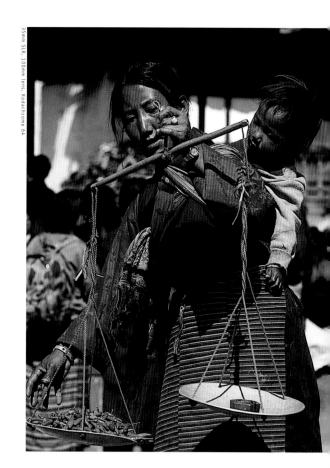

35mm SLR, 100mm lens, Kodachrome 64

❯ Sunday market, Thimpu, Bhutan

With a sleeping baby on her back this woman weighs a customer's order. Anticipate transactions and you'll have a point of interest in your pictures.

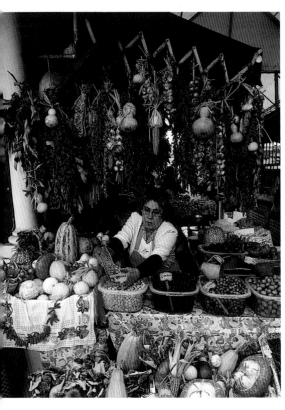

On a very bad weather day I was grateful that one of Porto's markets was covered. This stall was on a corner with its main counter facing a narrow, dark passageway, quite unsuitable for decent pictures. I waited at the end for the owner to come into the light as she filled an order.

173

INTRODUCTION

MARKETS

⌄ *Pasar Kuin floating market, Kalimantan, Indonesia*

The floating market at the junction of Kuin and Barito Rivers attracts hundreds of boats. Boat to boat trade is a fascinating sight. To show the buying and selling of eggs in the context of the market a high viewpoint was needed. Standing up in a little boat that's rocking about can be tricky. If you include the horizon make sure it's straight and use a fast shutter speed to prevent camera (or boat) shake.

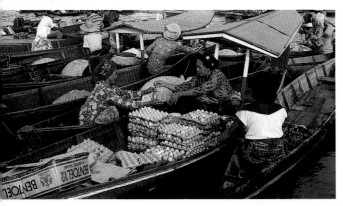

Food is high on the priority list of many a traveller. Where, what and when to eat are important decisions that can consume hours of each day. While your thinking about it why not photograph it? The way food is cooked and displayed in many markets is close to being an art form. Catch a cook dishing up a meal or fill the frame with fruit to emphasise its colour and texture. Try including several different fruits or vegetables to highlight the colour and design of the display.

For close-ups the light must be even. Ensure you don't block the light yourself or cast a shadow over your composition. Photographing vegetables close up probably confirms the local people's suspicion that tourists are mad but it's a small price to pay for the colour and interest food pictures add to the overall coverage of a destination.

35mm SLR, 100mm, 1/125 f2.8, Ektachrome E100VS

35mm SLR, 50mm lens, 1/60 f4, Ektachrome E100VS

⌃ *Red Chillies, San Cristobal, Mexico*

⌃ *Lemon Water, Yangon, Myanmar*

》 *Chillies and lemons, Phnom Phen, Cambodia*

Photograph food up close to emphasise the presentation, textures and colours. When the display is horizontal, ie, not stacked high, try to keep the camera parallel with the produce to ensure sharp focus across the entire frame. You'll often have to lean right over the display, so watch for your own shadow.

Art and craft for local and tourist consumption is usually available at the general market, but products aimed a tourists are hard to miss in popular destinations. Artesian markets have the added bonus that often you can photograph the craftspeople at work. Although pictures of the products themselves are relatively easy to take (they're stationary, in the same place every day and there's lots of choice) careful composition to make the most of the graphic elements in the displays and good lighting will always set pictures, even simple ones, apart.

35mm SLR, 100mm lens, 1/125 f8, Kodachrome 64

35mm SLR, 100mm lens, 1/125 f8, Ektachrome E100VS

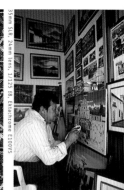

35mm SLR, 24mm lens, 1/125 f8, Ektachrome E100VS

⌃ left *Blankets for sale, La Paz, Bolivia*

A common sight at markets is a load of the same product stacked high, hung on walls or laid out on tables. Use the repetition of shape, texture and colour to create graphic images. Even an isolated detail like this gives a sense of place.

⌃ centre *Beadwork at street market, Durban, South Africa*

Markets provide an endless supply of items to photograph up close. Most compact cameras have a minimum focusing range of around 0.6m to 1m. Although this limits close-up possibilities, set your camera on its minimum focussing distance and look for subjects that fill the frame. This will extend your vision and range of photos.

⌃ right *Artist, Antigua, Guatemala*

At the handicraft market in Antigua artist, Oscar Peren, works on another painting for his collection. Unless you want to photograph a particular art or craft, a quick walk around the market is all it takes to locate people working in conditions favourable to photography. Spend your time in these locations rather than using time and film in difficult and unsatisfactory situations.

》 *Handicraft market, Havana, Cuba*

Large colourful paintings are a feature of the handicraft market on Tacon between the Cathedral and the Harbour.

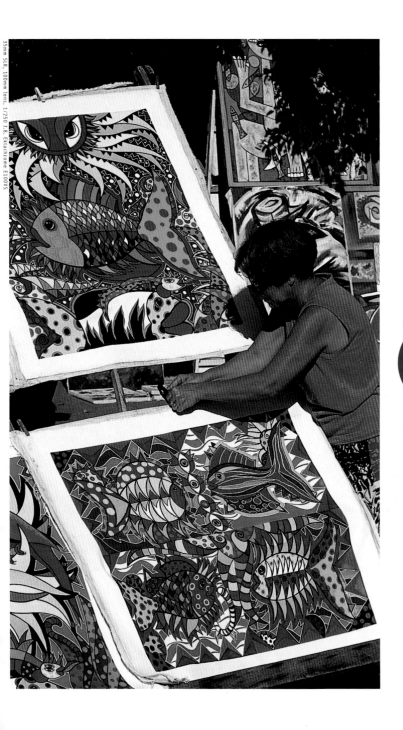

35mm SLR, 100mm lens, 1/250 f.8, Ektachrome E100VS

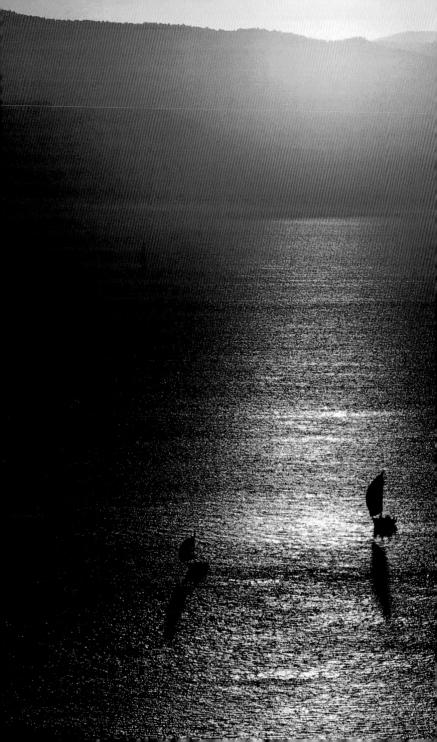

SUNRISE & SUNSET

A coloured sky, swaying palm trees and a couple of boats silhouetted by a golden sun low on the horizon ... it's the stuff of holiday dreams and a staple image for travel brochures. Sure it's cliched, but like famous places, that adds to the challenge. Just because the sky is a nice colour doesn't automatically mean a good picture. Preplanning the place and subject you want to photograph before the sun sets or rises is always a good idea. The sun sets much quicker when you're frantically trying to find a vantage point for photography than when you're sitting on a beach drinking piña coladas.

When there are clouds in the sky the changing colours make a very attractive subject in their own right. Try looking for a subject that can be silhouetted against the light background. Turn your back to the sun just after it peeps over the horizon or is about to disappear for the night and the world will be washed in a deep, warm, golden light.

When the sun is below the horizon, behind cloud or isn't in the frame, meter readings are usually accurate. If the sun is in the frame, override the recommended meter settings or the image will be underexposed (leaving

« *Yachts off Hamilton Island, Whitsunday Islands, Australia*

Yachts sail along this stretch of water heading to and from the harbour, so it was a pretty safe bet there'd be some going past at sunset. Shooting down meant that the sun wouldn't shine directly into the lens so flare wasn't a concern, but it got very low before boats finally did show up.

you with a well-exposed sun in the middle of a dark background). This effect is exaggerated with telephoto lenses. To retain colour and detail in the scene take a meter reading from an area of sky adjacent to the sun and then recompose. With slide film, overexpose by one and two stops. With print film underexpose by one and two stops.

Bracketing sunrises and sunsets is recommended, particularly if the sun is in the frame. If you have a compact camera avoid including the sun in your composition, or at least take a couple of shots, one with and one without the sun.

FLARE

When shooting directly into the sun watch for lens flare caused by stray light entering the lens. This reduces contrast and records as patches of light on the film. With SLRs you can usually see lens flare (if you're looking for it) and it can be highlighted by stopping down the lens with the depth of field button. A slight change in camera angle or viewpoint will usually solve the problem. Lens hoods help prevent flare but shading the lens with your hand may also be required (don't let it enter the field of view), or try placing the sun directly behind an element in the scene.

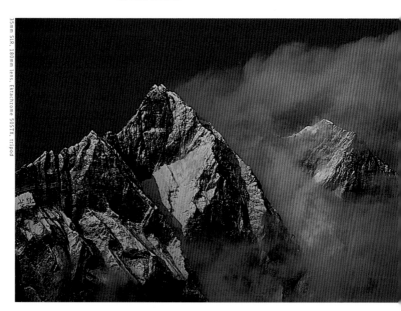

35mm SLR, 180mm lens, Ektachrome 50STX, tripod

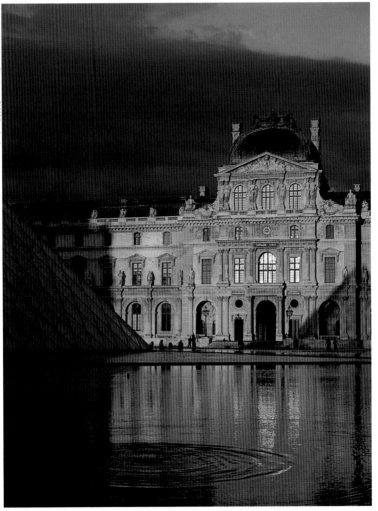

ᐱ *The Louvre, Paris, France*

A couple of minutes before sunset the Louvre was bathed in a golden light. When there are lots of clouds it's hard to predict if the sun will break through for spectacular effect or just fade away into the night. At these times it pays to be alone. Very few people are willing to stand around in the cold just in case a great photo opportunity arises and it's easy to be talked into leaving.

ᐸᐸ *Lhotse and Nupste, Dingboche, Khumbu Himal, Nepal*

For most of the day the Himalayan peaks gleam pure white, but at the very beginning and end of the day there's always the chance that they'll turn orange, red or yellow. Even if the mountain is in cloud, set up and wait – sudden changes in the weather are common.

When you expose for the colours of sunrise and sunset objects in the foreground are back lit and recorded without detail as silhouettes. An interesting or familiar shape silhouetted against a bright and colourful background gives a point of interest and adds depth to an image. Ensure that the subject to be silhouetted is surrounded by a bright background and doesn't disappear into dark areas. Look for separation between elements or their shape and impact will be lost.

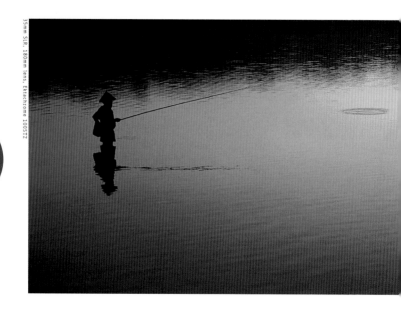

35mm SLR, 180mm lens, Ektachrome 100STZ

∧ *Fishing at sunrise, Sanur, Bali, Indonesia*

Isolating the fisherman with a telephoto lens has created a very simple composition. With the light behind the fisherman and exposure set for the highlights in the water he has recorded in silhouette. By placing him on the left side of the frame he's looking into the composition, keeping the viewer's eye within the frame and leading it to the circles on the water.

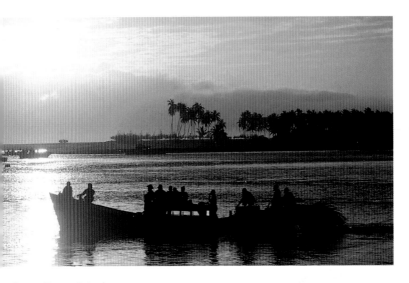

⌃ *Sunset, Marang, Malaysia*

As the sun sets, fishing boats head out for the night from the small town of Marang on Malaysia's East Coast. With the sun in the frame I took a reading from the sky and then recomposed. Shooting this scene on automatic would have caused underexposure by around two stops. It takes a while to get used to overriding the meter by this much, but even when you're confident, bracketing is recommended when you're shooting into the sun.

⌄ *Camel trader, Pushkar, India*

A camel trader keeps a close eye on his animals as the sun sets over the Thar Desert. Many of the people were down in the valley, but I searched for an area where I would have a better chance of finding people and camels that could be silhouetted.

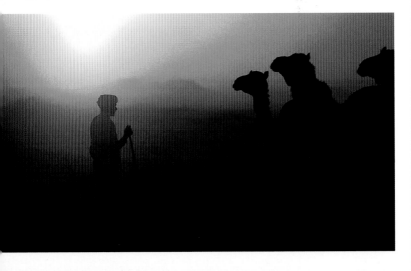

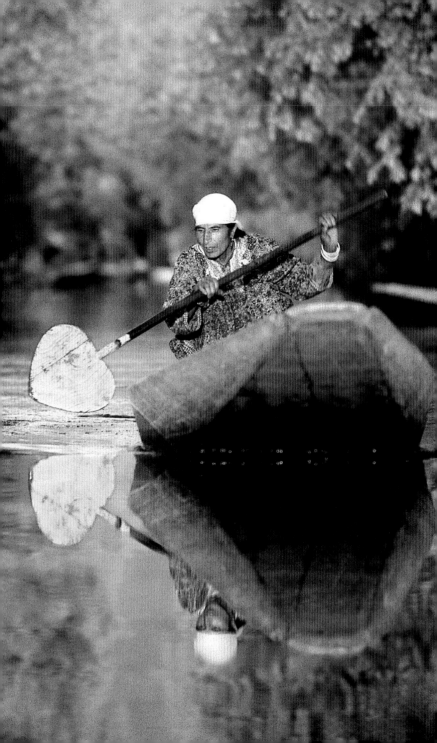

MOVING

SUBJECTS

Dancers in Mexico, speeding becaks in Yogjakarta, wind-surfers in Port Elizabeth, fireworks, moving cars … there are lots of subjects that just won't keep still.

O *You'll be more successful if you adopt a shoot first and think later policy with subjects that are on the move.*

Fast shutter speeds will freeze the action at an interesting moment, slower speeds can be used to express movement. If you're the one moving – on a camel, in a train, bus or cable car – success rates are going to be low. If you must shoot under these circumstances:

- Set the fastest shutter speed possible. Aim for 1/1000 second.
- Select a standard to short telephoto lens (50mm-70mm) to frame out the foreground.
- Focus on infinity.
- If you're shooting through a window, turn off the flash and switch autofocus to manual focus.
- Look ahead for a potentially clear viewing spot.
- Don't hesitate.

« *Dal Lake, Kashmir, India*
When you're moving and your subject is moving select the highest shutter speed possible to prevent camera and subject movement, unless desired. A subject moving straight towards the camera can be 'frozen' with a shutter speed of 1/125, but a subject going past you will require 1/500 or 1/1000 to freeze their movement.

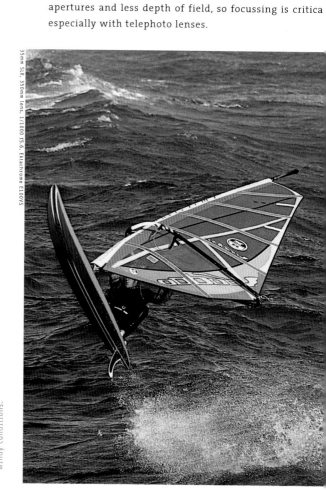

FREEZING THE ACTION

Where the activity is fast and furious shutter speed
faster than 1/500 second will freeze the action and cap-
ture the moment with great detail. Outdoors this shoul
not be a problem on 100 ISO film, but indoors use 400 ISO
or 800 ISO film. Fast shutter speeds will result in wide
apertures and less depth of field, so focussing is critica
especially with telephoto lenses.

> *Windsurfer, Port Elizabeth, South Africa*

Port Elizabeth is a famous windsurfing centre. I used the fastest shutter speed possible to freeze the move-
ment of the windsurfer and to guard against camera shake — I was having trouble staying on my feet in the
windy conditions.

35mm SLR, 350mm lens, 1/1000 f5.6, Ektachrome E100VS

>> *Sumo wrestler, Nagoya, Japan*

A sumo wrestler warms up for his next bout. Indoor events will rarely be lit well
enough to use 100 ISO film. Often in these situations longer lenses and higher
shutter speeds are required to fill the frame with the subject and stop the action

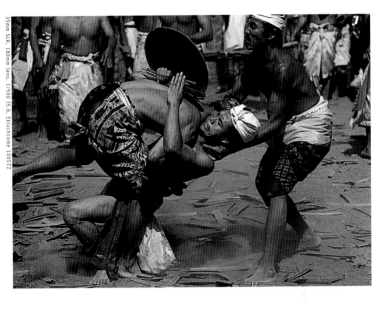

∧ *Usuba Sambah Festival, Bali, Indonesia*

The Usuba Sambah festival is a most unusual event. Amid the beautiful clothing and traditional dancing the men gather in two teams and vigorously rub each other's backs with spiny cactus shards until they bleed. A 180mm lens kept me clear of the blood but let me capture the expression that clearly shows what it's like to have a cactus shard run down your back.

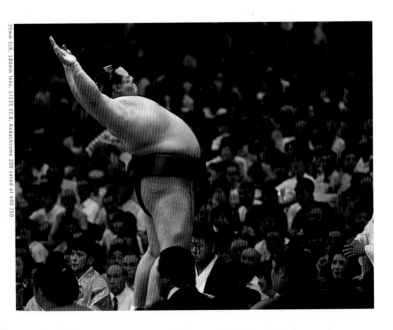

Panning and blurring are techniques that allow you to suggest movement in a still photograph. Rather than freezing the subject for maximum detail, part of the image is blurred, either the background or the subject, sometimes both.

PANNING

Generally, panning is used to keep a moving subject sharp while blurring the background, giving the impression of movement and speed. The speed the subject is moving at will determine the shutter speed. Start with a 1/30 and 1/15 second. Train your camera on your subject and follow it as it moves. As it draws level with you press the shutter release and keep following the subject. The shutter must be fired while the camera is moving. Don't expect a high success rate, but with the right subject panning produces very effective pictures.

ˇ *Becak and scooter, Yogjakarta, Java, Indonesia*
The streets of Yogjakarta are filled with three-wheeled becaks and two-wheeled scooters. I found a spot where there was a regular stream of traffic and the background wasn't too messy. The results of panning are unpredictable so allow plenty of film for experimentations.

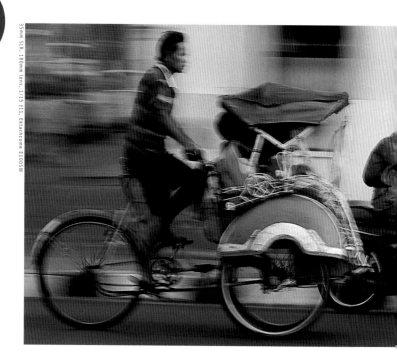

35mm SLR, 180mm lens, 1/15 f11, Ektachrome E100SW

BLUR

Action and activity can also be suggested by using a shutter speed that is slow enough to blur a moving element in your photograph, but still retain sharpness elsewhere. It can be as subtle or as obvious as you like. The key is not to shake the camera or record movement in the wrong part of the image. When a potter is at work a slow shutter speed will blur the spinning wheel with great effect, but if the potter also moves the image won't work.

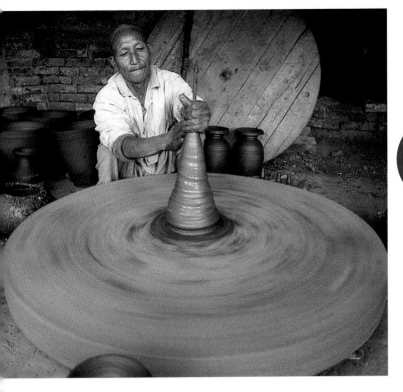

∧ Potter, Bhaktapur, Nepal

A 1/30 second shutter speed allowed the movement of the potter's wheel to be recorded, but was fast enough to prevent subject and camera shake. The minimum shutter speed required to avoid camera shake can be reduced by selecting wide-angle lenses. Don't go too slow though, or you increase the risk that the subject will move.

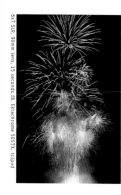

> *Fireworks, Melbourne, Australia*

Fireworks can be photographed hand-held, but you'll get more colourful and interesting pictures with long exposures that record several bursts on one frame. Given you can never be sure exactly where the fireworks will be in the sky, use a lens with a wider field of view to take in the general area. You can always crop in later.

FIREWORKS & LIGHTS

FIREWORKS

Fireworks are best photographed using a tripod and cable release. Mount the camera on a tripod and use 100 ISO film and much more interesting and colourful pictures can be made if several bursts of light are recorded on the one frame.

- Set the shutter speed on the B setting (which leaves the shutter open for as long as you wish).
- Set the aperture to f8.
- Set the focus on infinity. Switch auto-focus to manual.
- Turn off the built-in flash.
- Frame a part of the sky where you anticipate the fireworks to burst
- Release the shutter with a cable release and allow several sets of fireworks to trace their paths on the film.
- Between exposures, cover the lens with a dark cloth, ensuring that you don't disturb the camera.

Avoid setting up in a brightly-lit place where extraneous light can enter the lens and overexpose the film. Trial and error is required so ensure that all your exposures are not the same length.

The same technique can be used for photographing lightening.

LIGHTS

Tracing the patterns left by moving lights can add interest and colour to areas that would otherwise record as solid black. Use the technique described for fireworks, but set the aperture at f11 for depth of field and expose the film at 10, 20 and 30 seconds or longer. There are no guarantees with this subject because the intensity of the lights can vary from frame to frame, so bracket away. Many built-in meters have automatic shutter speeds to 30 seconds. As a starting point, fire the camera on automatic and time how long the shutter is open. Then switch to manual and the 'B' setting and bracket around what the camera recommended.

⌃ *Firework man, Antigua, Guatemala*

Beware of men wearing wooden frames loaded with fireworks over their head. When they go off the hiss of eye level rockets will have you ducking for cover. These guys are one of the highlights of New Year's Eve festivities and photographing them requires a fair bit of luck. A telephoto lens is good so you don't have to get too close.

⌄ *Traffic on Tower Bridge, London, England*

There was enough light for a short exposure, which suited me. My camera and tripod were balanced on a road dividing sign (in the middle of the road) and there was a good chance of it moving as the cars and buses rushed by. I took a reading off the bridge stonework because the headlights would have caused the meter to underexpose.

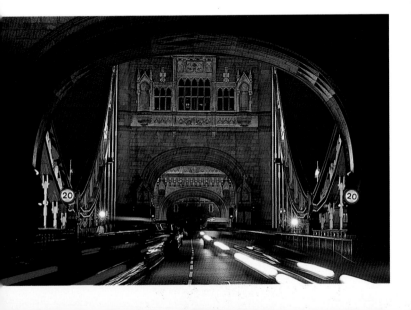

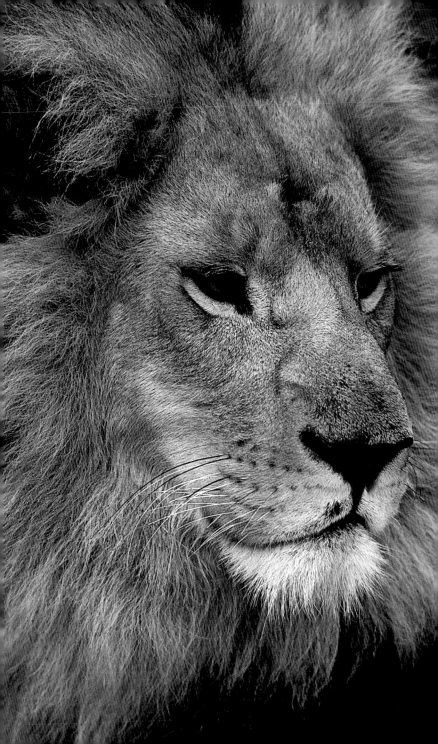

WILDLIFE

Photographing animals requires an abundance of patience, time and luck. Animals aren't renowned for their cooperation and you'll have to work hard to build a collection of recognisable, interesting and varied photos. Seeing animals in the wild is pretty special, but it's no excuse for forgetting everything you've learned about good photography. The first challenge is to get close enough. You might know it's an elephant, but if you have to tell the person looking at the photo what it is, consider the image a failure. It's also important to select a viewpoint that considers the direction of the light and the background, just as with any subject. Always focus on the eyes, everything else can be out of focus but if the eyes are not sharp the photograph will fail. Because the focussing screen is in the centre of the frame, consider recomposing after focussing on the eyes to avoid the central, and often static, placement of the subject in all your pictures.

Some wildlife photography is possible with compact cameras with zoom lenses (38mm-90mm) or SLRs with

« *Lion, Moremi Wildlife Reserve, Botswana*

« After six weeks and sixteen game parks in Southern Africa, it became clear that just seeing the animals could be a challenge. It wasn't until the twelfth park that I finally got to photograph lions, and then they were everywhere – well, all within 500m of where I had to get out of my vehicle to dig it out of the deep sand it had got stuck in.

standard zooms (28mm-105mm). In many national parks, particularly around camp grounds, some animals are quite used to human presence and will allow you to get close enough. In the wild the limitations of the equipment can make for a frustrating experience. The eye will zoom in on distant animals and exaggerate their size, but they will be insignificant on film. To avoid disappointment concentrate your efforts on animals that you can get close to and compositions that show the animal in its habitat.

For wild animals a focal length of 300mm is generally considered essential. The magnification is strong enough to satisfactorily photograph the majority of animals and will allow frame filling portraits of those you can get close to. If wildlife photography is a part of your travel plans and your longest lens (fixed or zoom) is less than 300mm, consider purchasing a teleconverter, which will give you many more opportunities without the expense and weight of another lens. If you have a 300mm already, a teleconverter will open up a whole new range of opportunities (see Teleconverters in the Equipment chapter).

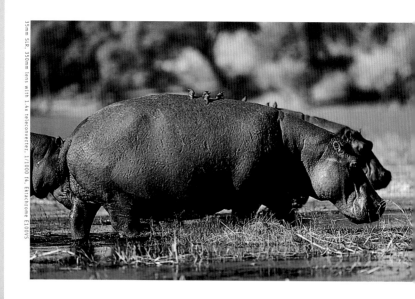

35mm SLR; 350mm lens with 1.4x teleconverter, 1/1000 f4, Ektachrome E100VS

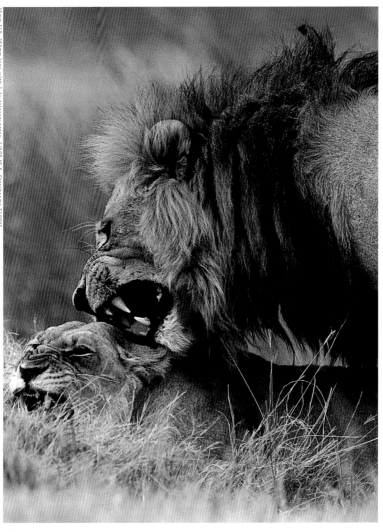

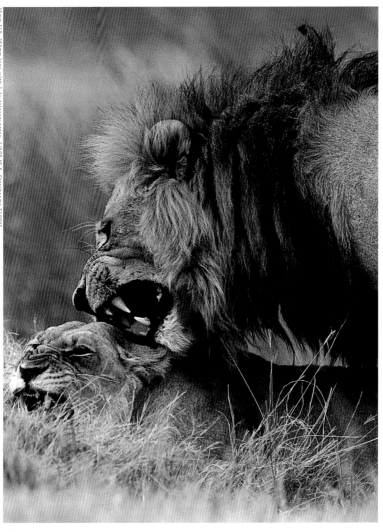 

195

∧ *Mating lions, Moremi Wildlife Reserve, Botswana*
One of the few wildlife activities that can be guaranteed to be repeated while you wait is lions
mating. In fact, lions engage in the act so often (300 times during the mating season) you'll only
have to wait 15 mintues between photo opportunties.

〈 *Hippopotamus, Chobe National Park, Botswana*
Hippos don't generally do much during the day, so it was good to see this group heading for the
water. Make sure that your settings are appropriate for the situation and lens you are using. If
you're in a moving boat use the fastest shutter speed you can.

The game parks of Africa are the most famous destinations for animal encounters. If an African safari is on your itinerary take extra film: most people use a lot more than they expect. Most game viewing is experienced in national parks from vehicles, which you're prohibited to leave. Be constantly aware of the direction of the light so that you can position the vehicle quickly or give directions as to where you want to shoot from. You'll soon learn how close you can get to a particular animal before it moves off and this will allow you to select the right lens, or set your zoom at the appropriate focal length, before you approach the animal. With long lenses fast shutter speeds are required to prevent camera shake, and they also stop blurring if the animal moves.

You'll find yourself holding the camera to your eye for much longer periods than normal as you observe the animals and wait for the perfect moment. This can be very tiring. The vehicle window makes an excellent support and can be moved up and down to suit your height. In vehicles with pop-up tops, rest your camera on the roof while following the action. Use a piece of clothing or camera bag to rest the camera on and turn the engine off to stop unnecessary vibrations.

Animals are at their most active early in the morning and late in the day. If you're using zoom lenses at their maximum focal length (210mm, 300mm) you'll need to use the appropriate fast shutter speeds (1/250, 1/500 second) and your maximum aperture will be around f5.6 to f8. Be prepared to use 400 ISO film at these times and switch to your standard film as soon as it's bright enough.

>> *Impala, Mlilwane Wildlife Sanctuary, Swaziland*

Impala are everywhere and if you go to enough parks you'll find some you can get close to. If you don't have long lenses look for situations that show the animals in their habitat. These pictures will be particularly pleasing when the animal hasn't been alerted to your presence.

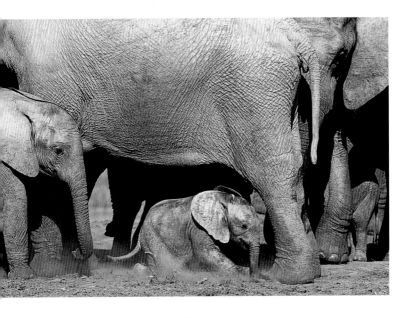

^ Baby elephant, Addo National Park, South Africa

Elephants are great because they're so big and allow you to get so close. Even standard lenses will let you fill the frame. Then again, you may not want to get quite so close. Baby elephants on the other hand are little, so it's back to the big lens. This one was having some trouble keeping its feet. The rangers can give you a good idea when and where you'll see the herds of elephants in national parks.

Zoos and wildlife sanctuaries are interesting subjects in their own right but are also great places to practice and prepare for photographing animals in the wild. Spend a day at your local zoo or wildlife park before heading off on safari and you'll discover the limitations of your equipment and how close you need to get to animals large and small to make strong pictures.

Eliminating cage wire is possible by placing your lens against the cage, and selecting the widest aperture available (f2.8 or f4). This technique works best with a telephoto lens and if the animal is at least 2m from the cage. With compact cameras remember that what you see through the viewfinder is not what the lens sees. Place the lens through an opening in the cage wire, and then look through the viewfinder, even if you see wire it won't be recorded on film.

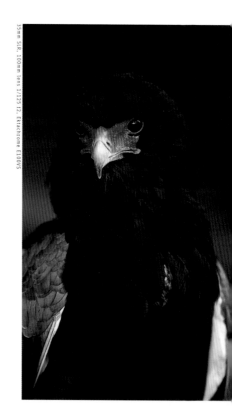

35mm SLR, 100mm lens 1/125 f2, Ektachrome E100VS

❭ *Bateleur eagle, Zimbabwe*
This beautiful Bateleur eagle was photographed through the wire of a sanctuary enclosure using a telephoto lens and wide aperture. I'm not a big fan of caging large birds but the opportunity to take 'a portrait' was hard to refuse.

❭❭ *Whiptail wallaby, Cape Hillsborough National Park, Australia*
Many national parks have wildlife that's used to the presence of people. These animals provide the perfect subject for practicing wildlife photography. Even when you can get close to animals in the wild, quick and accurate focussing, metering and composition is required.

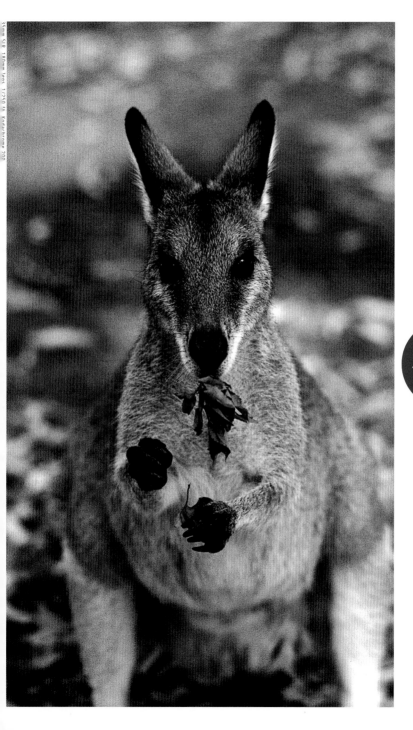

35mm SLR, 180mm lens, 1/250, f4, Kodachrome 200

BIRDS

Birds are even harder to photograph than animals. They're mostly small, rest high up in trees, fly off at the slightest disturbance and rarely sit still for very long. A 300mm lens is adequate for larger birds, but to have any hope of filling the frame you really need a focal length of 500mm or 600mm.

A quick introduction to the trials and tribulations of bird photography is available in you're own garden or at local parks.

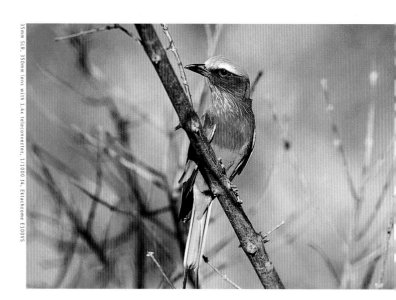

35mm SLR, 350mm lens with 1.4x teleconverter, 1/1000 f4, Ektachrome E100VS

⌃ Lilac breasted roller, Hwange National Park, Zimbabwe

Unless you're very well equipped and dedicated, photographing birds can be very frustrating. At least the lilac breasted roller gives you a chance to get close … but that's with a super telephoto lens.

≫ Stork, Kruger National Park, South Africa

Without very long lenses the large waterbirds are a subject that may reward some patience at water holes or rivers. If you arrive first and wait for them to come to the water you may be close enough to take recognisable pictures.

≫ Ground hornbill, Chobe National Park, Botswana

The ground hornbill is one of the easier birds to get close to with standard equipment.

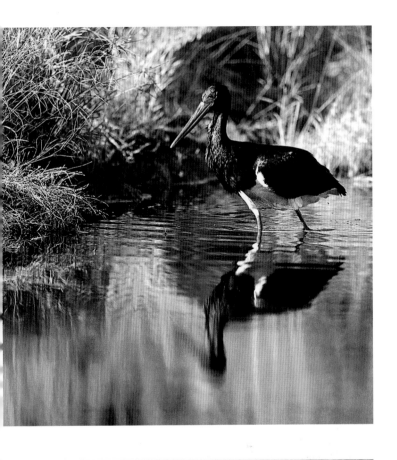

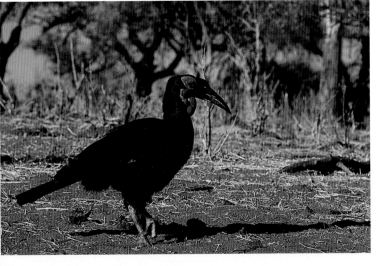

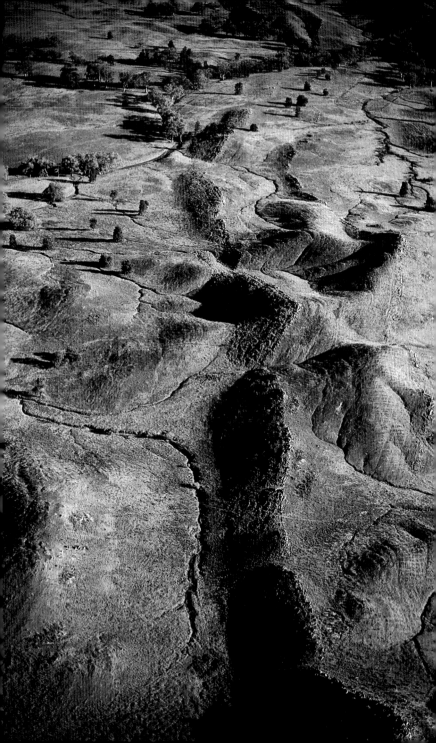

FROM THE AIR

The world certainly looks different from the air and can inspire even the most reluctant camera user to blow the film budget. Opportunities from commercial aircraft are limited, but joy flights in light planes, helicopters and hot air balloons are offered at many places.

COMMERCIAL FLIGHTS

Good pictures are difficult to get from commercial planes. Often the windows are marked or dirty and the curve in the plastic windows cause the image to go out of focus. If you're behind the wing, vapour from the engines may interfere with the view. To increase the possibility of good aerials from a commercial aircraft:

- Find a seat forward of the wing and on the opposite side to the sun.
- Wipe marks and fingerprints off the window.
- Place the lens close to the centre of the window to minimise reflections from the cabin and blurring from the curved Perspex. Don't rest it against the window.
- Don't use a polarising filter because it doesn't work with Perspex.
- Use standard focal lengths (35mm-70mm).

« Flinders Ranges, Australia
As with all landscapes, aerials benefit from shooting early in the day. The low angle of the sun casts shadows that emphasise the texture and form of the land. The lower light levels can mean having to use slower than preferred shutter speeds, but light plane flights are often smoother early, before the wind picks up.

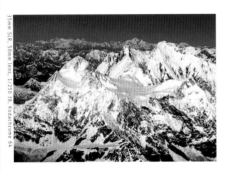

∧ *The Himalaya, Nepal*
The flight between Lhasa and Kathmandu has to be one of the most spectacular commercial flights in the world. Cruising at 10,500m you're only 1,700m higher than Mount Everest. It's a low altitude flight in a commercial jet and the view is great from both sides of the plane.

· Keep shutter speeds high to minimise camera shake and vibration.

· Look for photo opportunities just after take-off and during the longer descent.

LIGHT PLANES & HELICOPTERS

Flying at low altitudes over natural attractions is a wonderful experience. To capture it on film is a challenge, but a little planning will help. Helicopters provide clear views, but make sure you request a window seat. High-winged planes offer a clearer view than low-winged planes. Talk to the pilot about the best place to sit to take photos and if a window can be opened. If you're with family or friends and are taking every seat, you could inquire about having the door of the plane or helicopter removed. It's not as radical as it sounds. Most companies work with photographers and will treat this as a standard request. When photographing from planes and helicopters:

· Set the shutter speed at 1/1000 second, or as high as possible.

· Don't rest your arms or lean against the aircraft. Vibrations will cause camera shake.

· Don't hesitate: shoot quickly and often.

· Keep horizons straight. This requires constant adjustment.

· Use a polarising filter over water.

· Keep the camera within the cabin. Don't let it protrude through the window or open door: it's impossible to keep it still.

· If the door is off wear camera straps around neck (and keep your seatbelt on!).

· Start the flight with a fresh roll of 36-exposure film.

· Have spare film handy and out of all packaging.

HOT AIR BALLOONS

Balloons are an ideal camera platform. They are steady and provide an unhindered view down to earth (if you lean out a bit) and out to the horizon. They can't be manipulated with the speed of a helicopter or plane but they provide a much more peaceful and relaxed environment for taking pictures. Shutter speeds of 1/125 and 1/250 are sufficient and once at cruising height there's time to consider compositions, change lenses and films … and enjoy the view.

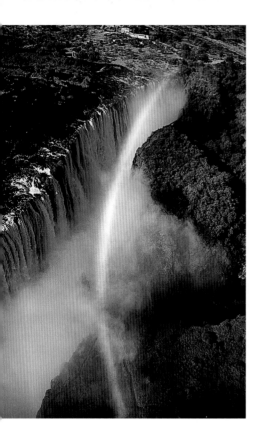

‹ Victoria Falls, Zimbabwe
I booked the helicopter flight over the falls to coincide with the time of day when the sun was lighting up the narrow gorge and the rainbows appear in the spray. It's hard to beat the unimpeded view from a helicopter with the door off. The main thing to watch for is not to photograph the blades when framing vertically or when the pilot is turning to your side.

⌄ Kathmandu Valley, Nepal
It took a couple of hours of standing around in the cold, waiting for the fog to lift before our balloon could take off, but it was worth it. There is no other viewpoint in the Kathmandu Valley where you can see the layering of the middle hills like this.

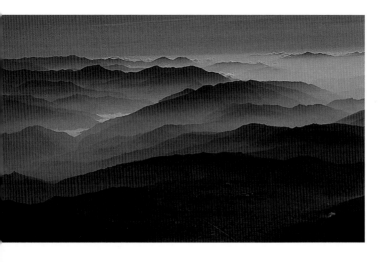

PART FOUR: BACK AT HOME

Arriving home and going through the photographs from a trip is pretty exciting. This part of the book covers how to make the most of all those travel photos once you arrive back home, from assessing the photographs to storing, displaying and maybe even making some money from them.

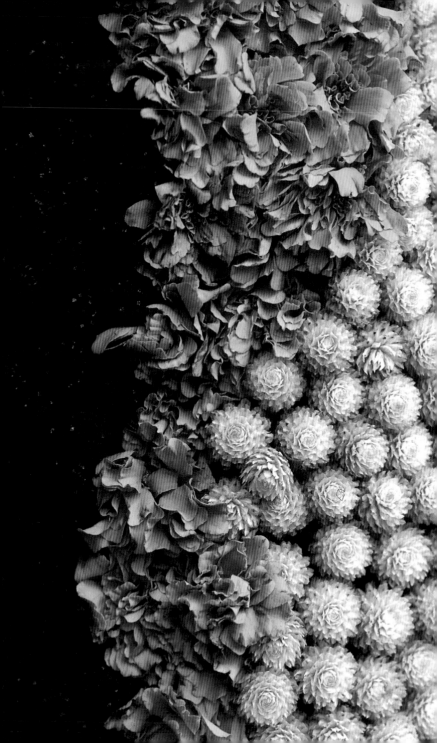

ASSESSING YOUR PHOTOGRAPHS

Once you've got your prints or slides back from the lab, sorting them out and getting them ready to show others can be achieved in a variety of ways. If you've taken prints you can show them without any further effort by handing out the packets from the minilab. If you've taken colour slides you have to prepare them for projection. Given that you've gone to a lot of trouble to take the photos why not go to a little extra trouble and present them well? The process of assessing and editing your photos is a great way to improve your photography. And while you're at it you may as well get really organised and store your negatives, prints and slides in a way that protects them and makes them easy to find. If you've done really well you might even start to contemplate the possibilities of selling your images.

∧ ⟩ Same print, different minilab. If you're unhappy with the prints you're given it's well worth asking for a reprint.

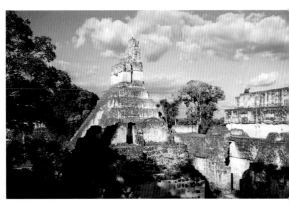

ASSESSING PRINTS

Colour prints are easy to assess because they're returned from the minilab in a print size that's easy to see. Many people choose to have their colour prints processed as they're travelling, but it isn't until you get home that you'll have the final set. If you do bring all your films home you may be able to negotiate a cheaper rate with a local minilab if you have more than 20 films.

Unfortunately, the standard of prints that minilabs produce varies wildly. If you get a set of prints that are really disappointing it's well worth explaining the problem to your photo-finisher and requesting a reprint. If they refuse or suggest that they have supplied the best prints possible, get a second opinion from another minilab.

ASSESSING SLIDES

Assessing colour slides requires additional equipment, unless you want to hold them up to the sky or room lamp. You need a light source to shine through the slide and a magnifier to enlarge it. The cheapest and simplest option is a slide viewer. Slides are viewed one at a time by placing them into the unit between a small light globe and a magnifying lens. Apply slight pressure to the slide mount and the light comes on. The unit is handy because it enlarges the image slightly, but makes comparing slides difficult and involves a lot of handling of the slides. You could also use a slide projector to view your slides, but it's time consuming

and impractical if you have anything more than a few rolls.

The only way to assess slides properly is on a colour corrected light box (or light table). The fluorescent tubes provided produce the same colour as daylight, so that the colours in your slides are faithful to the film. Slide viewing will be much more enjoyable and practical if your light box is large enough to see at least an entire slide filing sheet of 24 mounted slides (see Storing Negatives, Slides & Prints later). If you're going to prepare slide shows you'll appreciate a light box that is large enough to lay out a hundred slides at once. Slides on a light box are viewed with a loupe, an optical accessory that magnifies the slide. Prices range from US$12 to US$175. Buy the best you can afford. A good quality loupe is an essential piece of equipment for anyone using slide film. Viewing slides with the naked eye, or a cheap loupe, is not practical or fun. If you don't use a loupe, not only will you miss so much of the detail and colour saturation: slides nearly always look deceptively sharp.

EDITING PRINTS & SLIDES

It doesn't matter who you're showing you photos to (except perhaps people who were there), you should edit you photos tightly. Heavy sighs and excuses are not what you want to hear when you invite friends and family around to see your latest travel pictures. It's what you'll get if you bore everyone with several images of the same thing and a long winded story about every photograph.

We all take bad pictures – the trick is not to show them to anyone. Edit the technically poor and creatively weak pictures out and you'll be left with a much stronger and interesting set of photos. It takes a fair bit of discipline to discard pictures. Consider the place of each picture in the overall presentation and think of the whole rather than each picture.

The assessing and editing process is also an excellent time for reflection and self-teaching. Your best pictures and worst failures will stand out clearly. Study them to see what you did wrong and what you did right. Look for patterns. Are all you best pictures taken on a tripod? Are all the out of focus frames taken with the zoom at its

Swaziland Mbabane 1999
Young dancer at Sod Cutting
Ceremony

LONELY PLANET IMAGES BN: 1524
© Photograph by Richard I'Anson
lpi@lonelyplanet.com.au ph: (61) 03 9819 1877

maximum focal length? Next time you can eliminate the cause of your failures and concentrate on the things that worked. Your percentage of acceptable pictures will start to rise. This process of self-critique is an important and never-ending process in the life of a photographer.

CAPTIONING & FILING

Captioning pictures is hard work. If you've kept notes during your travels your life will be a lot easier. If you do nothing else, number and title the negative and slide sheets by destination and file them by country. You'll probably always remember what country a picture was taken in.

STORING NEGATIVES, SLIDES & PRINTS

Prints, slides and negatives should be stored in a cool, dry, dark place for protection and easy access. The most popular way to store negatives, slides and prints is to leave them in the packets and boxes they're returned from the lab in ... and then every year promise yourself you'll organise them. But there are better ways. Photographic materials fade over time, and that can be a very long time, if they're stored properly. The things to avoid are heat, humidity and storage materials such as vinyls and wood that can emit harmful chemicals that react with photographic materials. Use archival quality products that are chemical and acid free.

NEGATIVES

Negatives generally come back from photo-finishers in clear neg holders cut into strips of four, which satisfy most people. If you're taking lots of film and would like to get really organised you can buy negative filing sheets. (Archival sheets are made from polyethylene or polypropylene.) Generally, they take seven strips of six exposures and are made for ring binders and hanging in filing cabinets. They have room for writing relevant information at the top. Ask your lab not to cut the film so you can cut it yourself into strips of six exposures for most efficient use of the negative files.

SLIDES

Slides are generally stored in boxes or slide filing sheets. Boxes are not recommended if you intend to access your slides regularly. They require excessive handling and don't allow easy viewing. The recommended option is to use archival slide-filing sheets that hold 20 or 24 mounted slides. These are then stored in ring binders or in filing cabinets. They allow easy viewing on a light box or can be held up to any light source. There's a wide range to choose from and some are better than others. Ensure that the slides fit snugly into the pockets so that they're easy to put in and remove but don't fall out if the sheet is held upside down. Also, make sure that they are truly clear. There are some on the market that make it almost impossible to see what the slide is of, let alone judge exposure and sharpness. If you're handling a lot of slides you'll also find the top-loading sheets are best for quick access.

PRINTS

Prints are traditionally stored in photo albums. The main album styles have self-adhesive pages, plain pages or slip-in pockets. Many of the self-adhesive pages are cheap, but over time the contact can wear off and the prints fall out. If they don't fall out they're probably in contact with harmful chemicals. Albums of plain paper allow you to write directly below the photographs but require you to supply adhesive or photo corners. Most of us don't expect to remove pictures once they're in an album, but if you do photo corners might suit you, although they're very fiddly. If you're sticking the pictures in, rather than using normal glue, ask your photo retailer what they recommend. The slip-in, clear pocket albums don't allow for various size pictures and you can't be creative with how you lay the pictures out. Captions are important, not just so that you can remember where you've been, but they allow the photos to be enjoyed by people who weren't there.

Before you quickly put every photo in the album why not pick out your favourites for enlarging? This will highlight your best photos and make sure they get the extra attention they deserve. You could also use enlargements to introduce each new country or theme. One big advantage

of prints is that you can crop them. Cropping allows you to enlarge the main subject or eliminate unwanted elements around the edges of the print.

WALL PRINTS

Framing your favourite prints for wall display is very satisfying. If you've used colour negative film most minilabs can print or organise enlargements up to poster size (20x30 inches). If you've used colour slide film, or want the best possible print from a negative, seek out a professional lab to handle the enlargements. A good lab will advise which slides and negatives will and won't print well, rather than just taking your order. If you decide to frame your print behind glass, use plain glass, not non-reflective glass. Non-reflective glass takes the edge off the sharpness and dulls the colours. Careful positioning of the print on the wall helps minimise reflections ... as does a little step to the left or right by the viewer.

Prints should not be placed in direct contact with the glass. Traditionally, a border called a window mount goes around the print and separates the print from the glass. If that look doesn't suit you, a good picture framer will advise on the options. You'll also have choice of mount board and mounting adhesives. Ask for the archival products. Place the framed print in an area that doesn't receive direct sunlight.

SLIDE SHOWS

The only way to show any quantity of slides to others is to project them. Original slides shouldn't be projected, instead, have a set of duplicate slides made. The intense light from projection globes will fade slides over time. There's also the possibility of damage from a projector malfunction. Slides should be glass mounted as this stops them popping out of focus, which is a very annoying feature of many presentations.

Slide shows are a great way to present a lot of photos in a short time and the images themselves will never look better. But it's easy to turn a set of great pictures into a dry slide show instead of the entertaining and informative experience it should be. You have a captive audience and

it's your duty not to bore them. Below are a few suggestions that will have your family and friends calling out for more.

· Always view the show yourself first to ensure the slides are the right way up and there are no large dust spots or hairs.

· Don't leave slides on the screen for more than six seconds, four seconds is fine. At four seconds each you can show 225 slides in 15 minutes.

· Don't show similar pictures of the same subject. Just select the best one.

· Edit hard and only show your best images.

· Grouping destinations or themes reduces the commentary because you can introduce a sequence of slides with the first image.

· Have some order to the slides. The chronological order of the trip is most logical. If you're coming and going from a home base, or a country more than once, group the slides into countries rather than jumping back and forth.

· Keep the length of the show to around fifteen minutes.

· Play appropriate music to cover the sound of the projector, to set the atmosphere and to help prevent you feeling the need to talk about every slide. Let some of the slides speak for themselves.

· Project slides in the darkest room possible. Too much stray light will reduce the impact of your images.

· Show the slides earlier in the evening rather than later. After dinner and a couple of drinks it's easy for people to fall asleep in a dark room with music playing.

STOCK PHOTOGRAPHY

If you feel your photographs are good enough and might be of interest to others, you may want to investigate ways of selling your work. You can contact potential users directly to find out what their needs are and how they go about buying pictures. Before you do that, study their products carefully to see the kind of pictures they use, this will let you concentrate on contacting relevant publications. Most magazines have a submission guideline document available on request or on their Web site. Careful study of these will save you a lot of time.

The largest market for travel photographs is book and magazine publishers who buy stock photographs. Stock refers to images that are shot speculatively at the photographer's expense and then placed in an image library ready to meet the needs of picture buyers who require existing images, rather than commissioning new ones. There are specialist libraries that hold extensive collections of one subject, such as wildlife or sport, but the

majority of stock libraries cover all subjects, including travel. Libraries represent the work of many photographers with the aim of always having an appropriate image on file to meet their client's requests.

Travel stock is very competitive. To even get pictures into a library can be tough and the terms and conditions may not suit you. Libraries are businesses and they're there to represent the work of photographers, many of whom rely on stock sales for their living. Your pictures will not only be judged on their own merits, but against the images that are already in the library. Then, when they go before a customer, they'll have to compete against the best pictures from other libraries for the buyer's attention. The more common subjects and the most popular destinations face the greatest competition. You only get paid for a stock image when it's used.

Once you're represented by a library, you'll be expected to make regular submissions. The way to make money from stock is to be continually adding to your own collection and to have as wide a coverage as possible. The more pictures and the wider their coverage, the more times they'll go in front of picture buyers. The key is variety. If you can provide a range of views of a particular subject under different lighting conditions you greatly increase your chances of filling the requirements of a picture buyer.

Professional stock photographers plan their travels carefully and shoot stock in a very organised way. While researching a destination a shot list is developed of subjects that need to be covered based on what's already in the library, requests already received from the library, and on anticipated requests.

If you want to sell pictures you've got to take the kinds of pictures that people are going to want to buy. You can start educating yourself by checking the picture credits in books and magazines. Often the photographer and library are both named. After a while you'll start to see the kind of pictures that sell and the sort of publications that buy them.

SUBMITTING STOCK TO LIBRARIES

Stock libraries all have their own requirements and guidelines on how they prefer to receive submissions. Generally, to establish whether or not your images are of suitable quality and content, a library will want to see an

nitial submission of around 200 original colour slides. When preparing your submission remember that the people assessing your work will not have the same emotional attachment to the pictures you have. In my role at Lonely Planet Images I've looked at over 300,000 slides in the last couple of years from all over the world. I suggest the following to ensure that you make the best impression with your first submission.

If the library you're interested in has a Web site study it carefully with particular attention to the coverage of the places and subjects you intend to submit.

Read their submission guidelines and follow them exactly.

Edit your submission tightly. Don't send in technically poor images. Out of focus, over or underexposed pictures will detract from your overall submission.

Slides must be captioned, preferably with typed labels. Put the image caption on the top half of the slide mount and your details on the bottom half. Typed captions look professional and are easy to read.

Slide sheets must be clean, clear and the slides easily removed and replaced.

Don't use tape to secure slides in the sheets.

Make sure all slides are up the right way.

RELEASE FORMS

If you intend to submit photographs of people or private property to an image library you need to know about release forms. Release Forms (model release and property release) are given to the person in a photograph, or the owner of private property in a photograph, to sign, giving their permission for the photographer to use the photographs however they see fit. Practically, it's difficult, time consuming and just too hard to ask everyone you photograph to sign a form (and that's if you speak their language).

The general understanding is that photographs used for editorial purposes, such as books, magazines and newspapers, don't require release forms, unless the image is defamatory. The advantage of a signed release is that the image can also be considered for use in the advertising world, which pays the highest fees for licensing stock images, but usually requires that people pictures have signed releases.

The sample release forms on the inside back cover of this book can be copied onto your own letterhead.

GLOSSARY OF PHOTOGRAPHIC TERMS

aperture – hole in the lens that allows light in to the camera body: variable in size and expressed in f-numbers

angle of view – image area that the lens covers measured in degrees and determined by the focal length: the shorter the focal length the greater the coverage

auto-focus – system that allows focus to be set automatically (also known as AF)

auto-exposure lock – control that locks and holds exposure on the subject while recomposing (also known as AE Lock)

auto-focus lock – control that locks and holds focus while recomposing (also known as AF Lock)

bounce flash – technique of reflecting the light from a flashgun from a ceiling, wall or other reflective surfaces to diffuse and soften the light

bracketing – technique used to ensure that the best possible exposure is achieved by adjusting only the exposure for each frame: particularly useful when using slide films

C-41 – common term for the chemistry used to process colour negative films

CCD (Charge Coupled Device) – a sensor that converts light into electrical signals

cable release – an accessory that allows the shutter to be released without touching the camera to prevent camera shake

centre-weighted metering – reads the light reflected from the entire scene and provides an average exposure reading biased toward the centre section of the viewfinder

contrast – the difference between the lightest and darkest parts of a scene

dedicated flash – flashgun that connects to the camera's metering system and controls the power of the flash to produce a correct exposure

depth of field – the area of a photograph that is considered acceptably sharp

depth of field preview – control that allows the aperture to be stopped down manually and provides a visual check of the depth of field at any given aperture

DX coding – system that automatically sets the ISO by reading the film speed from a bar code printed on the cassette

emulsion – light sensitive material

exposure compensation dial – allows over or underexposure of the film by 1/3 or fh stops up to 2 or 3 stops when using automatic exposure modes

E-6 – common term for the chemistry used to process slide film (except Kodachrome)

fast film – very light sensitive film

fast lens – lens with a very wide maximum aperture

fill-flash – technique used to add light to shadow areas containing important detail

filter – optical accessory that is attached to the front of the lens altering the light reaching the film: used for a wide range of technical and creative applications

flare – stray light which degrades picture quality by reducing contrast and recording as patches of light on the film

focal length – the distance from the centre of the lens when it is focussed at infinity to the focal plane

focal plane – the flat surface on which a sharp image of the subject is formed: film is stretched across the focal plane

f-stop – numbers that indicate the size of the lens aperture

grain – silver halide crystals of a film emulsion visible in a photographic image: the faster the film, the coarser the grain

guide number (GN) – indicates the power output of a flash unit with 100 ISO film

highlight – the brightest areas of the subject

hot-shoe – place on camera body for mounting an accessory flash unit

incandescent lighting – artificial light source

ISO – abbreviation for International Standards Organisation, which sets the standards for film-speed rating

ISO rating – the sensitivity of the film to light: the higher the ISO the more light sensitive the film

macro lens – lens designed to give a life-size image of a subject

multi-zone metering – measures the light from several areas of the scene and gives a reading based on what it evaluates as the

most important parts of the scene (also called matrix, evaluative, multi-segment, multi-pattern or honeycomb pattern)

perspective control – allows control of the angle of the plane of focus through tilt and shift movements on special lenses to prevent distortion of perspective

pixel – abbreviation for picture (PIX) elements (EL): the smallest bits of information that combine to form a digital image

predictive auto-focus – sophisticated focussing system that continuously tracks a moving subject (also known as tracking focus)

programmed exposure – fully automatic exposure setting in which the camera's metering system sets both aperture and shutter speed

pushing film – intentional underexposure of colour slide or B&W film by exposing it at a higher ISO setting than its actual film speed

push processing – increasing the development time to compensate for underexposing the film

rangefinder – focussing system that measures the distance from camera to subject by viewing it from two positions

short lens – wide-angle lens

shutter – mechanism built into the lens or camera that controls the time that light is allowed to reach the film

shutter speed – the amount of time that the cameras shutter remains open to allow light onto the film

SLR – (Single Lens Reflex) a camera design that allows lenses to be interchanged and for the user to view subjects through the lens being used to take the picture

spot metering – light meter reading from a very small area of the total scene

sync speed – fastest shutter speed that can be used to synchronise the firing of the flash with the time the shutter is open

teleconverter – optical accessory that fits between the camera body and the lens to increase the focal length of the lens

telephoto lens – lens with a focal length longer than a standard 50mm lens

TTL – abbreviation for Through the Lens metering: light sensitive cells in the camera body measure light passing through the lens

tungsten lighting – artificial light source

viewfinder – camera's optical system used to view a subject

wide-angle lens – lens with a focal length shorter than a standard 50mm lens

zoom lens – lens with variable focal lengths

Burian, Peter K., and Robert Caputo. *National Geographic Photography Field Guide: Secrets to Making Great Pictures.* National Geographic, 1999.

Busselle, Michael. *Better Picture Guide to Travel Photography.* Amphoto, 1998.

Calder, Julian, and John Garrett. *The New 35mm Photographer's Handbook: Everything You Need to Get the Most Out of Your Camera.* 3rd ed. Crown, 1999.

Eaton, George. *Conservation of Photographs.* (Kodak Publication No. F-40) Silver Pixel Press, 1985.

Hedgecoe, John. *The Photographer's Handbook.* 3rd ed. Knopf, 1992.

Hicks, Roger, and Frances Schultz. *Travel Photography: How to Research, Produce and Sell Great Travel Pictures.* Focal Press, 1998.

Krist, Bob. *Spirit of Place: The Art of the Traveling Photographer.* Amphoto Books, 2000.

Langford, Michael. *35mm Handbook.* Knopf, 1993.

McCartney, Susan. *Travel Photography: A Complete Guide to How to Shoot and Sell.* 2d ed. Allworth Press, 1999.

McDonald, Joe. *The New Complete Guide to Wildlife Photography.* Watson-Guptill, 1998.

Millman, Anne, and Allen Rokach. *Focus on Travel: Creating Memorable Photographs of Journeys to New Places.* Abbeville Press, 1993.

Peterson, B. Moose. *Wildlife Photography: Getting Started in the Field.* Silver Pixel Press, 1998.

Rowell, Galen. *Mountain Light.* Sierra Club Books, 1995.

Waite, Charlie. *The Making of Landscape Photographs.* Trafalgar Square, 1993.

Wignall, Jeff. *Kodak Guide to Shooting Great Travel Pictures: The Most Authoritative Guide to Travel Photography for Vacationers.* 2d ed. Fodor's, 2000.

Agfa Photo Product
http://agfaphoto.com

Canon
http://canon.com

Eastman Kodak Company
http://kodak.com

Fuji
http://home.fujifilm.com

Fujifilm Corporation Japan
http://fujifilm.co.jp

Lonely Planet
www.lonelyplanet.com

Minolta
http://minolta.com

National Geographic Society
http://nationalgeographic.com

Nikon
http://nikon.co.jp

Olympus
http://olympus.com

Outdoor Photographer Magazine
http://outdoorphotographer.com

Pentax
http://pentax.com

photo.net Web service
http://photo.net

PhotoSecret's Links to Photo and Travel Sites
http://photosecrets.com

Photo Travel Guides Online
http://phototravel.com

Shutterbug Magazine On Line
www.shutterbug.net

Travel Photography
http://travel-library.com

INDEX

TRAVEL PHOTOGRAPHY

pictorials

The new range of lavishly illustrated Pictorial books is just the ticket for both travellers and dreamers. Off-beat tales and vivid photographs bring the adventure of travel to your doorstep long before the journey begins and long after it is over.

calendars & diaries

Yes, we know, work is tough, so do a little bit of deskside-dreaming with the spiral-bound Lonely Planet Diary or any Lonely Planet Wall Calendar, filled with great photos from around the world.